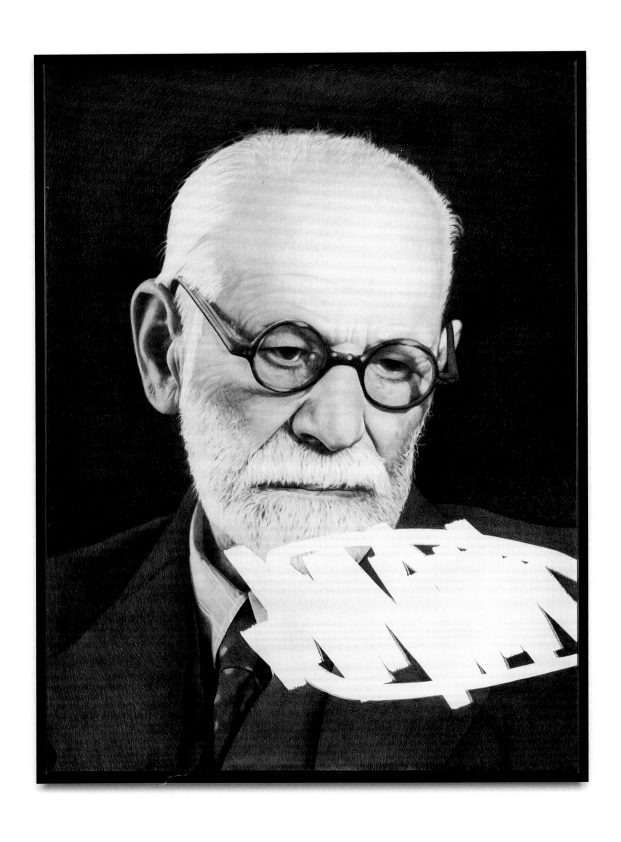

KARL HAENDEL

[DOUBT]

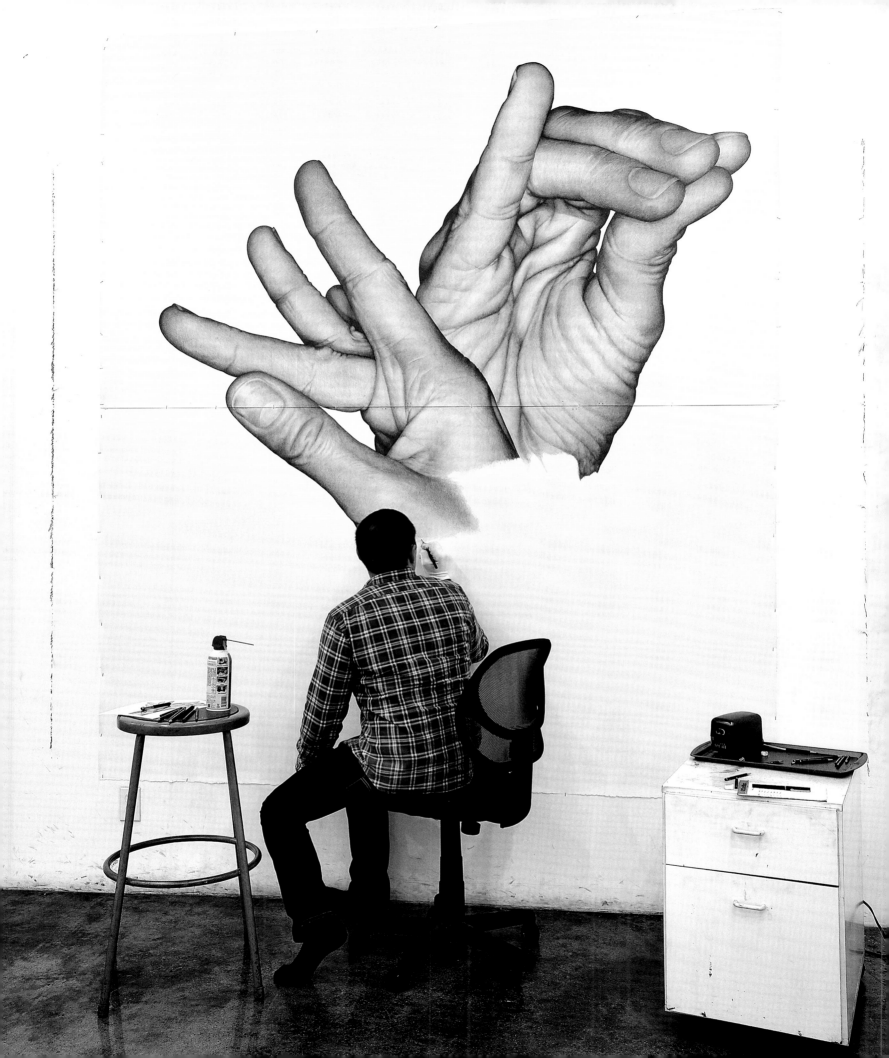

ADVENTURES OF THE AMPERSAND

CHRISTIAN RATTEMEYER

Karl Haendel traffics in images. For nearly two decades, his primary material has been an expanding catalogue of found images, which the artist has sorted, indexed, categorized, and reused in large-scale drawing, film, and slide installations. His handling of this material has remained remarkably stable: primarily drawn in graphite (and very rarely in colored pencil or gouache), Haendel produces an enlarged image of the source by projecting the original motif onto large sheets of fine drawing paper and redrawing parts of the projected image (often isolating heads, torsos, or other significant visual elements) against an otherwise untreated white background. These monumental drawings are then tacked or pinned to the wall, or given special artist-designed frames made of MDF, and sometimes are further reworked by introducing deliberate

tears and rips, which are then mended by crudely stapling the edges back together onto a wooden support frame. Sometimes, drawings are overlapped, and frequently, individual sheets and framed works are arranged in dense installations that can take up entire walls, if not entire galleries.

The structural background to Haendel's work is resolutely conceptual: after a BA in semiotics and art history at Brown,[1] he attended the Whitney Independent Study Program before he went on to the Skowhegan School of Painting and UCLA, where he received his MFA in 2003, and where he has lived and worked ever since. It is tempting to believe that Haendel's academic grounding in the operative potential of signs and signifiers, and a resulting critical approach to imagery more generally,

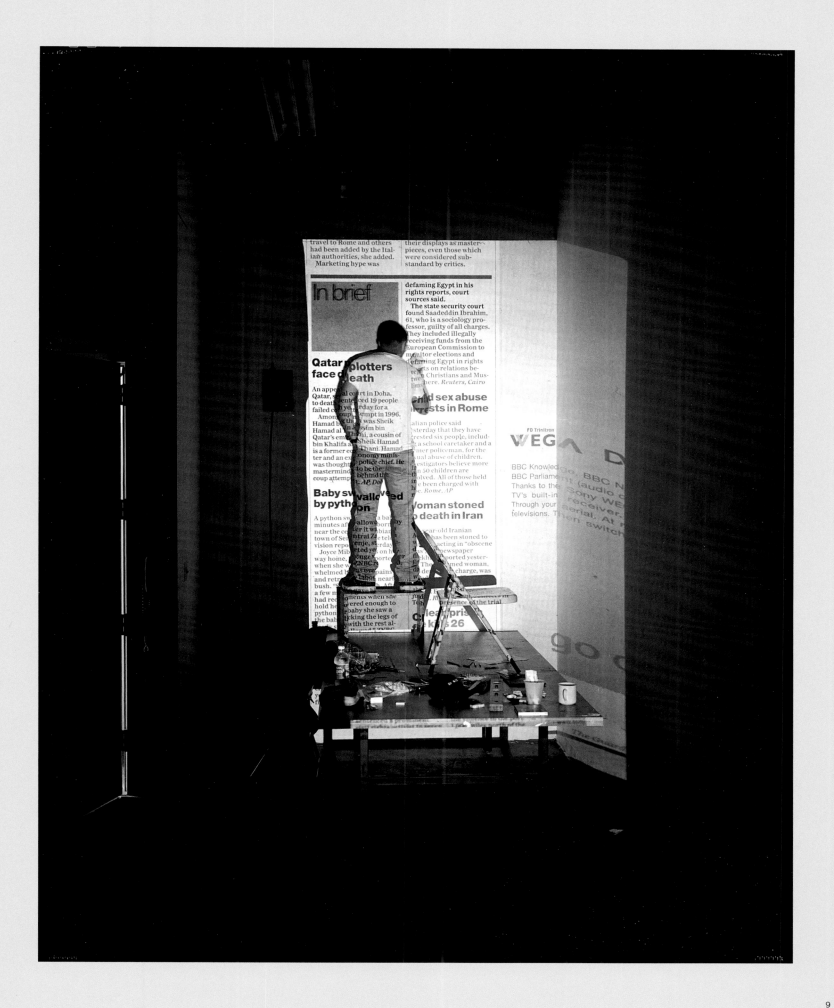

TOP TO BOTTOM:

Studio installation, 2002

Troy Brauntuch
Untitled, 1981
Pencil on paper, 46 x 32 in. (116.9 x 81.3 cm)
Courtesy of the artist and Petzel, New York

OPPOSITE PAGE:

In Brief, 2002

has steered his practice from the very beginning and has not only guided the artist's choices in arriving at his overarching project, but has also guided our trust in the (critical) validity of his approach. I am not the first to suggest that Haendel's drawing installations recall linguistic conceits: artist and curator Michelle Grabner has recognized Haendel's practice as a "process of language building" and describes the use of Haendel's drawings as "words and punctuation" with the artist "referring to each drawing in his visual vocabulary as a concept/image/word."[2] Crucially, Grabner also points to the way we receive Haendel's works as she contemplates the way understanding is constructed in a field of circulating images: "We construct meaning, opinions and belief systems through the consumption of signs and images, and Haendel's drawing project slows down the process for us, exposing the bias and speed inherent in the information industry. At the same time, his drawings also underscore the pleasures of study and interpretation in a cultural field of infinite signs."[3]

Haendel's work has, almost from the beginning of his career, been widely discussed as a continuation of or reengagement with appropriation art, an artistic procedure of reusing, quoting, lifting, and stealing images, objects, and artworks from either prior periods or different contexts. It is by now almost a cliché to discuss Haendel's work in relation to artists of the so-called Pictures Generation, such as Richard Prince, Troy Brauntuch, and particularly Robert Longo, whose own meticulously executed and monumentally scaled graphite drawings of found imagery of the past two decades has invited

In brief

Qatar plotters face death

An appeal court in Doha, Qatar, sentenced 19 people to death yesterday for a failed coup attempt in 1996.

Among them was Sheik Hamad bin Jassim bin Hamad al Thani, a cousin of Qatar's emir, Sheik Hamad bin Khalifa al Thani. Hamad is a former economy minister and an ex-police chief. He was thought to be the mastermind behind the coup attempt. *AP, Doha*

Baby swallowed by python

A python swallowed a baby minutes after it was born near the central Zambian town of Serenje, state television reported yesterday.

Joyce Mibenge was on her way home, ZNBC reported, when she was overwhelmed by labour pains and retreated into a nearby bush. "She gave birth. After a few moments when she had recovered enough to hold her baby she saw a python licking the legs of the baby with the rest already swallowed," ZNBC said. *Reuters, Lusaka*

Cairo court jails rights activist

An Egyptian court sentenced a prominent civil rights activist to seven years in jail yesterday after finding him guilty of defaming Egypt in his rights reports, court sources said.

The state security court found Saadeddin Ibrahim, 61, who is a sociology professor, guilty of all charges. They included illegally receiving funds from the European Commission to monitor elections and defaming Egypt in rights reports on relations between Christians and Muslims there. *Reuters, Cairo*

Child sex abuse arrests in Rome

Italian police said yesterday that they have arrested six people, including a school caretaker and a former policeman, for the sexual abuse of children. Investigators believe more than 50 children are involved. All of those held have been charged with rape. *Rome, AP*

Woman stoned to death in Iran

A 35-year-old Iranian woman has been stoned to death for acting in "obscene films", the newspaper Entekhab reported yesterday. The unnamed woman, who denied the charge, was stoned by court officers in the presence of the trial judge at Evin prison, Tehran. *Reuters, Tehran*

Chilean prison fire kills 26

A fire during a prison riot in the northern Chilean city of Iquique killed 26 inmates, the government reported yesterday. It was not known what triggered the violence in the port 1,000 miles north of the capital, Santiago. *AP, Santiago*

frequent comparison to Haendel's practice. But nevertheless, it is the context of appropriation art where the more recent critical engagement with Haendel's work has made the most impactful commentary. Grabner offers a qualified reading of Haendel's work in the discursive context of appropriation, stating that while, "like his forebears, he toys with the idea of authorship and the power of the idea over the experience, his work doesn't have quite the undermining effect of an earlier generation's. It isn't a commentary on commodification, but rather something more appropriate to a decade dominated by punditry. Maybe the work could be more aptly labeled 'appropriated editorializing.'"[4] The most profound recent discussion of Haendel's work in this light has been art historian Natilee Harren's three-part essay published online for the scholarly magazine *Art Journal Open*, the contemporary journal of the College Art Association. "Knight's Heritage: Karl Haendel and the Legacy of Appropriation" looks at three "episodes" in Haendel's practice that connect, from different vantage points, to the broader context of appropriation.

The first episode centers on a graduate school experiment, during Haendel's first year in graduate school at UCLA in 2000/2001, when the artist created, based entirely on photographic documentation and extensive research but without firsthand knowledge of the actual object, as faithful as possible a reproduction of a seminal (yet little known) sculpture of minimal art, Anne Truitt's sculpture *Knight's Heritage* from 1963. Harren's discussion tackles two central questions. One concerns intention: how must we understand Haendel's gesture in relation to the

intention of appropriation as an artistic procedure. Harren highlights this question through a comparison to Haendel's studio neighbor and friend, the artist Sharon Hayes:

For a time, his studio was next door to that of Sharon Hayes, a friend; they participated in the same feminist reading group and curated shows together. On the face of things, Hayes's practice, centered on the reperformance of historical protest gestures and language, would seem to bear little in common with Haendel's (typically) object-based work, and yet both artists engage in the replication of extant images and gestures. To imagine their work as part of a shared conversation about appropriating or reperforming signal moments in the history of art and politics illuminates the way in which appropriation operates differently within the value system associated with objects and performance, respectively. To copy an artwork (as image or object) is to steal it, whereas repetition is ontologically necessary for a work of performance art to persist, and the very act of reperformance is typically coded as being positively motivated by care.[5]

This also has implications for the production of value: what does it mean for a young male artist (or art student) to "validate" a historic work by an (overlooked but significant) female artist whose work should, under circumstances not shaped by the gender bias inscribed in the art world's value system, not need such validation. The second question concerns meaning: "What happens when we read the supposedly modernist work of Truitt

through the lens of Haendel as a second-generation postmodernist?"[6] Was Haendel drawn to the "allusive, allegorical quality"[7] of Truitt's work by reading it as "surprisingly more postmodern in its operations than that of Judd or Morris"?[8] Harren considers these questions in relation to a larger academic rereading of the historical accounts of modernism in general and appropriation art in particular, coinciding with Haendel's practice and conducted by scholars of his generation. What if, in other words, works by artists (and thinking by scholars) of Haendel's generation would allow us to reconsider the projects of a previous generation of artists "not only in terms of critical deconstruction, but as constructive projects"[9] that establish connections across historical periods, artistic communities, and individual narratives. Harren comes to the conclusion that, despite the uneven, problematic power dynamic of value mentioned before, we might have to understand Haendel's gesture of replication as a generative, and generous, procedure; far from simply "taking" the work, Haendel invested time and labor in it, enabling it "to appear again,"[10] while blurring the line between original and copy, underscoring, at once, both his own investment in it and enabling us to have an "authentic experience of a copy."[11]

This has larger ramifications for our understanding of the practice of appropriation as a whole, Harren suggests. By highlighting the relationships across time between artists, or images, rather than insisting on the function of critique often understood at the core of such revisitation, she invokes a more generous understanding of appropriation:

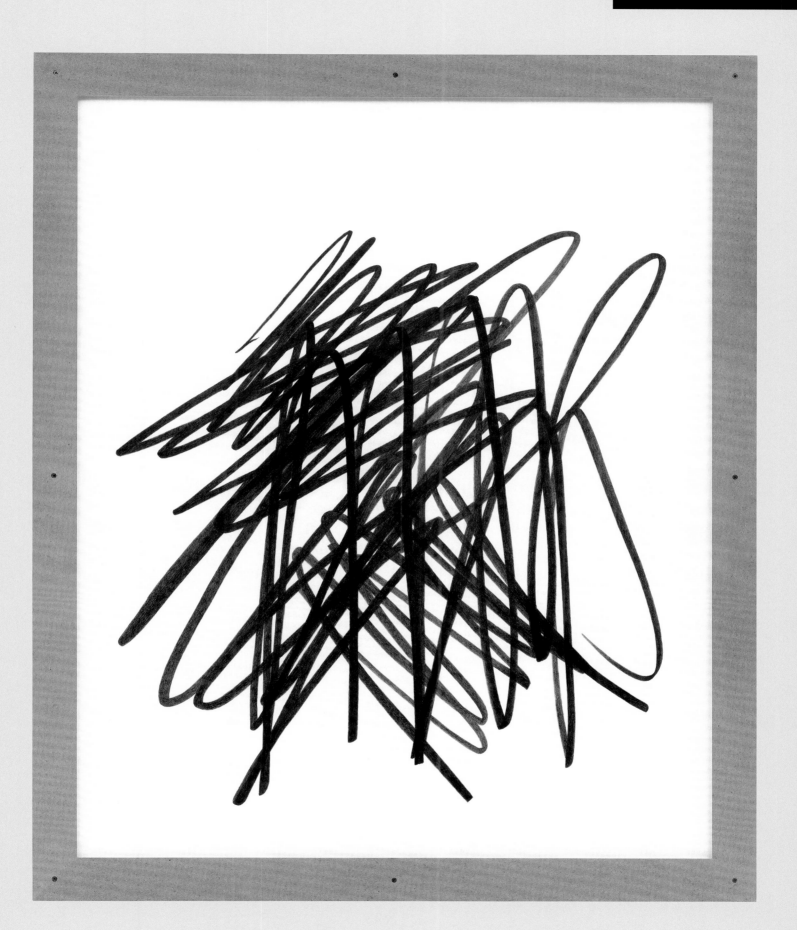

Accordingly, revised accounts of appropriation art have begun to attend in finer detail to the identity-driven, subjective motivations of appropriative gestures, such that we can begin to understand them as productively redrawing lines of historical relation rather than automatically amounting to the undermining of authorship or authenticity. Instead of a teleological, vertically hierarchical, Oedipal notion of historical time, acts of appropriation may imagine time as lateral and constellational. Repetition is not always an act of erasure or over-writing past artistic gestures. It may be a means of deliberate and sympathetic alignment, of establishing one's elective affinities.[12]

I am giving this analysis so much room not only to underscore the preponderance of this line of contextual reading of Haendel's work, but also to acknowledge the high level of subtlety, sophistication, and generative potential these prior analyses have produced. Thus, rather than follow in this genealogy, I would like to highlight some questions that arise from these previous arguments: others have mentioned some, although only in passing. Still others might be regarded as a rephrasing of already extent questions, altered ever so slightly by re-articulating them anew (a gesture not so dissimilar to Haendel's practice itself). Few, I hope, might be original, and of interest to some.

It seems reasonable to accept the claim that the free circulation of images as well as the artistic impulse to put existing images to new use through appropriation and selective

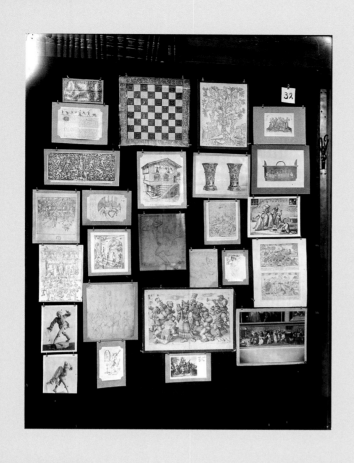

editing is not only a fundamental principle of appropriation art, but also a condition that all recent art must address. Subsequently, we need to understand the consequences of these conditions for the way art functions, and what it might mean. Generally speaking, the paradigm that rules Harren's (and Grabner's) arguments is a discussion of the operative potential of appropriation, one that locates the relevance and meaning within the nexus of procedures and intentions, and ascribes value and meaning based on the capacity for allegorical richness, and the linguistic slippages these operations can engender. Ethics come into play as issues of agency, authorship, power, and intention are located in the way in which the gestures of appropriation must be understood as expressions of critique, reverence, or care. But can

we understand these operations in other generative ways, ways that take at their core the role appropriation and appropriated images might play in producing meaning, as a category of reception, not intention? Simply put, what readings can these works engender that are distinct from the critical intentionality of the artist as operative in the discursive procedures of the work—to speak in the preferred postmodern terminology: to elevate the allegorical over the discursive, the act of looking over the act of analyzing.

For this, I am returning to a model of art historical thinking, a thinking in images, at its core, that sometimes is mentioned in passing as an example for the way Haendel works: Aby Warburg's *Mnemosyne Atlas*. Given that Haendel sorts and categorizes his images, and reuses motifs over and over, shifting their category from use to use (an image of Obama might belong to the category "politician" in one grouping, and "male portrait" or "crying men" in another), Warburg's *Atlas* certainly suggests itself as a predecessor, yet I am interested in Warburg in a deeper, or more general sense. Starting from the commonly accepted observation that "Warburg set art history 'in motion,'"[13] Georges Didi-Huberman, in his foreword to Philippe-Alain Michaud's the book *Aby Warburg and the Image in Motion*, summarizes Michaud's reading of Warburg as a three-fold observation of movement: "movement conceived of both as object and method, as syntagma and paradigm, as a characteristics of works of art and a stake in a field of knowledge."[14] The first observation concerns the "*image in motion*,"[15] and hews most closely to the traditional understanding of Warburg's thesis of

the *Nachleben,* or afterlife, of images, as motifs migrate from antiquity to the Renaissance; the second observation proposes an "*image-motion,*"[16] in a reference to Gilles Deleuze's term, when Warburg observes echoes of Laocoön in the Native American serpent ritual, translating and displacing images across temporal, geographic, and cultural divides; and the third is one of a "*knowledge-movement* of images, a knowledge in extensions, in associative relationships, in ever renewed montages, and no longer knowledge in straight lines, in a confined corpus, in stabilized typologies. Warburg's organic conception of his library, his iconographic archive—as seen in the extraordinary montages of his atlas *Mnemosyne*—is enough to show us the extent to which setting into motion constituted an essential part of his so-called method."[17]

But are Haendel's installations akin to Warburg's *Atlas?* On the surface, they share similarities. From around the time of his 2003 MFA thesis installation, Haendel has engaged in a game of loose associations that have steadily evolved into tighter and more legible rebuses. While his work before 2003 often included performative elements that featured the artist as a kind of shaman (a preacher, an idiot savant making drawings on the spot, even tending a live bunny in the gallery, in an obvious nod to Joseph Beuys), by 2003 he had settled on a style of drawing installation that valued the metonymic sequencing of drawn images over the enacted activation through the artist as performer. From now on, the viewer would enact the reading of the work, through acts of comparison and recall. At first, the categories of Haendel's drawings

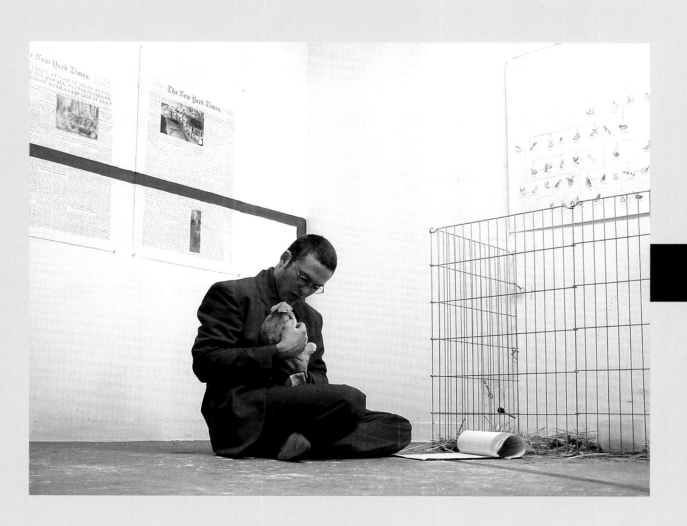

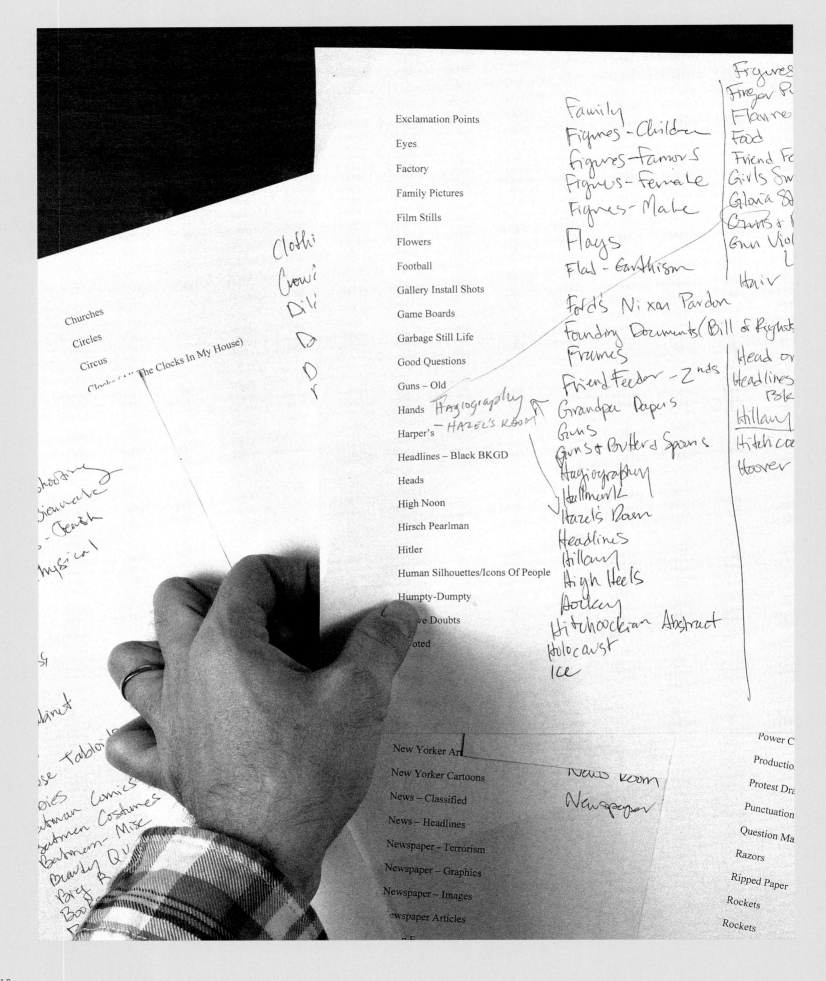

Churches

Circles

Circus

Clocks (All The Clocks In My House)

Exclamation Points

Eyes

Factory

Family Pictures

Film Stills

Flowers

Football

Gallery Install Shots

Game Boards

Garbage Still Life

Good Questions

Guns – Old

Hands

Harper's

Headlines – Black BKGD

Heads

High Noon

Hirsch Pearlman

Hitler

Human Silhouettes/Icons Of People

Humpty-Dumpty

New Yorker Art

New Yorker Cartoons

News – Classified

News – Headlines

Newspaper - Terrorism

Newspaper – Graphics

Newspaper – Images

Newspaper Articles

Power C

Productio

Protest Dra

Punctuation

Question Ma

Razors

Ripped Paper

Rockets

Rockets

18

appear hard to connect, even random: their order grows out of repetition, variation, and the underlying sorting paradigms that provide a conceptual (as well as iconographic) foundation to each individual motif. Over the past two decades, the artist has created a list of categories that structure his ever growing repository of images: his database of over 10,000 slides (both found images and those that he created himself are outputted to thirty-five-millimeter slides, categorized and stored in a slide archive to be used as sources projected onto the sheets of paper during the process of re-drawing) each categorized into a set of terms that range from "Abstraction" to "Yoga." In 2012, Haendel presented an exhibition, entitled *Oral Sadism and the Vegetarian Personality*, at Human Resources, an alternative art space in Los Angeles, where he installed around a dozen slide projectors that created a dense patchwork of projected images in the darkened gallery, each projector presenting a different story drawn from slides across Haendel's growing list of categories. An ongoing project, these projected installations have since been presented in different constellations and in different institutions, and might be the most Warburgian in their ongoing reshuffling of visual correspondences and affinities, not unlike an *Atlas* "remixed" for every occasion.

But even if his MFA exhibition still suggests an arrangement of drawings in space that owes more to an overall disjunctive reading based on sudden shifts of tone and indirect associations (a large, torn paper scribble next to a drawing of a screaming baby head and an inverted drawing of Uncle Sam does not suggest a clear line of references),

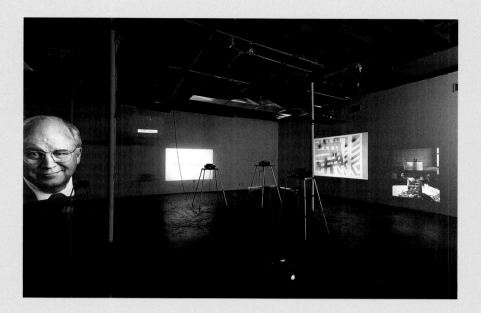

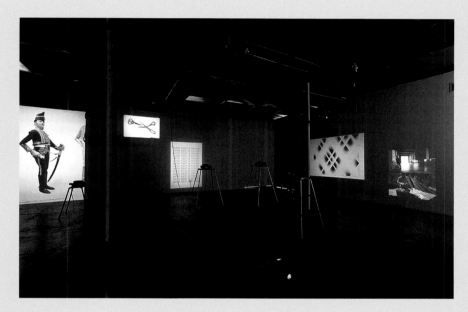

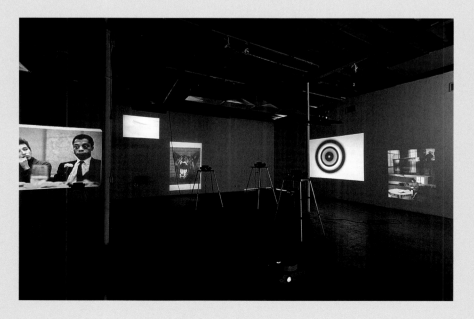

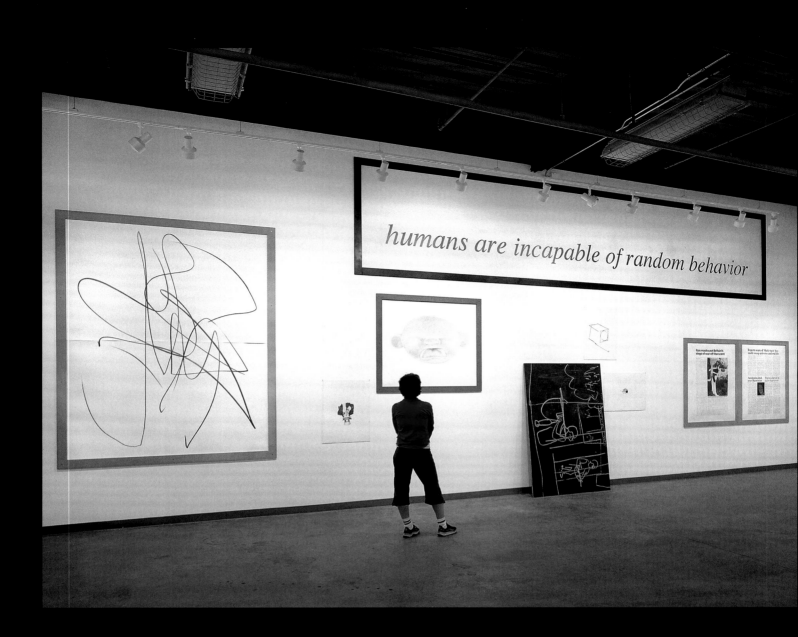

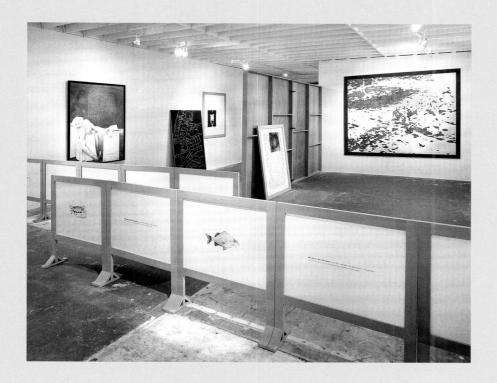

it still marks a dramatic shift from one of the earliest series of installed drawings that follow a different logic of organization and arrangement entirely. Executed around the same time as his replica of Anne Truitt's sculpture, *Sad Small Animals Somewhere in the Middle of the Food Chain* (2001), consists of a series of ten drawings of the titular animals—birds, a gopher, a fish, a crab, a frog, and so on—that are displayed in freestanding MDF frames joined by their edges as if to construct a small room divider. A description of the animal is drawn onto the backside of the paper sheet, with inane, yet scientific-sounding wordings such as "The Shy, Attractive Towhee is frequently heard, but not so often seen. It spends most of its existence in concealment." While clearly following a classificatory, vaguely scientific system of organization and selection

(in fact, both image and caption are taken from a 1970s World Book encyclopedia), *Sad Small Animals* lacks the insight that Haendel's later work accomplishes: their organizational mode is still operative from without, an external system of logic superimposed, or transposed onto the drawings in question. By subsequently arranging his drawings according to the infinitely more complex logic of his own categories and image archives, Haendel not only sheds his work of these outside orders, but more crucially, asks the question of how such classification can be borne *within* the images themselves.

By 2003, Haendel begins to ask different questions of his drawings, or rather, to have his drawings ask different questions of the viewer. The following year, for Haendel's installation for the 2004 California Biennial at the Orange County Museum of Art, a drawing of the same crying baby is making an appearance besides a negative inverted drawing of Uncle Sam, this time grouped with other drawings depicting, among other things, board games (an inverted Risk board hovering over a Monopoly board), a torn rendering of Caspar David Friedrich's *Eismeer* (*The Sea of Ice*, also known as *The Wreck of Hope*, 1823-24), and most crucially, a large, black and graphite mirrored question mark, dominating the central wall. The subject of the work, it seems to suggest, is the act of questioning itself, of setting into motion the fluidity of meaning that circulates and deviates among the individual drawings.

During the following decade, Haendel's installations circulate through a spiral of relational possibilities. For his 2005

The Shy, Attractive Towhee is frequently heard, but not so often seen. It spends most of its existence in concealment.

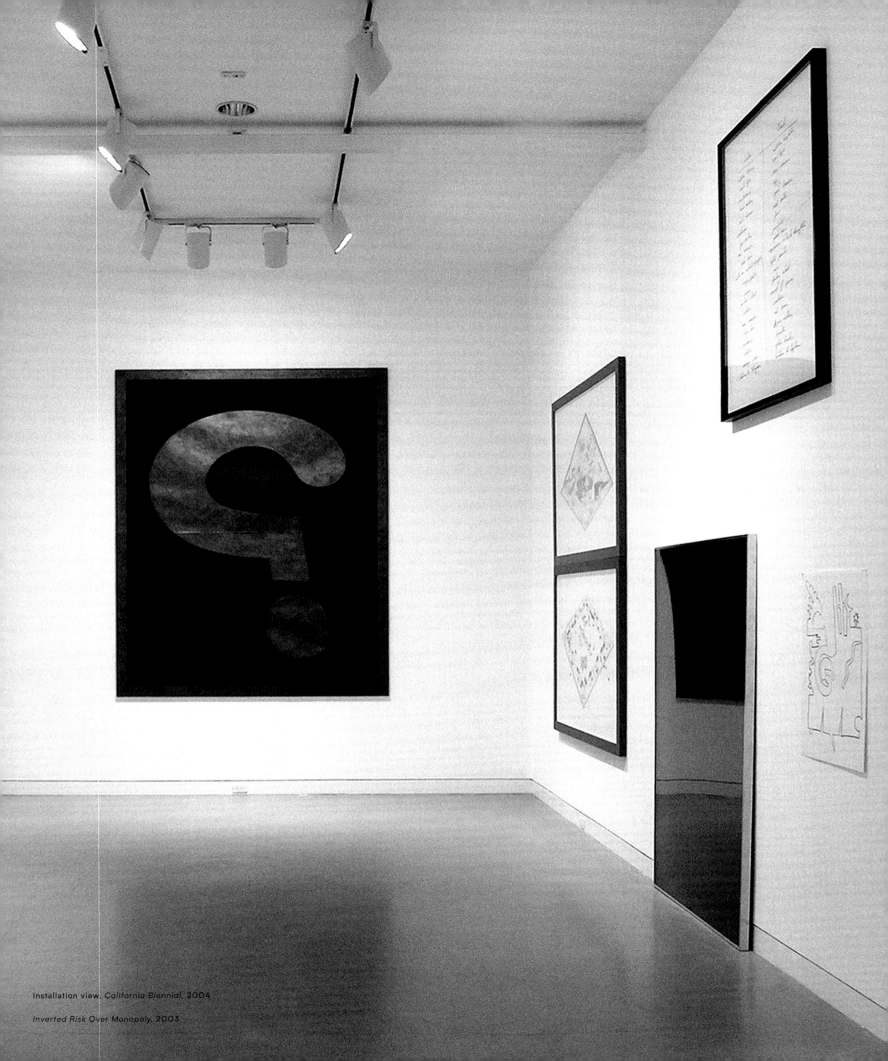

Installation view, *California Biennial*, 2004

Inverted Risk Over Monopoly, 2003

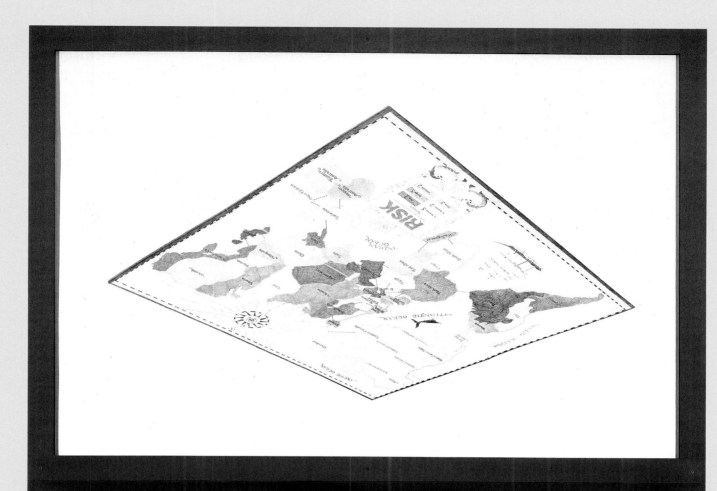

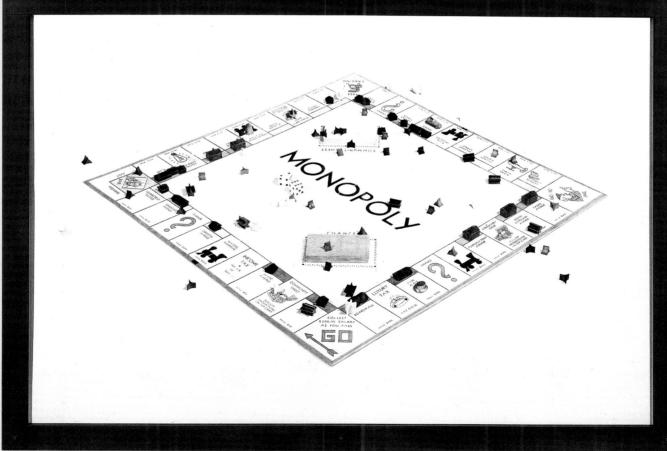

exhibition at Anna Helwing Gallery in Los Angeles, Haendel arranged a wall of drawings around an associative logic based on visual instability and the diagonal, displaying drawings of a tilted 40 Wall Street seen through a canyon of dramatic light and shadow, oblique exclamation points, renderings of Longo's *Men in the Cities* series, each shrunken and missing a leg, as well as a drawing of a loft's windows propped open with slanted mini-malist beams (the artwork that is the source of the image is Kishio Suga's *Limitless Condition*, from 1972).

As his images' sources grow wider and more disparate and his installations become more loose and intuitive—his participation in *Uncertain States of America* at the Hessel Museum at Bard College in 2006, or his *5th Column Group* from 2007, shown at

Haunted at the Guggenheim Museum, New York in 2010—the meaning of his installations open up to align with the disparity and diversity of the represented world itself, and the work shifts once more in its intention from a linguistic, or semiotic understanding of the relationships between images, organized and connected through the strategic use of punctuation symbols such as question marks, exclamation points and, crucially, ampersands, to one organized by the impact and drama of the images themselves. Importantly, Haendel's reliance on, and trust in, the emotional charge and semiotic field of each individual image lead the artist to a parallel thinning out and condensing of his pictorial strategies, sometimes, as in his 2012 gallery show *Informal Family Blackmail* at Susanne Vielmetter Los Angeles Projects, utilized simultaneously in

adjoining gallery spaces. For this show, Haendel installed in one gallery drawings isolated against single walls—a monumentalization of the single image previously not employed to such effect—while another gallery featured his dense signature tiling of all four walls (painted hot pink) with framed drawings of various sizes, stacked edge to edge, corner to corner, and aligned above and below a sort of horizon line established by the frames' horizontal edges.

I believe it is in this shift—from a sequential reading of images as an open field of referents to the understanding of the connectedness of all images through a mutual ground in the depicted world, and from a meaning constructed in the intention of the artist or the understanding of a shared iconography or similarity of form, expression, or shape to the localization of knowledge production through the recognition of a shared expressive drive, the "pathos" of a particular image or shape—that Haendel comes closer to Warburg's concept of the *Pathosformel*. For Warburg, this process came in pieces. Between 1888 and 1905, in his *Bruchstücke zu einer pragmatischen Ausdruckskunde*, Warburg "proposed to explore how the expressiveness of works is constituted, imagining their production and reception as an autonomous process, in order to isolate general categories that condition the creative act within any particular determination."[18] Once he had arrived at a concept, and a name, for his study of the expressiveness of images, the *Pathosformel*, Warburg aimed to understand how the recurrence of motifs through time and cultures might speak of a shared ground of emotional experience. As images

move from the ancient past to a more recent past, transform and translate across chronologies and culture, and ultimately engender new forms of knowledge production, an "art history without text," Warburg not only understood the image itself as a fundamentally mobile, history-traversing object of knowledge, but more importantly, he never lost sight of the fundamental drama—the *Pathos*—embedded in them. For Warburg, these images were expressions of a violent struggle of emotions, an ethics of temperaments. By placing the emphasis on the "phenomena of transition,"[19] Warburg not only shifted his study of images from what they *presented* to what they *represented*, the hidden dimension of their meaning, but also from the intention of their maker to that of their readers. For Didi-Huberman, this shift was by necessity psychoanalytical: "On the other hand, the *Pathosformel* gave art history access to a fundamental anthropological dimension—that of the *symptom*. Here the *symptom* is understood as *movement in bodies*, a movement that fascinated Warburg not only because he considered it 'passionate agitation' but also because he judged it an 'external prompting.'"[20]

It is through such a *symptomatic* reading of Haendel's image arrangements that we can perhaps most fruitfully generate new understandings: their meaning and their success now rely on the fervor of our own responses, on the longing they wrest in the viewer, or the poetry they allow us to experience within our own imaginations. Didi-Huberman's lesson from Warburg's studies was that the "image is not a closed field of knowledge; it is a whirling, centrifugal field. It is not a 'field of knowledge' like any other;

it is a movement demanding all the anthropological aspects of being and time."[21] Haendel's work reminds us of this fundamentally somatic, and symptomatic, effect of images, and his installations update Warburg's conviction that images have first and foremost the function "of creating a 'living' reciprocity between the act of knowing and the object of knowledge."[22]

[1] I am fascinated by the number of artists with a BA in semiotics from Brown, who are making work grounded both in a solid conceptual foundation and a strong commitment to the operative potential of imagery. Far from complete, the list includes Michael Bell-Smith, Louise Despont, Lucas Foglia, Coco Fusco, Chitra Ganesh, Sabrina Gschwandtner, Candice Lin, Cameron Martin, Keith Meyerson, Sarah Morris, Lisa Oppenheim, Sarah Oppenheimer, Rob Reynolds, Taryn Simon, and Kerry Tribe, among others. For the impact of Brown's semiotics program on the broader cultural landscape, see: http://archive.boston.com/news/globe/ideas/articles/2004/05/16/the_semio_grads?pg=full.
[2] Michelle Grabner, "Karl Haendel," in *Vitamin D2* (London, 2013), p. 116.
[3] Grabner, op.cit., p. 116.
[4] Eugenia Bell, "Karl Haendel: Harris Lieberman," *Artforum*, November 2007, p. 365.
[5] Natilee Harren, "Knight's Heritage: Karl Haendel and the Legacy of Appropriation, Episode One, 2000," in *Art Journal Open*, February 29, 2016, http://artjournal.collegeart.org/?p=6929.
[7] Harren, op.cit.
[8] Harren, op.cit.
[9] Harren, op.cit., emphasis original.
[10] Harren, op.cit., emphasis original.
[11] Harren, op.cit.
[12] Harren, op.cit.
[13] Harren, op.cit.
[14] Georges Didi-Huberman, "Knowledge: Movement," in Philippe-Alain Michaud, *Aby Warburg and the Image in Motion* (New York, 2007), p. 8.
[15] Didi-Huberman, op.cit., p. 9.
[16] Didi-Huberman, op.cit., p. 9, emphasis original.
[17] Didi-Huberman, op.cit., p. 10, emphasis original.
[18] Didi-Huberman, op.cit., p. 10, emphasis original.
[19] Michaud, op.cit., p. 31.
[20] Michaud, op.cit., p. 28.
[21] Didi-Huberman, op.cit., p. 15, emphasis original.
[22] Didi-Huberman, op.cit., p. 13.
[23] Didi-Huberman, op.cit., p. 18.

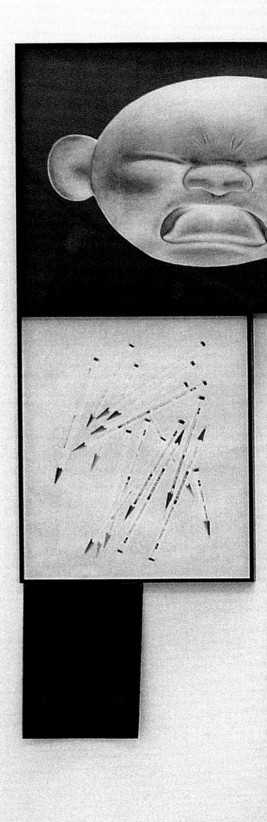

An Iraqi Offer:
Duels, Not War

BAGHDAD, Iraq, Oct. 1 (AP) — An Iraqi vice president offered an unusual suggestion today for solving the American-Iraqi standoff: President Saddam Hussein and President Bush and their top aides should fight a duel to settle their differences, and spare their people the ravages of war.

United Nations Secretary General Kofi Annan would be the referee for the duel, which should be held in neutral territory, the vice president, Taha Yassin Ramadan, said in an interview.

Mr. Ramadan gave no sign that he was joking.

Iraq has two vice presidents. Mr. Ramadan did not say whether he or the other one, Taha Mohiedden Maruf, would take on Dick Cheney.

!

how dumb bombs got smart
how dumb bombs got smart
how dumb bombs got smart
how dumb bombs got smart
how dumb bombs got smart
how dumb bombs got smart
how dumb bombs got smart
how dumb bombs got smart
how dumb bombs got smart
how dumb bombs got smart
how dumb bombs got smart
how dumb bombs got smart
how dumb bombs got smart
how dumb bombs got smart
how dumb bombs got smart
how dumb bombs got smart
how dumb bombs got smart
how dumb bombs got smart
how dumb bombs got smart

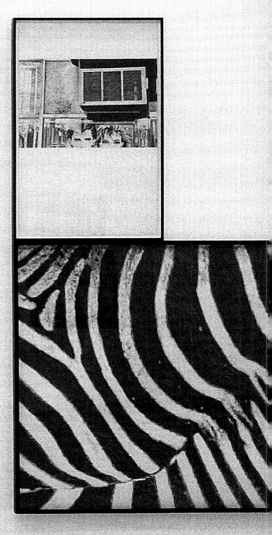

how dumb blonds got smart
how dumb blonds got smart
how dumb blonds got smart
how dumb blonds got smart
how dumb blonds got smart
how dumb blonds got smart
how dumb blonds got smart
how dumb blonds got smart
how dumb blonds got smart
how dumb blonds got smart
how dumb blonds got smart
how dumb blonds got smart
how dumb blonds got smart
how dumb blonds got smart
how dumb blonds got smart
how dumb blonds got smart
how dumb blonds got smart
how dumb blonds got smart

WE ♥ ABORTION
WE ♥ ABORTION
WE ♥ ABORTION
WE ♥ ABORTION
WE ♥ ABORTION
WE ♥ ABORTION

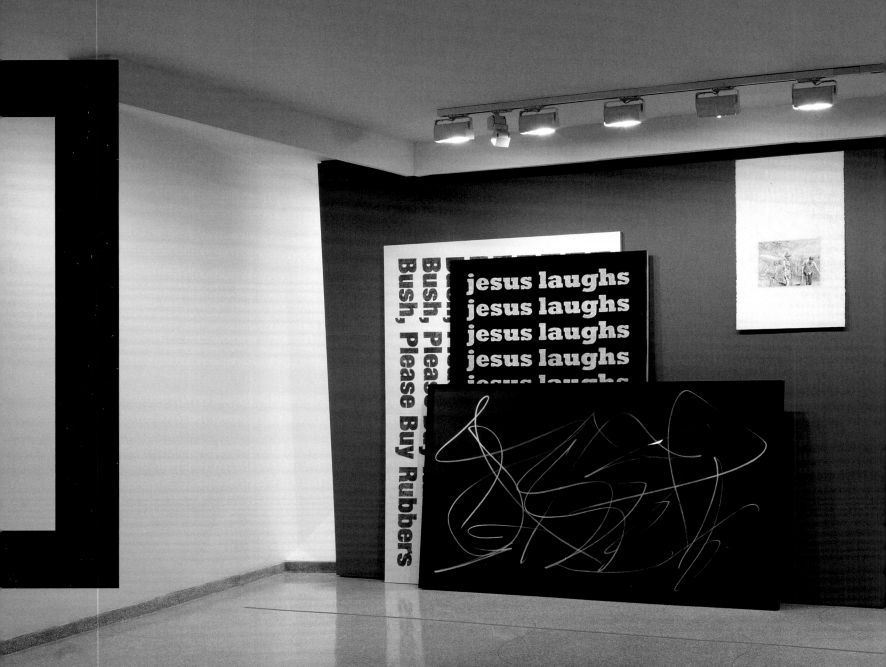

5th Column Group, 2007

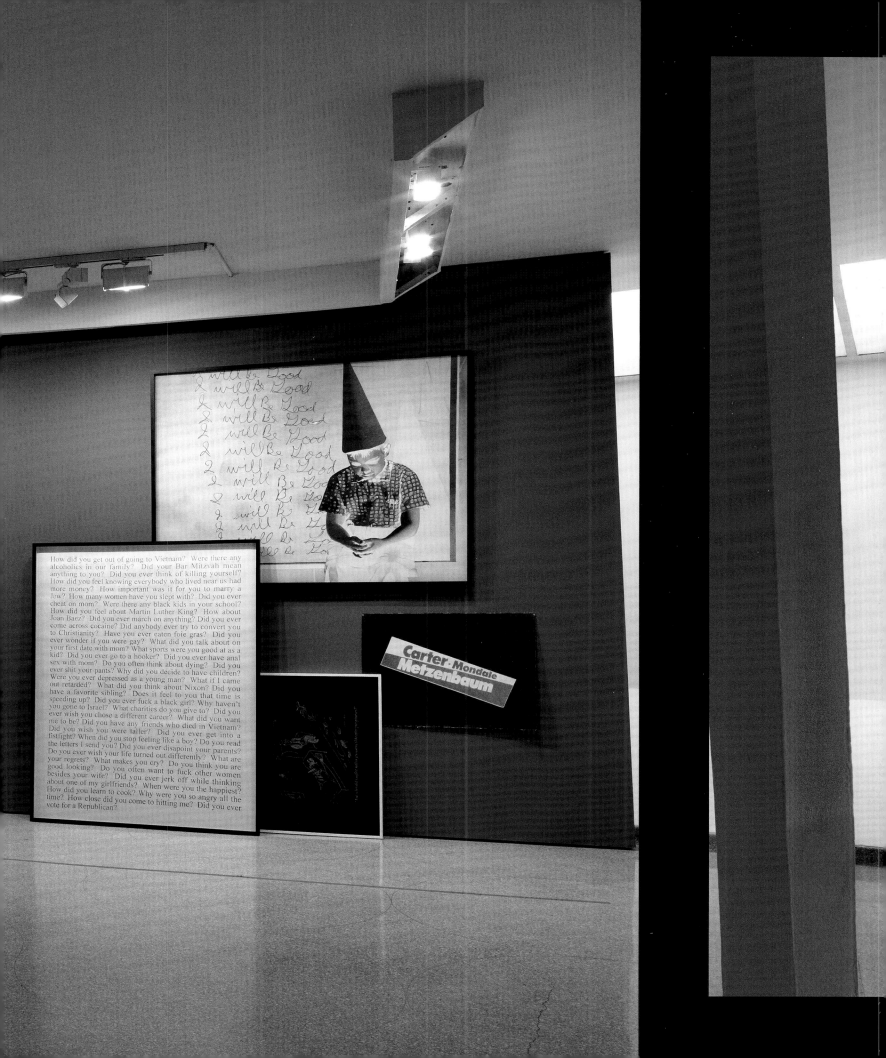

ПРАВДА

Орган Центрального Комитета КПСС

га основана
я 1912 года
ЛЕНИНЫМ

№ 183 [21152] • Четверг, 1 июля 1976 года • Цена 3 коп.

принципах марксизма-ленинизма,— «За мир, безпасность, сотрудничество и социальный прогресс в Европе».

МИР, БЕЗОПАСНОСТЬ, СОТРУДНИЧЕСТВО
СОЦИАЛЬНЫЙ ПРОГРЕСС В ЕВРОПЕ

...ня 1976 года в столице Германской Демократической Республики Берлине состоялась Конференция коммунистических и рабочих партий Европы. В ней приняли участие делегации следующих партий:

...ческой партии Бельгии во главе с товарищем Терфом, заместителем Председателя партии;

...коммунистической партии во главе с товарищем Живковым, Первым секретарем Центрального Комитета;

...ческой партии Дании во главе с товарищем Есперсеном, Председателем партии;

...коммунистической партии во главе с товарищем Миксом, Председателем партии;

...ческой единой партии Германии во главе с товарищем Эрихом Хонеккером, Генеральным секретарем Центрального Комитета;

...ческой партии Финляндии во главе с товарищем Саариненом, Председателем партии;

...ой Мартье, Генеральным секретарем партии;

...ческой партии Греции во главе с товарищем Флоракисом, Первым секретарем Центрального Комитета;

...ческой партии Великобритании во главе с товарищем Гордоном Макленнаном, Генеральным секретарем;

...ческой партии Ирландии во главе с товарищем О'Риорданом, Генеральным секретарем;

...й коммунистической партии во главе с товарищем Берлингуэром, Генеральным секретарем;

...коммунистов Югославии во главе с товарищем Тито, Председателем партии;

...ческой партии Люксембурга во главе с товарищем Урбани, Председателем партии;

...ической партии Нидерландов во главе с товарищем Хукстрой, Председателем Центрального...

...ческой партии Норвегии во главе с товарищем Гуннаром Кнутсеном, Председателем...

...ической партии Австрии во главе с товарищем Мури, Председателем партии;

...объединенной рабочей партии во главе с...

товарищем Эдвардом Тереком, Первым секретарем Центрального Комитета;

Португальской коммунистической партии во главе с товарищем Алваро Куньялом, Генеральным секретарем партии;

Румынской коммунистической партии во главе с товарищем Николае Чаушеску, Генеральным секретарем партии;

Санмаринской коммунистической партии во главе с товарищем Эрменджильдо Гаспарони, Председателем партии;

Левой партии—коммунисты Швеции во главе с товарищем Ларсом Вернером, Председателем партии;

Швейцарской партии труда во главе с товарищем Якобом Лехляйтером, членом Политбюро, секретарем Центрального Комитета;

Коммунистической партии Советского Союза во главе с товарищем Леонидом Ильичем Брежневым, Генеральным секретарем Центрального Комитета;

Коммунистической партии Испании во главе с товарищем Сантьяго Каррильо, Генеральным секретарем партии;

Коммунистической партии Чехословакии во главе с товарищем Густавом Гусаком, Генеральным секретарем Центрального Комитета;

Коммунистической партии Турции во главе с товарищем Исмаилом Биленом, Генеральным секретарем Центрального Комитета;

Венгерской социалистической рабочей партии во главе с товарищем Яношем Кадаром, Первым секретарем Центрального Комитета;

Социалистической единой партии Западного Берлина во главе с товарищем Эрихом Циглером, заместителем Председателя партии;

Прогрессивной партии трудового народа Кипра (АКЭЛ) во главе с товарищем Христосом Петасом, членом Политбюро Центрального Комитета.

Представители этих партий обменялись мнениями по ограниченному кругу вопросов, касающихся борьбы за мир, безопасность, сотрудничество и социальный прогресс в Европе. Достижению этих целей готова содействовать каждая из партий — участник конференции.

Участники конференции подчеркивают твердую решимость всех партий и впредь, на основе политической линии, совершенно самостоятельно и независимо разработанной и принятой каждой из них в соответствии с социально-экономическими и политическими условиями и национальными особенностями своих стран, вести последовательную борьбу во имя достижения целей мира...

демократии и социального прогресса, что отвечает общим интересам рабочего класса, демократических сил и народных масс всех стран.

Они со всей определенностью заявляют, что политика мирного сосуществования, активное сотрудничество государств, независимо от их социального строя, и разрядка международной напряженности соответствует как интересам каждого народа, так и прогрессу всего человечества и не только ни в коем случае не означают политического и социального статус-кво в той или иной стране, но, напротив, создают наилучшие условия для развития борьбы рабочего класса и всех демократических сил, для утверждения неотъемлемого права каждого народа свободно избирать путь своего развития и идти по этому пути, для борьбы против господства монополий за социализм.

Участники конференции констатировали, что в международном положении произошли существенные позитивные сдвиги, являющиеся результатом изменения соотношения сил в пользу дела мира, демократии, национального освобождения, независимости и социализма, результатом усиления борьбы народных масс и широких политических и общественных сил. Это определило процесс перехода от политики напряженности к нормализации и всестороннее развитие новых отношений и сотрудничества между государствами и народами.

На этой основе сложилась новая ситуация и в Европе. Важные проблемы, отравлявшие международную атмосферу, в том числе некоторые проблемы, остававшиеся неурегулированными со времен второй мировой войны, были решены путем переговоров; были заключены многочисленные договоры, соглашения, декларации и другие договоренности между государствами в духе мирного сосуществования. Все это создало условия для развития новых отношений и сотрудничества между государствами, для преодоления разделения континента на противоположные военные блоки, для разоружения.

Сам факт проведения в Хельсинки Совещания по безопасности и сотрудничеству в Европе с наибольшей очевидностью отражает перемены, происходящие на континенте в результате победы народов в войне против фашизма и проявления их воли жить и сотрудничать в условиях мира и безопасности и строить свое будущее в соответствии со своими законными устремлениями. Это совещание, имеющее историческое значение, разработало и закрепило принципы дружественных отношений и сотрудничества государств: суверенное равенство,

уважение прав, присущих суверенитету; неприменение силы или угрозы силой; нерушимость границ; территориальная целостность государств; мирное урегулирование споров; невмешательство во внутренние дела; уважение прав человека и основных свобод, включая свободу мысли, совести, религии и убеждений; равноправие и право народов распоряжаться своей судьбой; сотрудничество между государствами; добросовестное выполнение обязательств по международному праву;

Совещание по безопасности и сотрудничеству в Европе подтвердило возможность и реальную пользу рассмотрения и решения сложнейших международных проблем с участием всех заинтересованных стран и их полного равноправия. Оно открыло новые перспективы для дальнейшего укрепления мира и безопасности, для плодотворного развития отношений и сотрудничества между всеми странами Европы. Оно имеет позитивные последствия для всех народов.

Эффективность достигнутых в Хельсинки договоренностей в решающей степени зависит от того, насколько последовательно и точно все государства будут придерживаться десяти согласованных ими положений и проводить в жизнь все положения заключительного акта, представляющего собой единое целое. Будет тем выше, чем последовательнее государства-участники продолжат свои усилия, направленные на укрепление европейской безопасности и развитие равноправного сотрудничества в духе принятых на совещании договоренностей. Это необходимое условие того, что разрядка стала непрерывным, все более жизнеспособным, всеобщим по охвату процессом. Для достижения этой цели, как показывает уже накопленный опыт, требует новых активных усилий коммунистических и рабочих партий, всех демократических и миролюбивых сил, широкой общественности, народных масс континента.

Демократическая и антифашистская борьба рабочего класса, народных масс в Западной Европе поднялась сегодня на новую ступень. Свергнут фашистский режим в Португалии. В этой стране идет борьба за демократические и социальные преобразования... фашистской диктатуры в Греции. В Испании отживающая наследница последнего оплота фашизма в Европе... наталкивается на продолжающееся франкизмом поперек растущей сплоченной оппозиции всех антифашистских и демократических сил. Во всей капиталистической Европе растет движение трудящихся, прогрессивных сил, добиться демократических преобразований во...

(Продолжение на 2-й стр.)

Конференция коммунистических
рабочих партий Европы
завершила работу

...ференция коммунистических и рабочих партий Европы завершила свою работу второго дня на заседании представителей компартий...

Э. Берлингуэр, Коммунистической партии Люксембурга — тов. Д. Урбани; Португальской коммунистической партии — тов. А. Куньял; Французской коммунистической партии — тов. Ж. Марше; Коммунистической партии Норвегии — тов. М. Г. Кнутсен; Санмаринской коммунистической партии — тов. Э. Гаспарони; Венгерской социалистической рабочей партии — тов. Я. Кадар.

На заседаниях председательствовали товарищи: Ж. Марше (Французская коммунистическая партия), Х. Флоракис (Коммунистическая партия Греции), Г. Макленнан (Коммунистическая партия Великобритании), М. О'Риордан (Коммунистическая партия Ирландии).

Конференция проходила в деловой, товарищеской атмосфере.

Представители коммунистических и рабочих партий, участвовавших в конференции, выразили свое убеждение в том, что осуществление сформулированных ею целей отвечает интересам всех народов и станет важным вкладом в дело мира, национальной независимости, демократии и социализма на всей нашей планете.

В заключение своей работы конференция приняла итоговый документ «За мир, безопасность, сотрудничество и социальный прогресс в Европе» и решила его опубликовать.

(ТАСС).

...м в честь участников Конференции
...унистических и рабочих партий Европы

(ТАСС). Центр... Социалистической Германии...

Встреча тов. Л. И. Брежнева с тов. Я. Кадаром

30 июня в Берлине Генеральный секретарь ЦК КПСС Л. И. Брежнев встретился с Первым секретарем ЦК ВСРП Я. Кадаром. Руководители двух партий затронули некоторые международные вопросы и отметили, что проведение Конференции коммунистических и рабочих партий Европы является важным шагом в деле сплочения коммунистического в рабочего движения на континенте.

Л. И. Брежнев и Я. Кадар обменялись информацией о ходе реализации решений XXV съезда КПСС и XI съезда ВСРП и выразили полное удовлетворение углублением венгеро-советского сотрудничества по партийной и государственной линиям.

Встреча прошла в атмосфере.

Встреча тов. Л. И. Брежнева с тов. Н. Чаушеску

30 июня в Берлине состоялась дружеская встреча Генерального секретаря ЦК КПСС Л. И. Брежнева с Генеральным секретарем РКП Н. Чаушеску. Обменявшись мнениями о работе Конференции коммунистических и рабочих партий Европы, они высказали убеждение, что решения этой конференции послужат развитию сотрудничества коммунистических партий, окажут благоприятное воздействие на все прогрессивные революционные силы континента.

Л. И. Брежнев и Н. Чаушеску затронули также актуальные вопросы дальнейшего углубления и развития взаимосвязей между РКП, Советским Румынией.

Встреча прошла в товарищеской атмосфере.

Встреча тов. Л. И. Брежнева с тов. Т. Живковым

30 июня в Берлине состоялась дружеская встреча Генерального секретаря ЦК КПСС Л. И. Брежнева и Первого секретаря ЦК БКП, Председателя Государственного совета НРБ Т. Живкова. Руководители КПСС и БКП подчеркнули важное значение Конференции коммунистических и рабочих партий Европы, обменялись мнениями по актуальным международным проблемам.

На встрече затрагивались некоторые вопросы дальнейшего развития советско-болгарского сотрудничества в социалистическом и коммунистическом строительстве, исходя из решений XXV съезда КПСС и XI съезда БКП. Встреча прошла в атмосфере братской дружбы.

Встреча тов. Л. И. Брежнева с тов. Г. Гусаком

30 июня в Берлине состоялась встреча Генерального секретаря ЦК КПСС Л. И. Брежнева с Генеральным секретарем ЦК КПЧ, Президентом ЧССР Г. Гусаком и имел с ним беседу, прошедшую в атмосфере братской дружбы.

В ходе встречи состоялся обмен мнениями по некоторым вопросам дальнейшего развития отношений между двумя партиями и странами. С удовлетворением было отмечено развитие советско-чехословацкого сотрудничества, выражено всестороннее партийное и государственное... национальной жизни, и рост общности в строительстве коммунистического общества в СССР.

Товарищи Л. И. Брежнев и Г. Гусак обменялись также по некоторым вопросам.

Встреча тов. Л. И. Брежнева с тов. Г. Мисом

30 июня в Берлине состоялась встреча Генерального секретаря ЦК КПСС Л. И. Брежнева с Председателем Германской коммунистической партии Г. Мисом.

Г. Мис высказал поддержку миролюбивой внешней политики КПСС, вновь подтвержденной в решениях XXV съезда КПСС, приветствовал мирные... за мир и демократию, за углубление процессов разрядки, за социальный прогресс... в области разоружения и других сферах и успехи в строительстве коммунистического общества в СССР.

Л. И. Брежнев подчеркнул, что КПСС и впредь будет проявлять солидарность с борьбой западногерманских... трудящихся, за дальнейшее укрепление отношений между ЦК КПСС и ГКП.

В беседе приняли участие кандидат в члены ЦК КПСС Б. Н. Пономарев...

(ТАСС). ...даю присутствующим здесь руководящим представителям коммунистических и рабочих партий братский привет и наилучшие пожелания дальнейших успехов в нашей борьбе за общее дело — дело мира, демократии и социализма!

...тов. Хонеккер провозглашает тост за братскую сплоченность коммунистических и рабочих партий Европы, за их взаимодействие со всеми миролюбивыми и демократическими силами, за совместное осуществление поставленных ими дел.

...риала для размышлений, для практических выводов.

Принятый нами документ содержит не только серьезную марксистско-ленинскую характеристику положения дел в Европе, но и, что особенно важно, тщательно продуманные, совместно выработанные цели нашей борьбы. Можно сказать, что мы сообща наметили хороший маршрут для движения вперед — вперед в Европе мира и безопасности, сотрудничества и социального прогресса. Этим маршрутом мы пойдем все вместе, кто по непосредственно работает все это время во имя того, чтобы...

...друга с успехом и пожелать друг другу больших достижений в борьбе за общие цели.

Необходимо, конечно, сказать еще одно. Не просто долг возможности, но настоящей искренней благодарности, чувства коммунистического товарищества призывают всех нас сказать большое спасибо ЦК Центрального Комитета СЕПГ, нашему другу Эриху Хонеккеру и, конечно, тем товарищам из братских партий, которые непосредственно...

...седу, прошедшую в атмосфере братской дружбы.

readers a number of proverbs. Many of these sayings became famous, including:

"A penny saved is a penny earned."
"God helps them that help themselves."
"Early to bed and early to rise,
Makes a man healthy, wealthy, and wise."

Such proverbs expressed Franklin's philosophy that foresight, wise spending, and plain living are not only good qualities, but also lead to success. This philosophy greatly influenced American thought before and after the Revolutionary War (1775-1783).

Franklin enlarged the almanac for the 1748 edition and called it *Poor Richard Improved.* In the preface to the final edition, published in 1757, he collected many of Richard's proverbs on how to succeed in business and public affairs. The preface, called "The Way to Wealth," was reprinted separately and was widely read in England and France as well as in America. However, this collection of proverbs provides a misleading view of Franklin's wisdom and character because it focuses chiefly on material gain and proper conduct. Many of Franklin's other sayings reveal that he also had a witty and sometimes skeptical mind. DEAN DONER

See also FRANKLIN, BENJAMIN (Publisher; picture: As an Author).

POORWILL. See WHIPPOORWILL.

POP ART is an art movement, largely American, that became well known during the 1960's. Many pop artists use common, everyday, "nonartistic" commercial illustrations as the basis of their style or subject matter. Much of their art is satirical or playful in intent.

Pop artists have no single way of working. Some are fascinated by the bold, simple patterns of commercial illustrations. For example, Andy Warhol has made exact painted copies of soup cans, repeating them over and over in the same painting (see WARHOL, ANDY). James Rosenquist and Tom Wesselmann use advertising art as the basis of paintings with their own com-

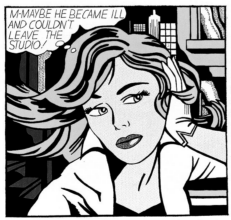

Wallraf-Richartz-Museum, Cologne, Germany,
Ludwig Collection (Ann Munchow)

Pop Art Painting, such as the comic-strip panel *M-Maybe* (1965) by Roy Lichtenstein, shows the influence of commercial art.

plex, often humorous, designs (see UNITED STATES [pictures: Painting Since 1913]). Several pop artists have made three-dimensional constructions that resemble and make fun of ordinary objects. See the color picture of *Giant Soft Fan, Ghost Version* by Claes Oldenburg in the SCULPTURE article. MARCEL FRANCISCONO

POPCORN is a type of corn with small, hard kernels. Under heat, the kernels "pop" (burst) into a tasty white food. A popcorn plant is smaller than most varieties of field corn, but it has the same food value. Each kernel has a tough covering and contains much starch.

J.C. Allen

These Hard, Shiny Kernels of Popcorn will turn into a delightful refreshment when they burst in the corn popper.

A popcorn kernel "pops" when it contains about 13.5 per cent moisture and is heated to about 400° F. (200° C). When heated, the moisture changes into steam. The hard covering keeps the steam from escaping, causing pressure to build up inside the kernel. The pressure finally bursts the kernel. Good popcorn kernels expand from 30 to 35 times their size when popped.

Farmers grow popcorn in much the same way as field corn. But rows of popcorn are planted closer together. The ears are carefully harvested after they have matured and dried. Most U.S. commercial popcorn is grown in Indiana, Iowa, Nebraska, and Ohio.

Scientific Classification. Popcorn belongs to the grass family, *Gramineae.* It is genus *Zea,* species *Z. mays,* variety *everta.* GUY W. MCKEE

POPÉ, *poh PAY* (? -1688?), was a Pueblo Indian leader. He helped plan and lead a major Pueblo revolt against the Spaniards in what is now New Mexico. Spanish explorers had come to this area about 1540. Through the years, they tried to convert the Indians to Roman Catholicism. They forced the Indians to work for them and to pay taxes with crops. In 1680, Popé helped lead a Pueblo revolt that drove out the Spaniards and kept them from the Indians' land for 12 years.

After the revolt, Popé, became the leader of several Tewa Pueblo villages. He tried to remove all traces of Spanish influence from Pueblo life. But Popé often used harsh punishments to enforce his rule. In 1688, the villages he controlled forced him from power. Popé died shortly after regaining the leadership of several Pueblo villages later that year.

Popé was born in the pueblo of San Juan, near what is now Santa Fe, N. Mex. His Indian name was *Po-png,* which means Pumpkin Mountain. JOE S. SANDO

See also INDIAN WARS (The Pueblo Revolt).

LEFT TO RIGHT:

Untitled (Pop Art). 2001

Untitled (Black Wave). 2001

Untitled (I want to love you). 2001

FOLLOWING PAGE:

Moral Continuum. 2000 [detail]

Experts warn of 'black wave' that could sweep universe and end life

BY CHARLES ARTHUR
Technology Editor

THE EARTH is at risk from the universe suddenly turning "inside-out", causing human life to be extinguished at the speed of light, experts said yesterday.

Dr Benjamin Allanach, from the particle physics laboratory at CERN in Geneva, warned of the prospect of a "black wave" sweeping over the world.

"The universe would suddenly and spontaneously swap from its present state into one where the electric force would turn off, and it would all become dark," he said.

The switch would be from our present state to one predicted in the theory of "supersymmetry", which states that every normal matter particle has a heavier counterpart.

It is theoretically possible that, at any point in the vacuum of the universe, such a swap could happen and spread like a rip in the fabric of matter, swapping every particle to its heavier counterpart and sucking up energy.

However, Dr Allanach said the universe had lasted 15 billion years and the prospect of the phenomenon was one in 169 million million or the equivalent of winning two consecutive lotteries.

Scientists have worked out how to stop asteroids from destroying the Earth. But Britain is doing little to chart this possible doomsday scenario, so the likelihood of a huge piece of rocky cosmic litter striking the Earth is just as likely as when it happened to the dinosaurs 65 million years ago.

Dr Duncan Steel, of the University of Salford, said methods to prevent an asteroid strike had been devised but enough warning had to be given to prepare nuclear weapons to divert it away from Earth.

However, Britain is not carrying out any observation of "near-Earth objects", and no organisation is watching the skies in the southern hemisphere from where a civilisation-destroying object more than 500 metres across could fall.

That will probably not happen this century. But Dr Steel said that in terms of the potential benefit compared to its cost, the project should have the highest priority. "We check for bombs on planes not because there are lots of bombs but because the consequences are catastrophic," he said.

Without such measures, the first we might know of an asteroid impact on the other side of the Earth would be earthquakes, followed 45 minutes after the impact by hot rocks raining down from the sky.

"The impact of a one-kilometre asteroid would set the Earth ringing like a bell, with quakes all over," said Dr Steel.

The biggest problems, in which up to half of humanity would be wiped out, would be the poisoning of the atmosphere by the nitrous oxides created in the impact.

Academics clash over Darwinism

BY STEVE CONNOR

A SCIENCE historian has attacked the evolutionary biologist Richard Dawkins and other scientists for equating Darwinism with atheism.

Michael Ruse of Florida State University, who describes himself as an "ultra-committed Darwinist", said Professor Dawkins, of Oxford University, was doing Darwinism a disfavour by saying that belief in God was incompatible with belief in evolution. Professor Dawkins was playing into the hands of Creationists, who believed in the literal truth of the Bible, Professor Ruse said.

"One of the things that has made the job of Creationist fighters – and I'm one – more difficult has been my fellow evolutionists, notoriously Richard Dawkins, because he links Darwinism to atheism," Professor Ruse told the British Association meeting.

"They are absolutely blunt that Christianity is a load of rubbish. It's certainly made it very difficult because people like Dawkins have been very openly and flamboyantly saying that Christianity is a refuge of

Dawkins: Blamed for dismissing Christianity

sort, it's for people with flabby brains," Professor Ruse said.

"Although I'm not a Christian, what I'm saying is that if you've even bothered to look at the Christian tradition and theology there are ways of dealing with science, including Darwinism," he said.

Professor Ruse, who is British, said that Creationism was undergoing a revival, especially in America, where it was being taught under the banner of "intelligent design", which argued that living organisms were too complex to be the result of chance.

Pupils jump to it in quake experiment

BY CHARLES ARTHUR

IF YOU feel the Earth move at 11am today, don't worry – it's probably just the children. To initiate Science Year, one million of them will jump off chairs at more than 3,000 schools across Britain in an experiment to investigate whether humans can make their own earthquakes.

According to Steven Chapman of the British Association, if one million children weighing an average of 50kg (7st 12lb) jump from a height of 20cm (8in) they will release 100 million joules. If they do this 20 times in the allotted minute for the experiment, they will release two billion joules, the same amount of energy as is released in an earthquake measuring 3 on the Richter scale.

"Certainly it would be feasible for seismologists to measure it," Dr Chapman said. "There are typically 100,000 earthquakes of this magnitude in the world every year. Though their effects cannot be felt, they can be measured."

Dr Ted Nield of the British Geological Society said Britain had hundreds of magnitude 3 earthquakes every year, "but they don't do anything". Teams at the society will be able to monitor their seismographs to see whether the experiment succeeds or whether there were too many truants.

A long-standing hypothesis suggests that if everyone in China were to jump off a chair at the same time, the movement of the Earth would cause a giant wave, or tsunami, that would engulf the west coast of America.

For obvious reasons that remains untested. But earthquakes generated by humans alone are more common than one might expect, and are generally associated with rock concerts. When the pop group Madness played at Finsbury Park, north London, in August 1992, the co-ordinated jumping of fans caused a mini-earthquake that was equivalent to magnitude 4.5 – enough to cause nearby tower blocks to sway.

Dr Chapman said the inspiration for today's experiment was not from that incident. "It was one of our workers, actually, who said that they tried the same sort of thing in Australia."

*I want to love you,
but I just can't right now.*

Floating Hitler Head. 2002

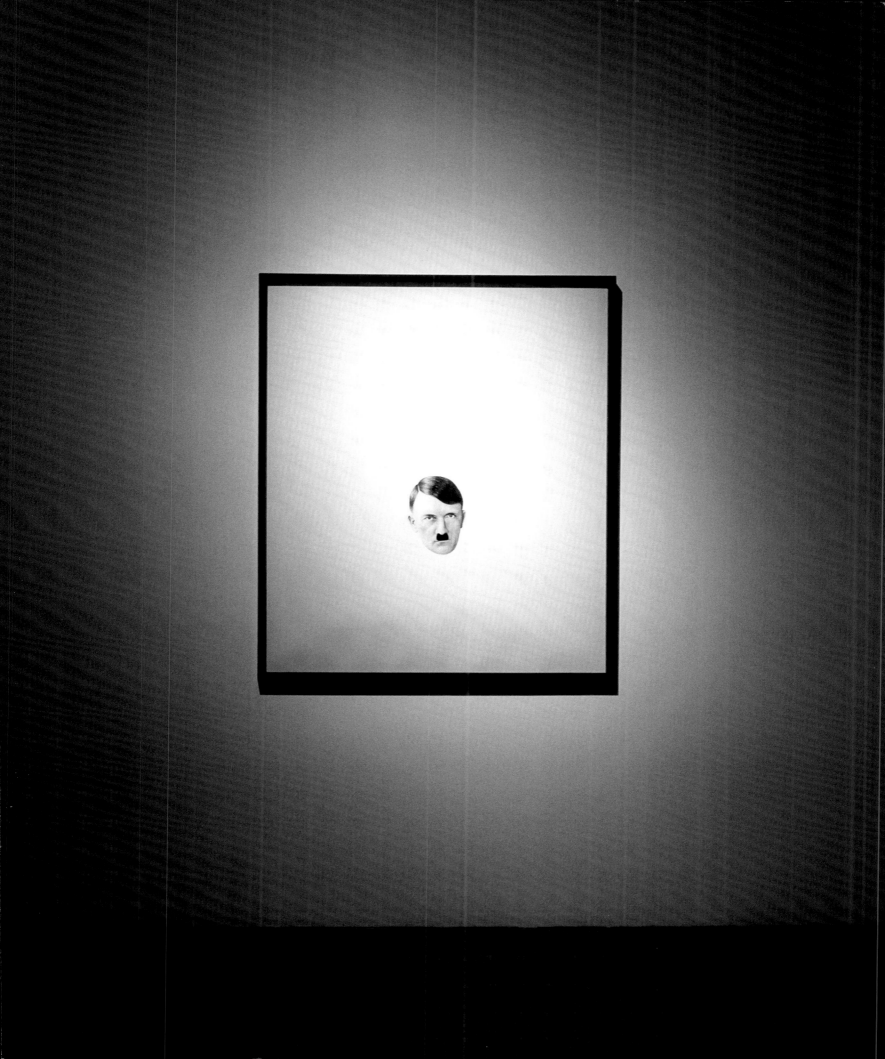

LEFT TO RIGHT:

German Radical, 2003

Floating Hitler Head, 2002 [detail]

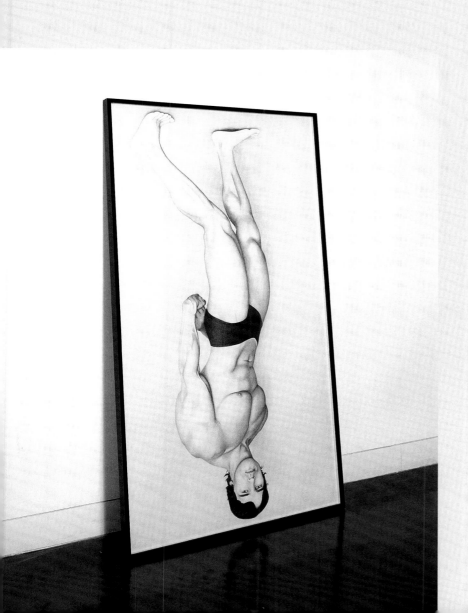

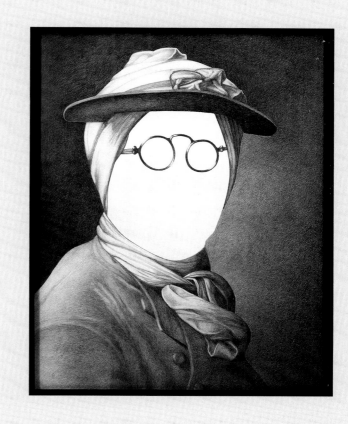

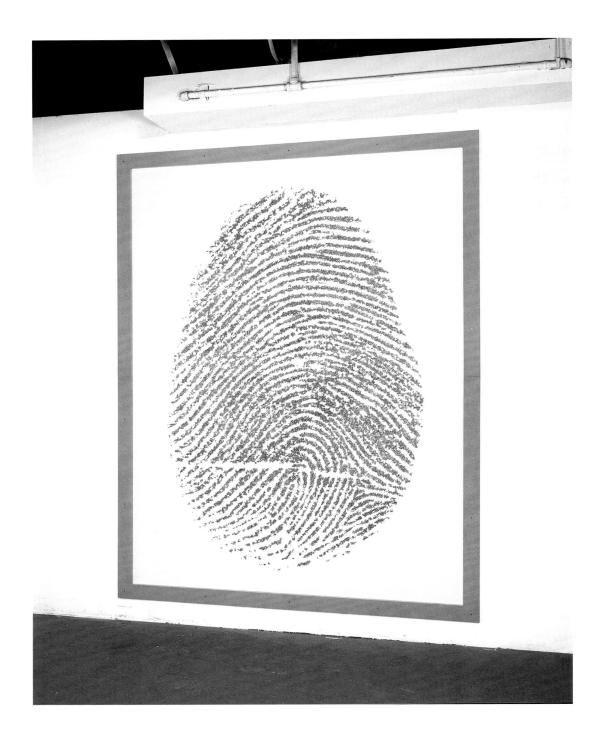

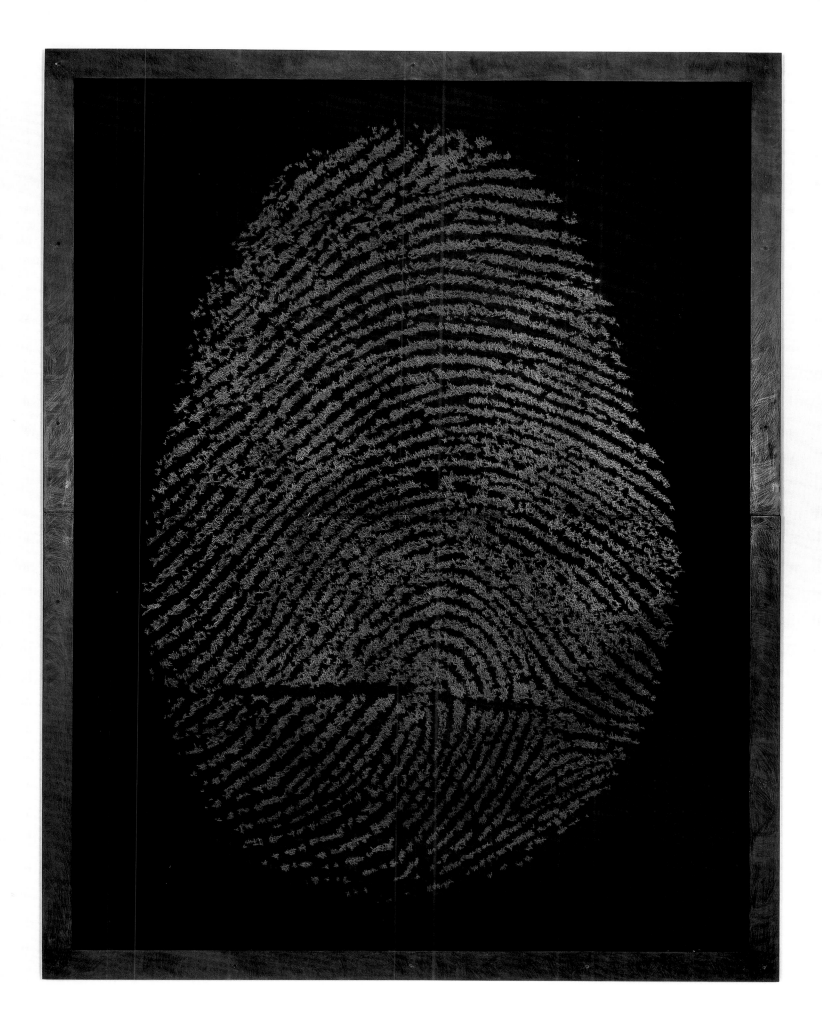

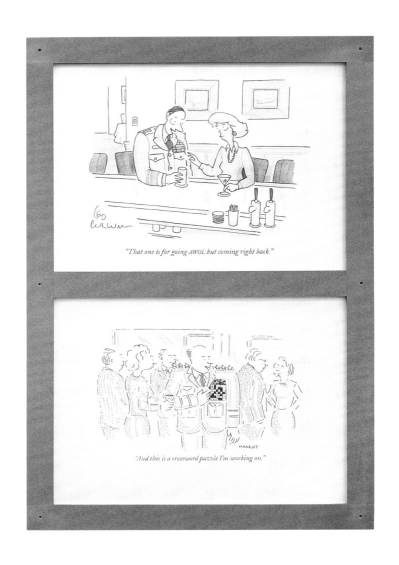

"That one is for going AWOL but coming right back."

"And this is a crossword puzzle I'm working on."

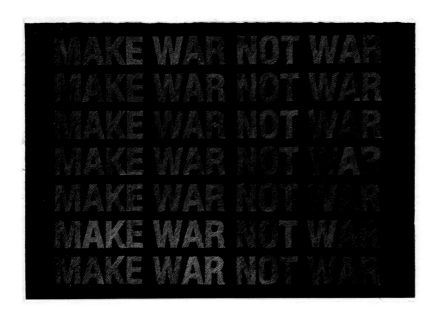

LEFT TO RIGHT:

Make War Not War, 2004

New Yorker Cartoon Drawing #5
and *New Yorker Cartoon Drawing #16*, 2004

3rd Question Mark, 2004

Inverted Uncle Sam (Ghost Version), 2004

Depressed Nude #2, 2004

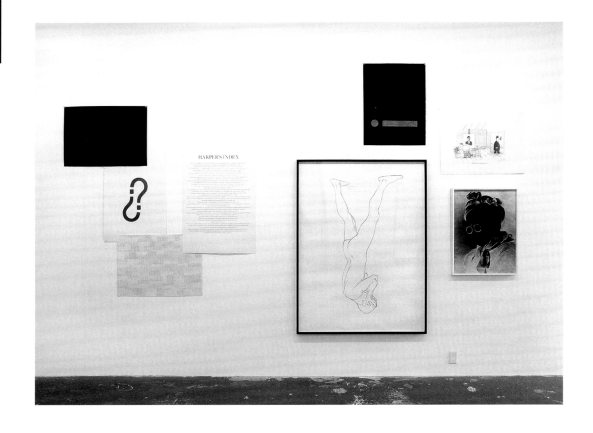

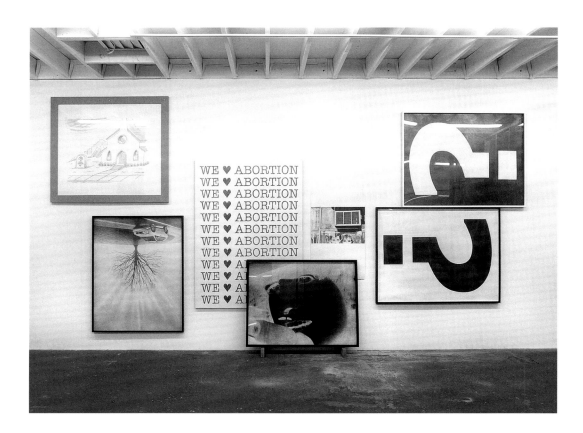

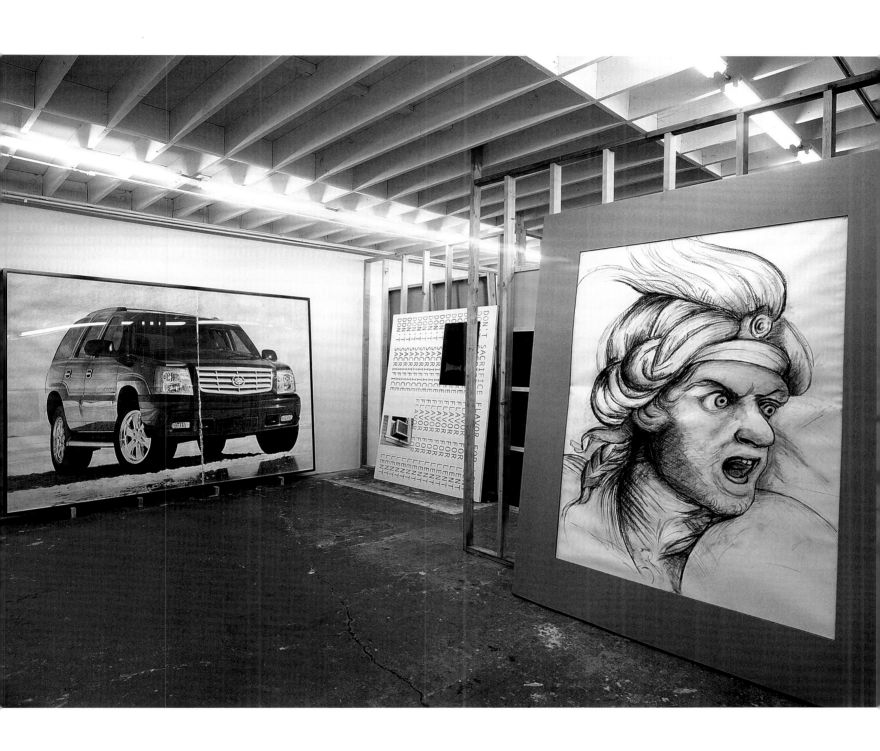

Loved ones who go away.

GHT:

ed Ones Who Go Away), 2005

ased Achille Lauro, 2006 [detail]

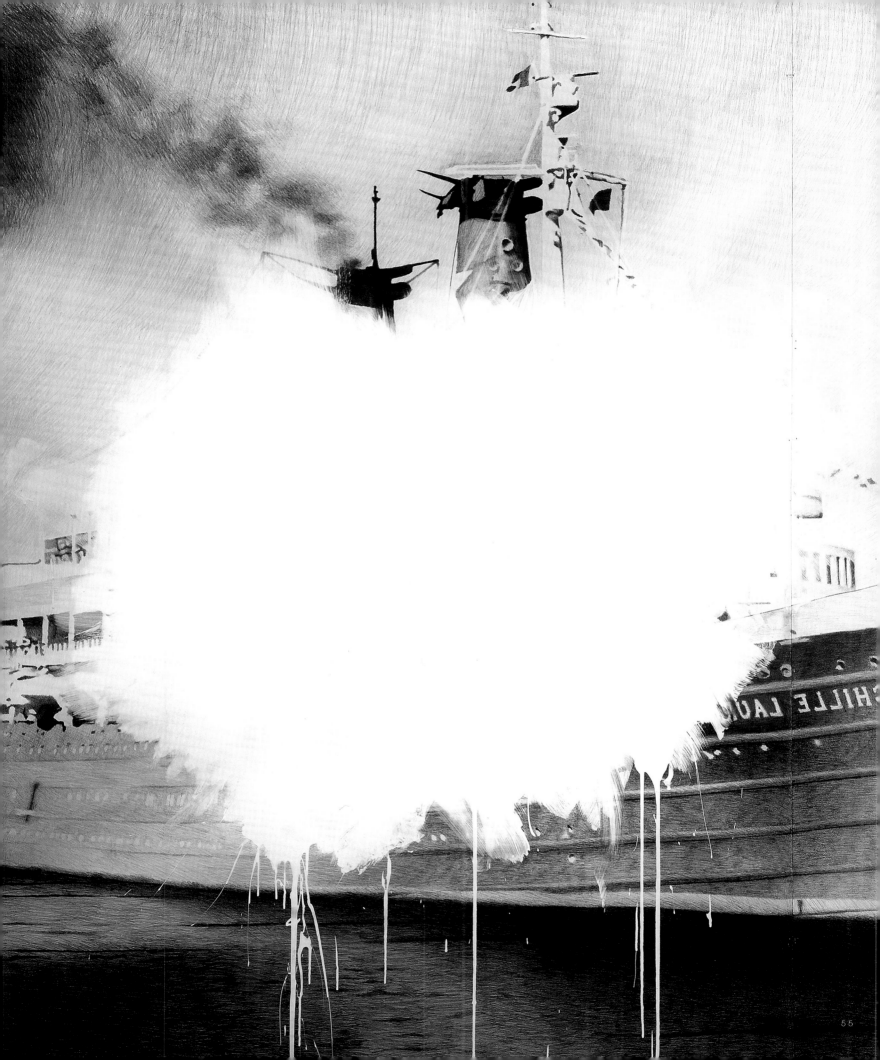

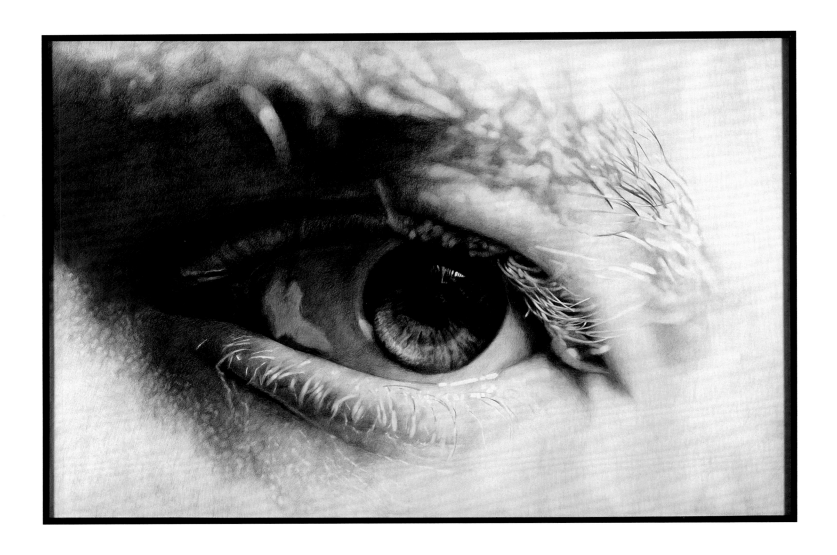

Hapa Group: *Karl's Eye, Mika's Eye*, 2006

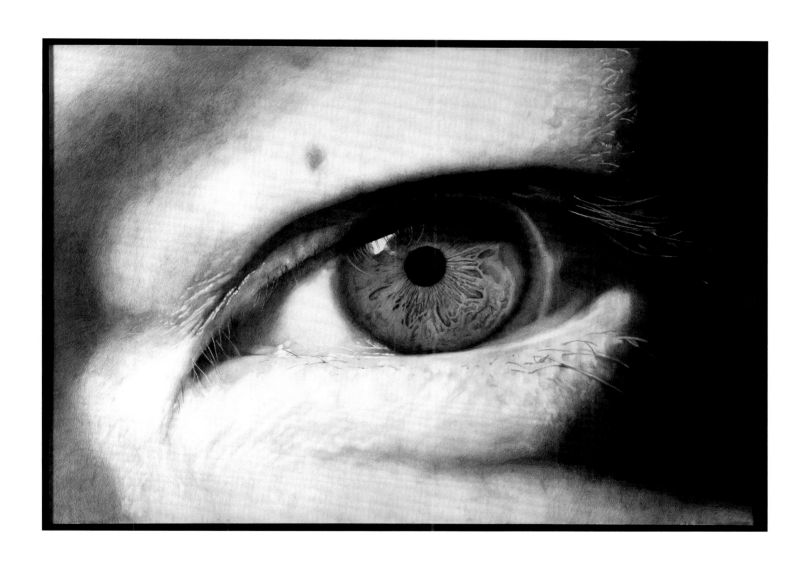

Let Marys M
Let Marys M
Let Marys M
Let Marys M
Let Marys M
Let Marys M
Let Marys M
Let Marys M
Let Marys M
Let Marys M
Let Marys M
Let Marys M
Let Marys M

We Miss Clinton

Installation view, *Make Me Down a Pallet on Your Floor*, 2006

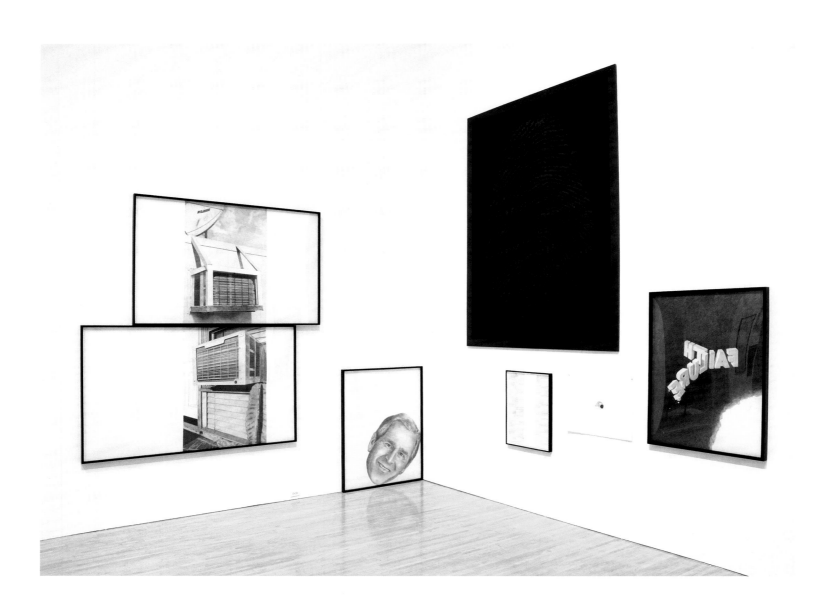

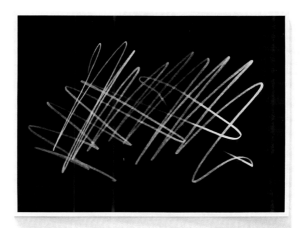

WE ♥ ABORTION
WE ♥ ABORTION
WE ♥ ABORTION
WE ♥ ABORTION
WE ♥ ABORTION
WE ♥ ABORTION
WE ♥ ABORTION
WE ♥ ABORTION
WE ♥ ABORTION
WE ♥ ABORTION
WE ♥ ABORTION
WE ♥ ABORTION

TO POINT (TO), TO DRAW (FROM), TO LOOK (

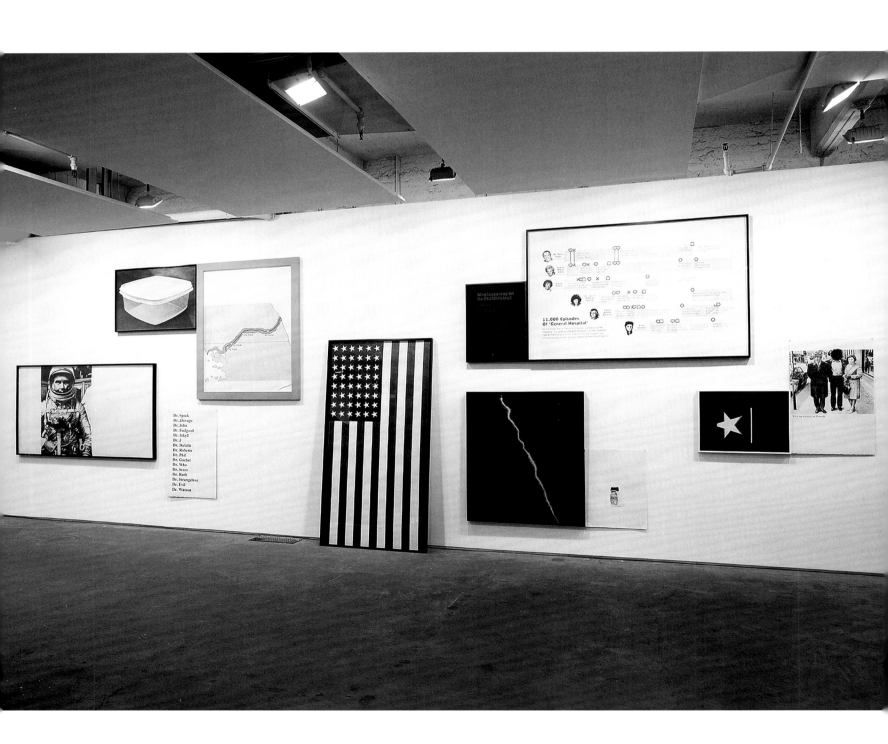

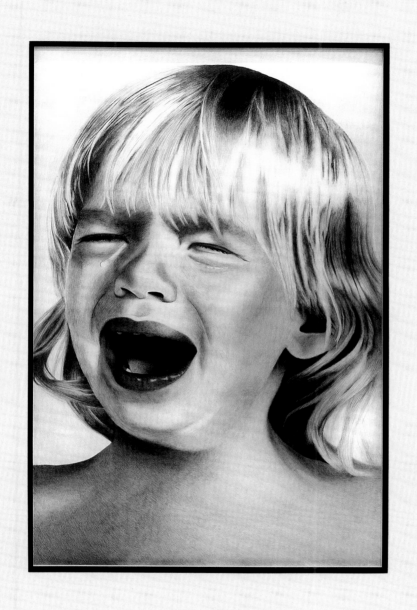

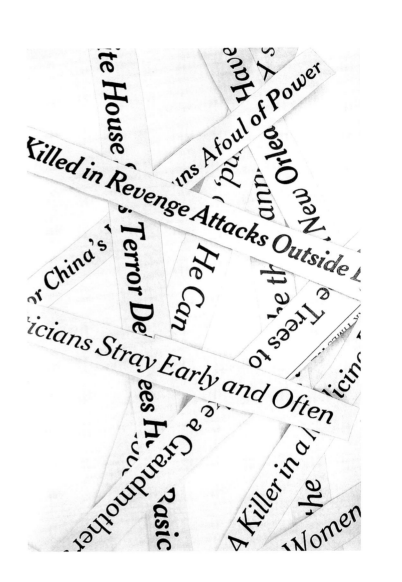

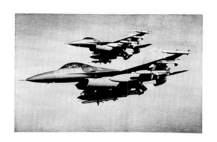

"He rubbed your belly and it felt good—that doesn't make you gay."

LEFT TO RIGHT:

Double Zoomy Squares, 2007

Scissors #1, 2007

Abstract (Futurist Cross), 2006

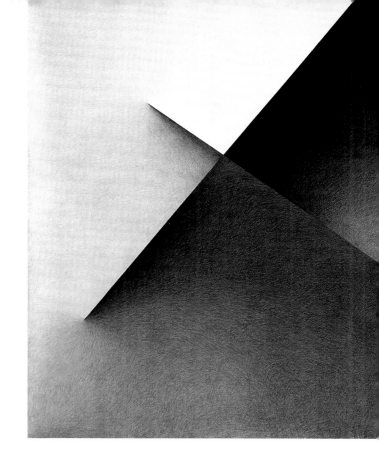
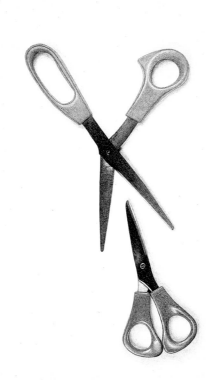

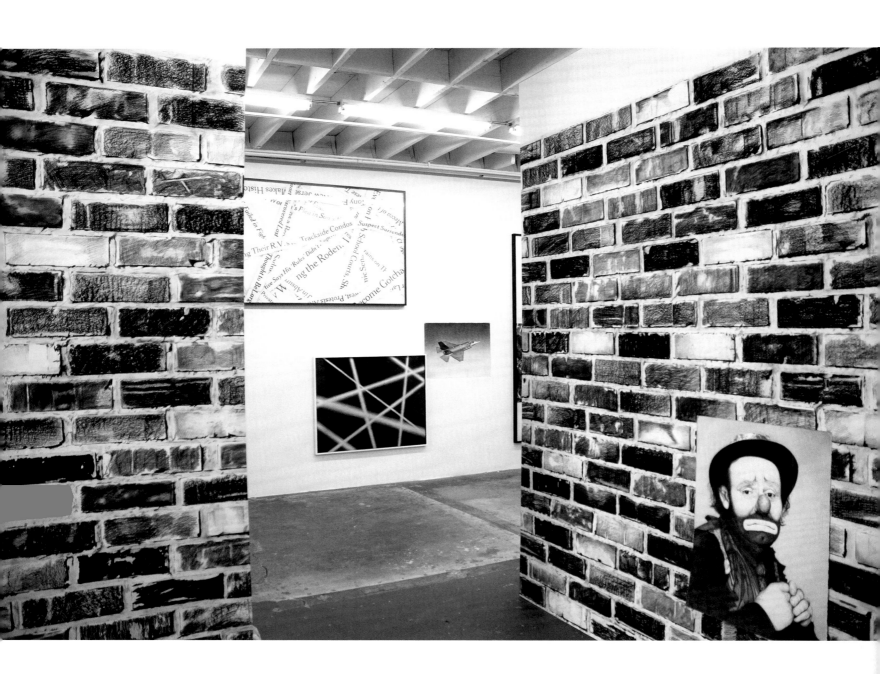

Installation views, *Make Me Down a Pallet on Your Floor*, 2006

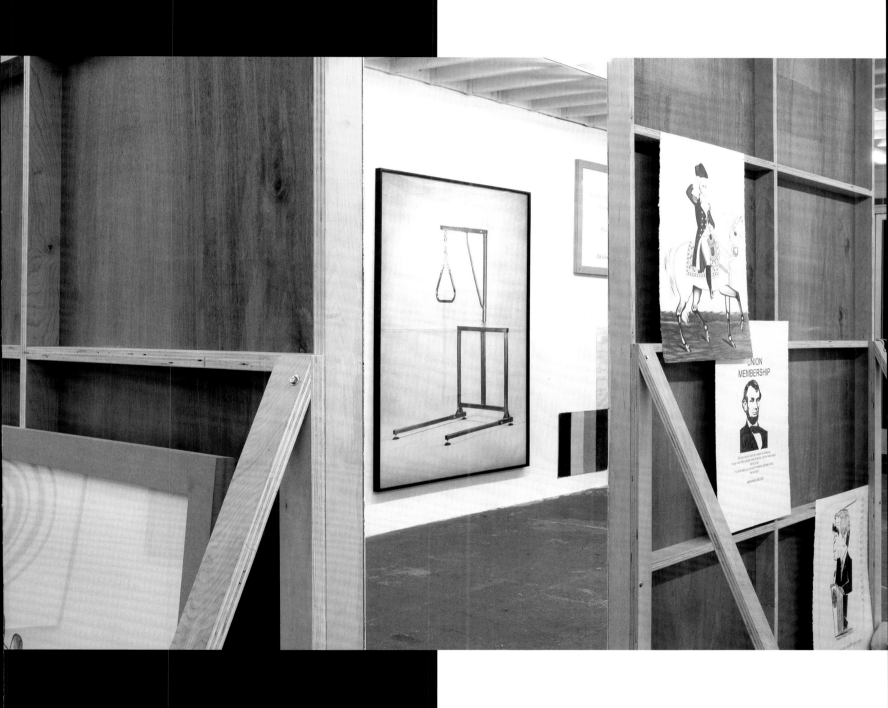

LEFT TO RIGHT:

The Last Waltz Group, 2007

Studio Still Life #3, 2007

Installation view, *Kommitment Karl,* 2008

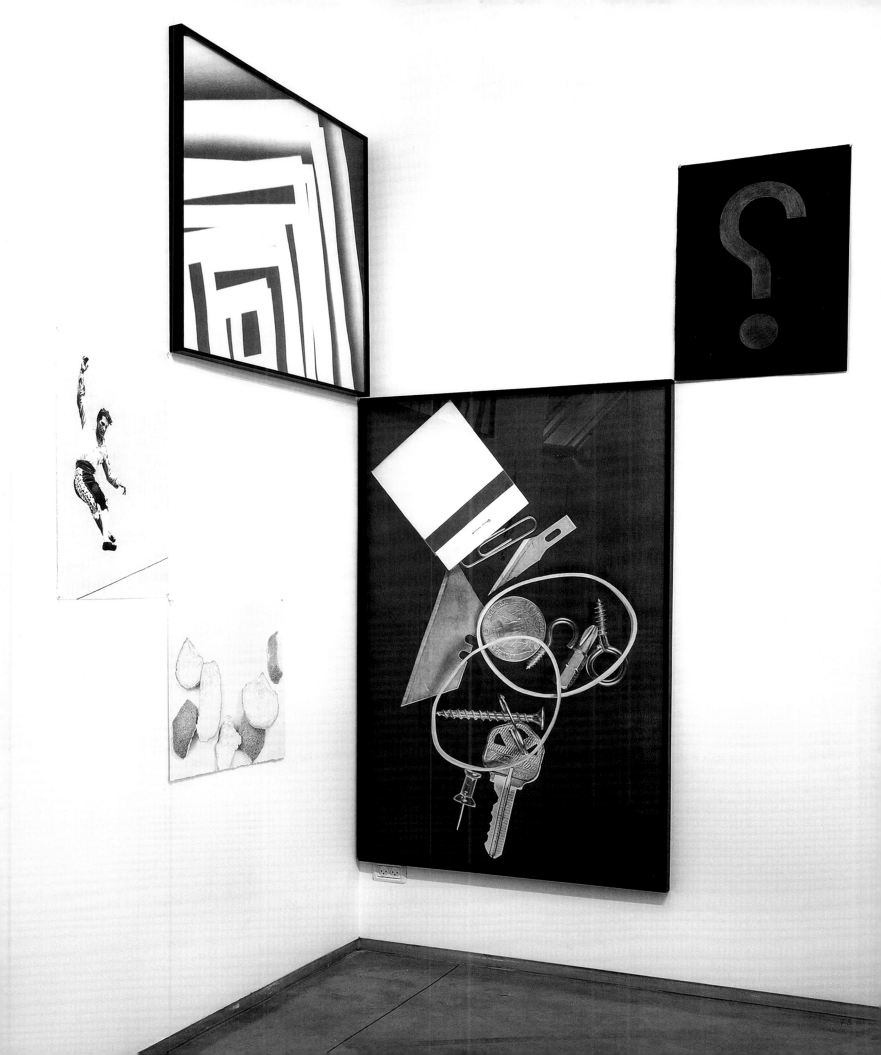

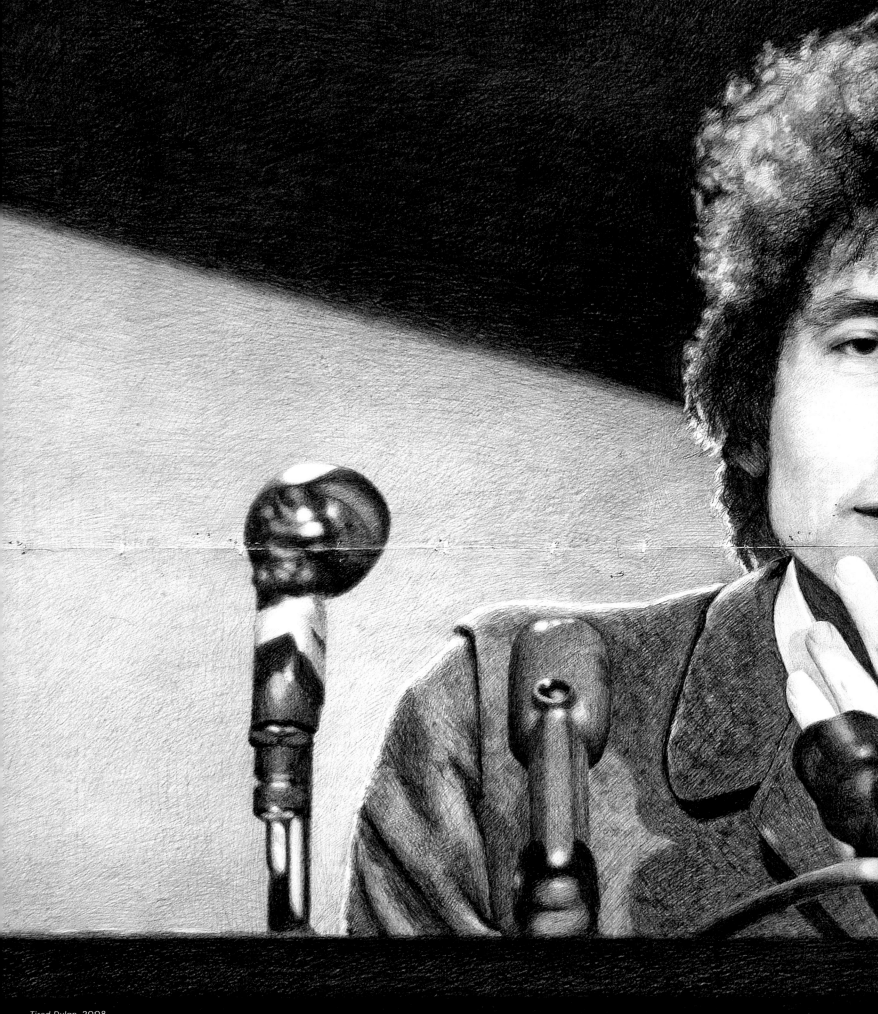

Tired Dylan, 2008

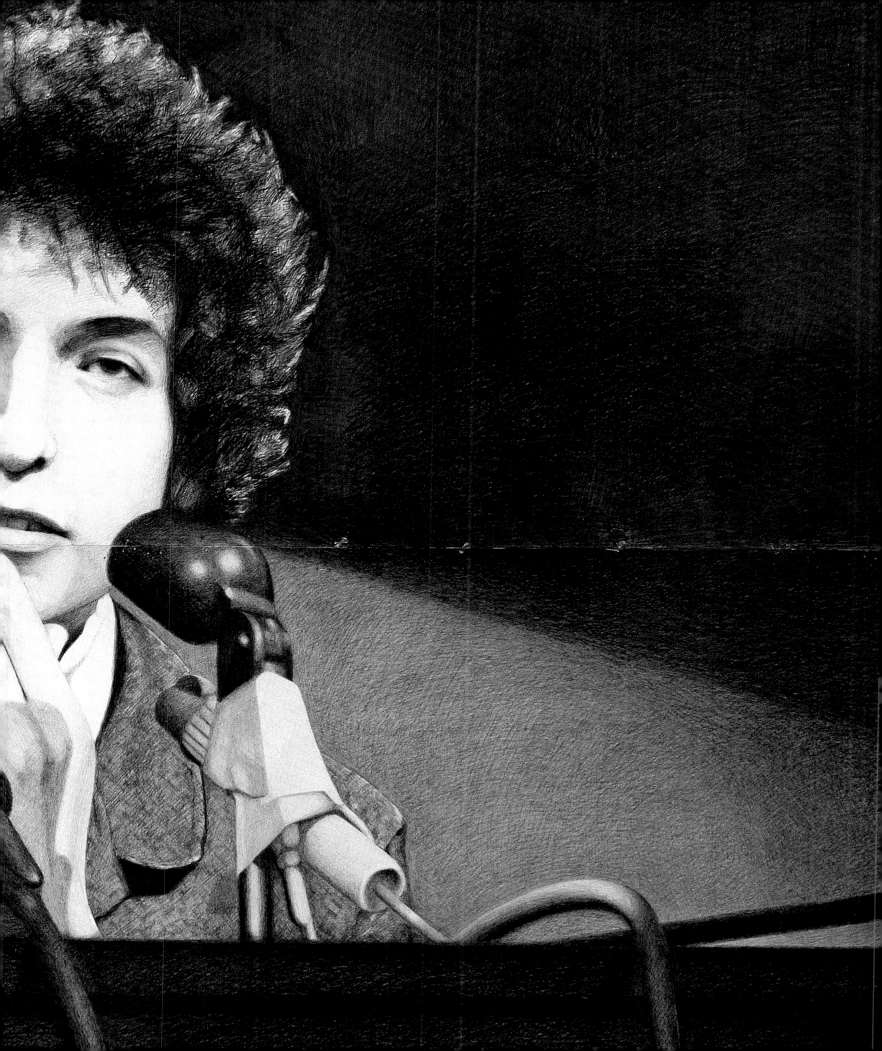

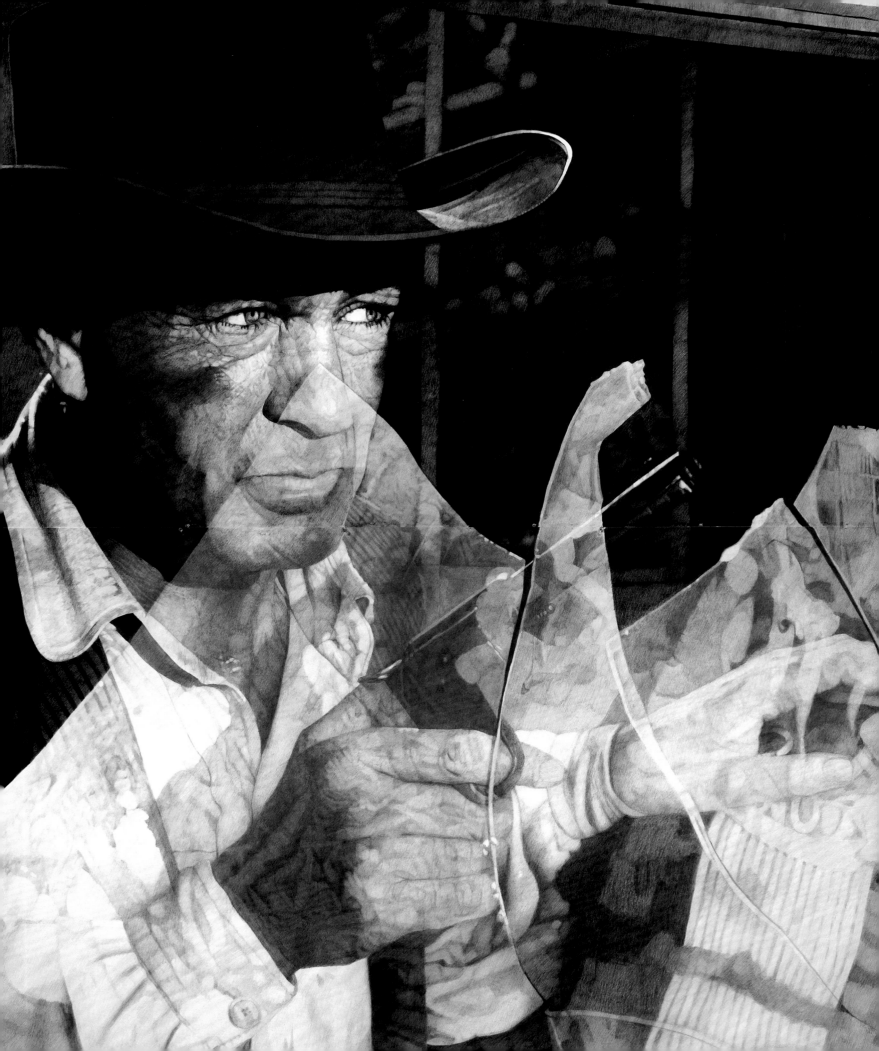

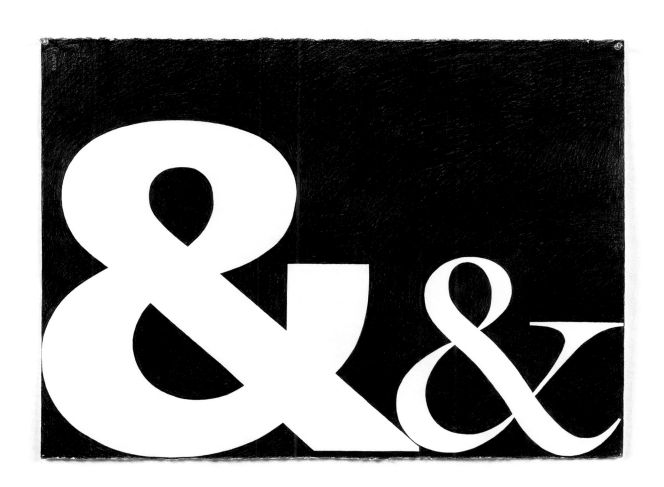

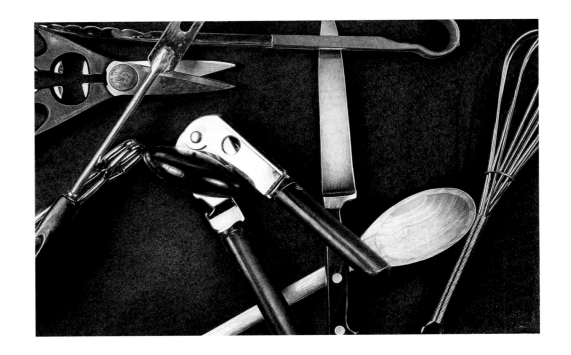

&

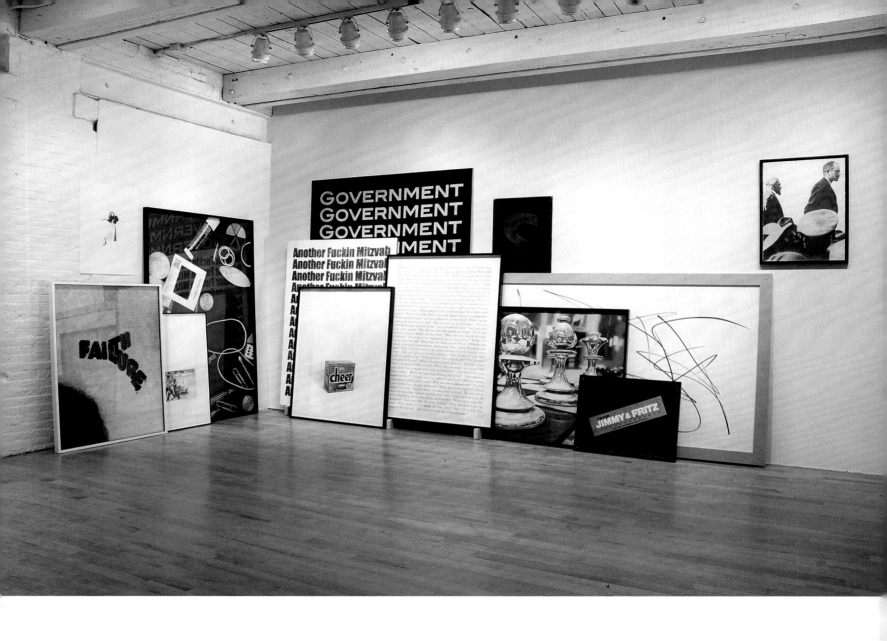

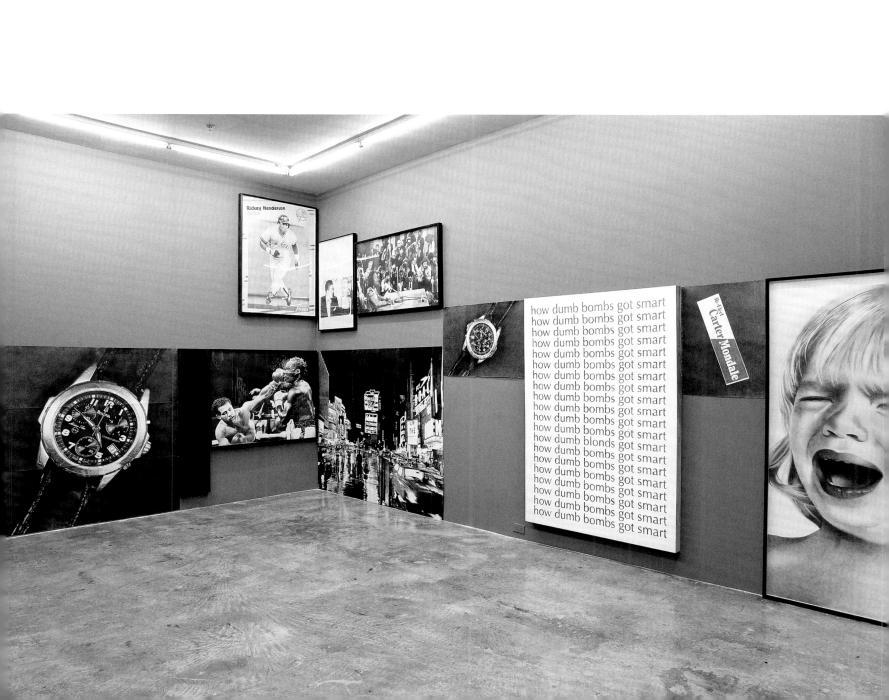

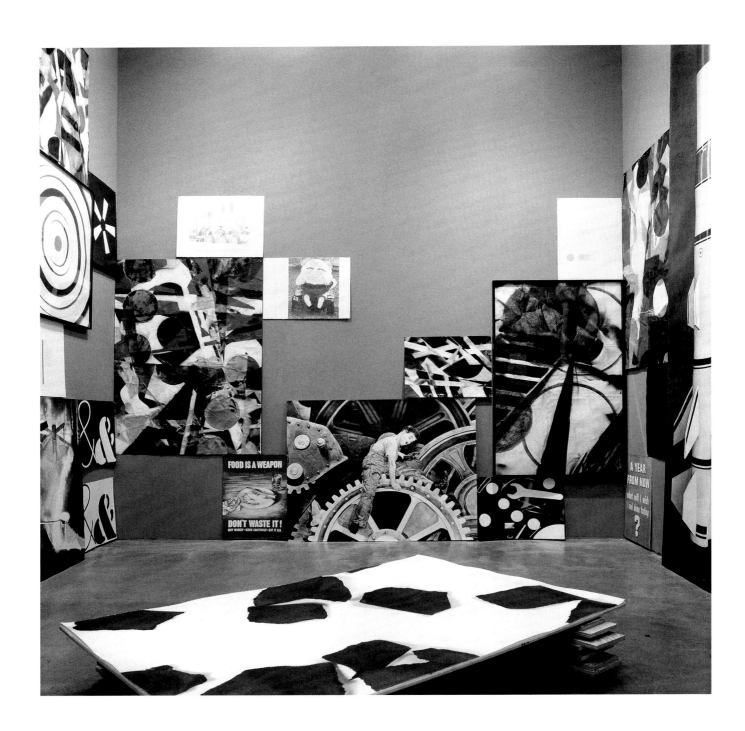

Installation views, *How to Have a Socially Responsible Orgasm and Other Life Lessons*, 2009

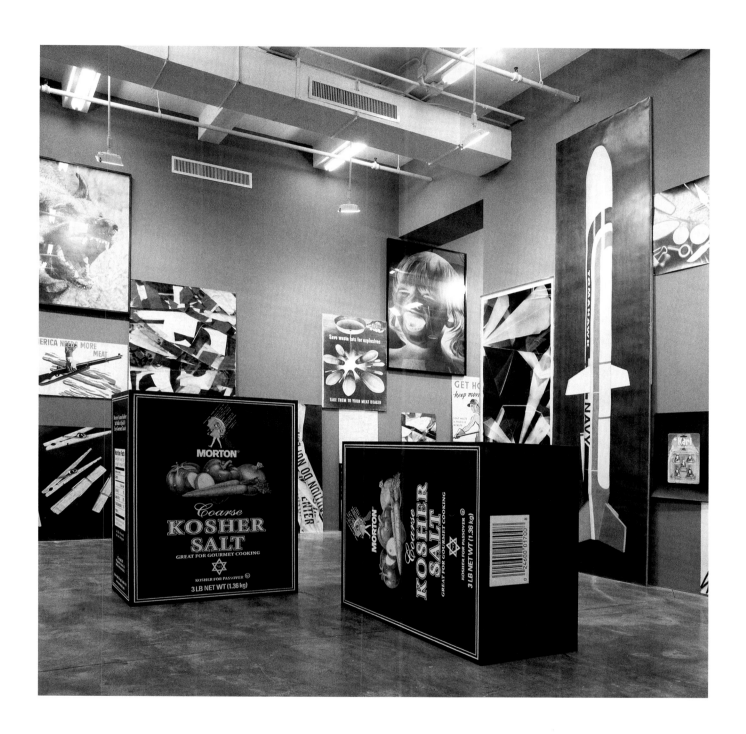

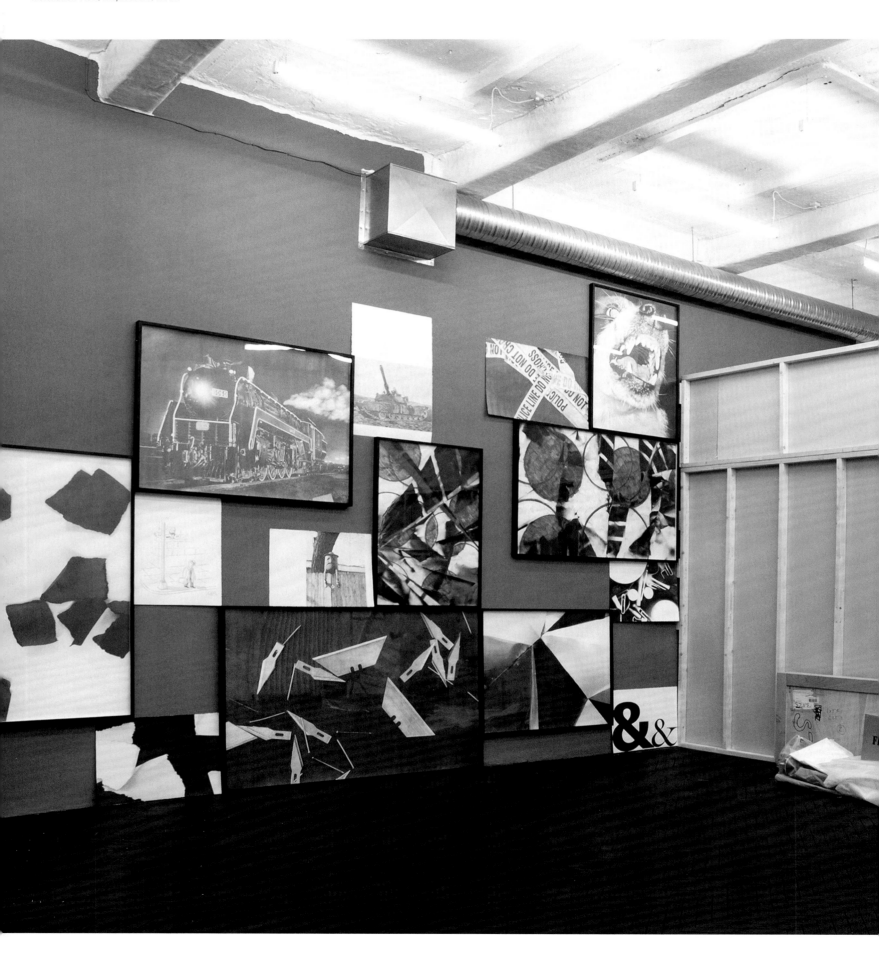

OK OK, 2010

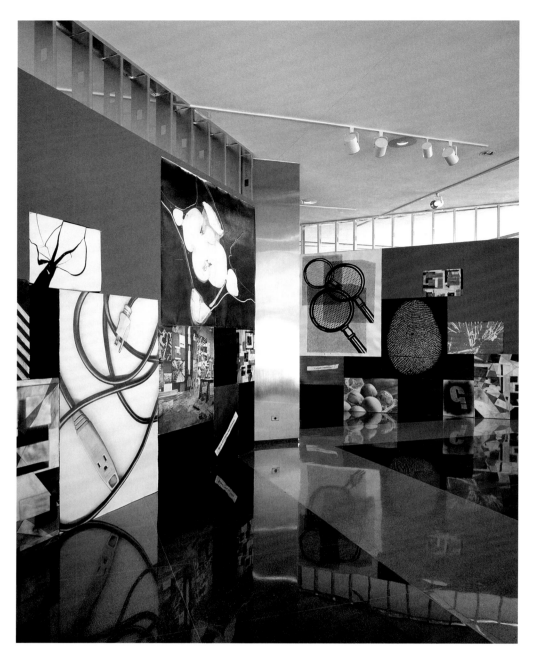

Installation views, The Lever House, 2010

Lady of the Potatoes
My Invisible Friend
Great Pantyhose Crafts
Madam as Entrepreneur
Career Management and House Prostitution
Stray Shopping Carts of North America
Games You Can Play With Your Pussy
Joy of Chicken
Theory of Lengthwise Rolling
Book of Marmalade
Waterproofing Your Child
Mating with Clowns
Very Big Hole Drilling
Amputee Management and its Labors
How To Become a Schizophrenic
Cause and Prevention of Old Age
Your Wife Came Home Speaking In Tongues
Movie Stars in Bathtubs
Not Worth Looking At
Guide to Bladder Control
Camping Among Cannibals
Teach Yourself Sex
Lull Before Drinking
Oral Sadism and the Vegetarian Personality
American Bottom Anthropology
How To Forgive Your Ex
Lesbian Sadomasochism Safety Manual
Highlights in the History of Concrete
Happy Though Married

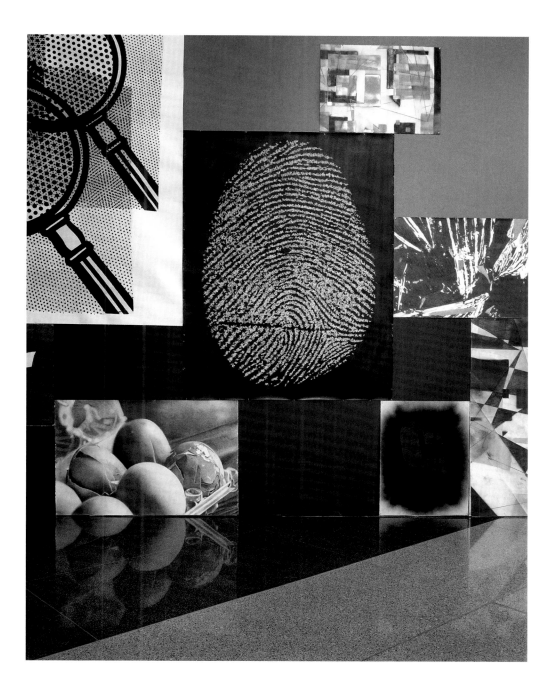

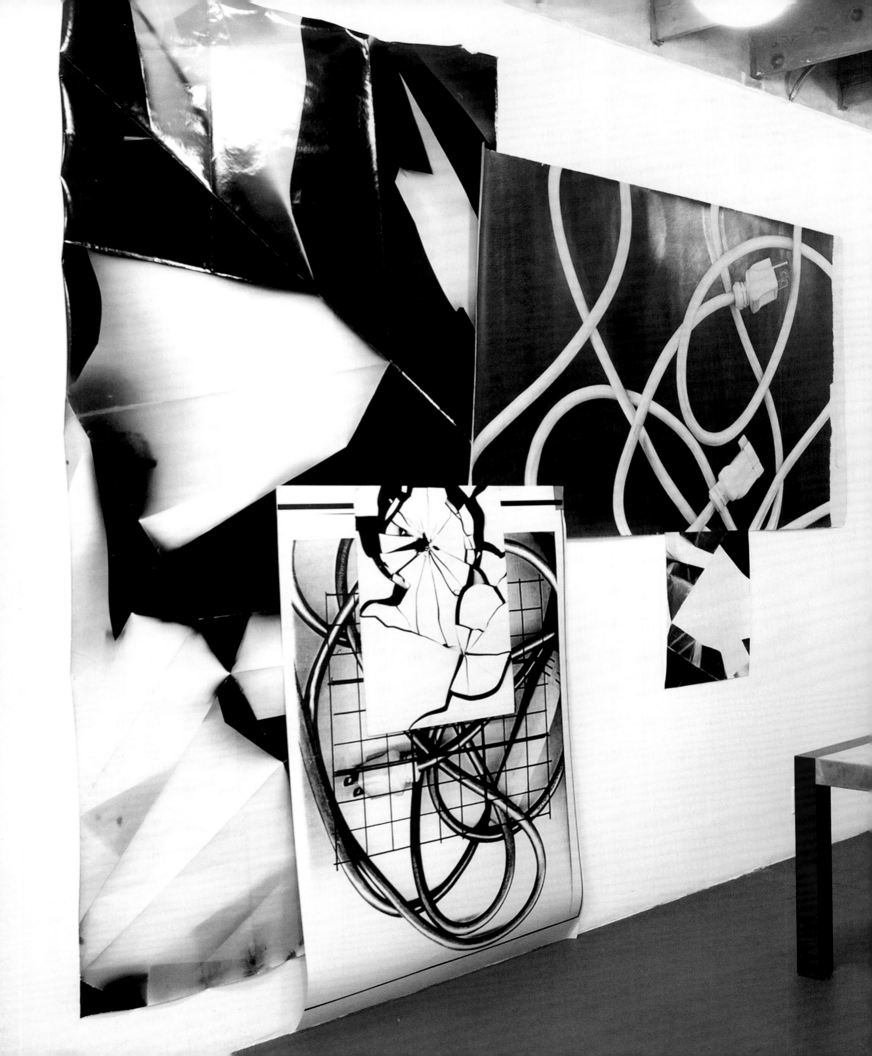

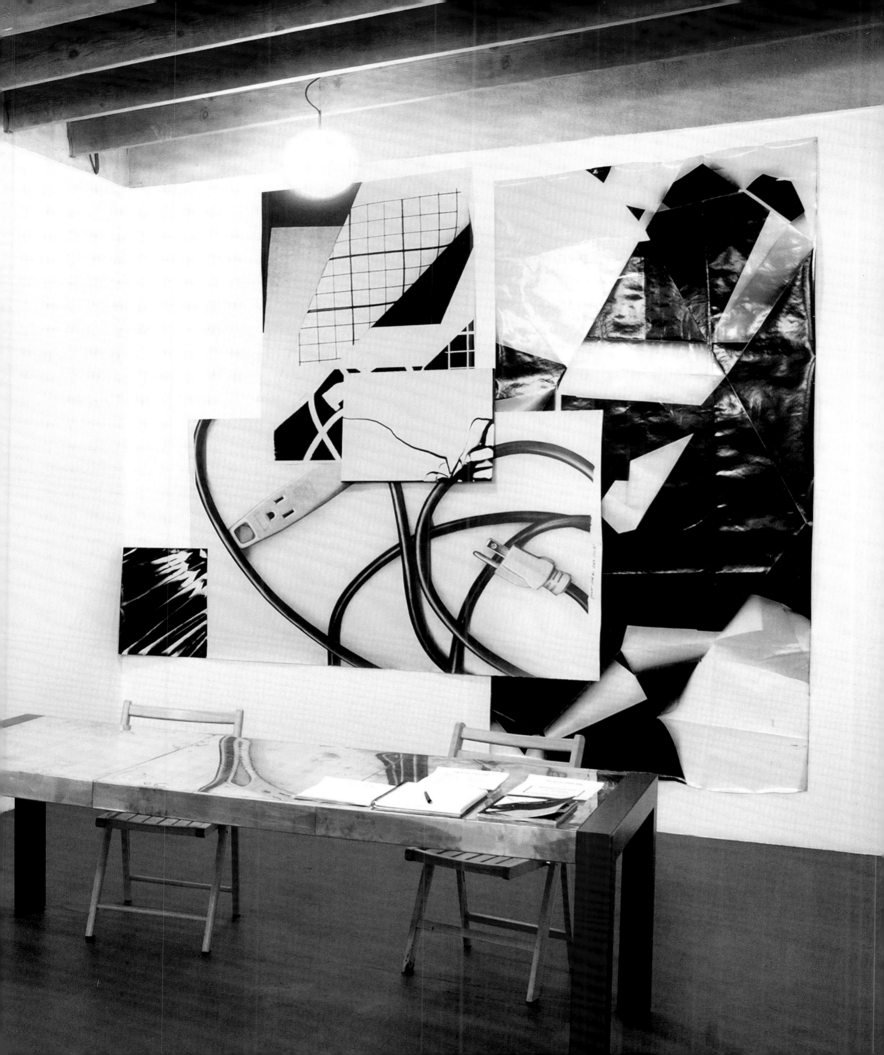

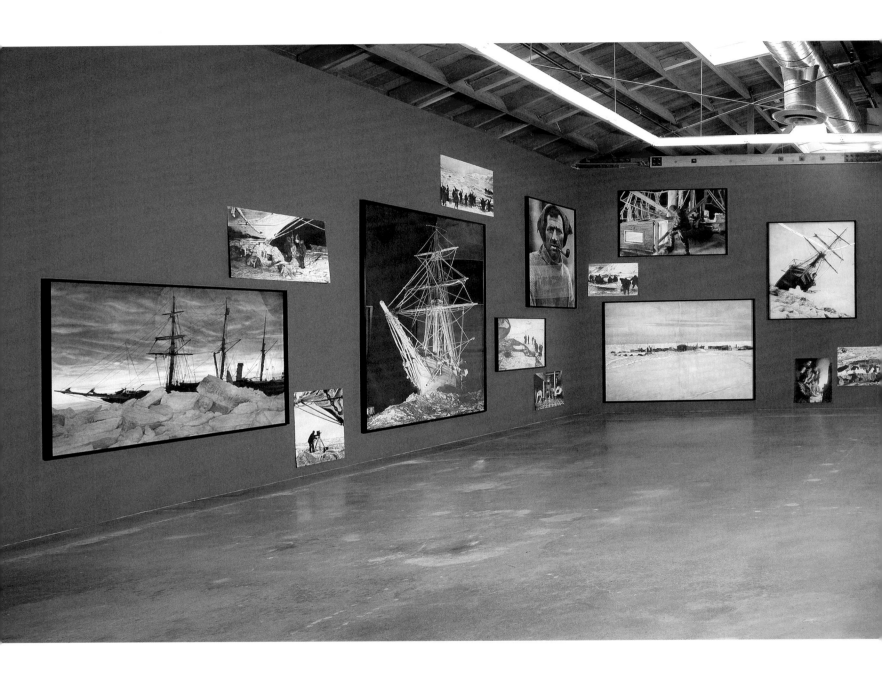

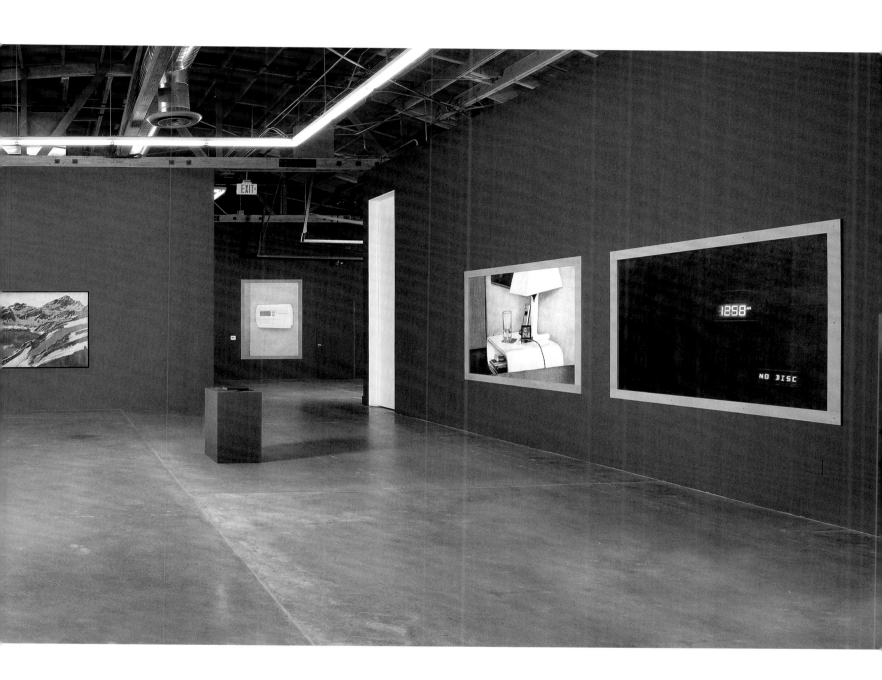

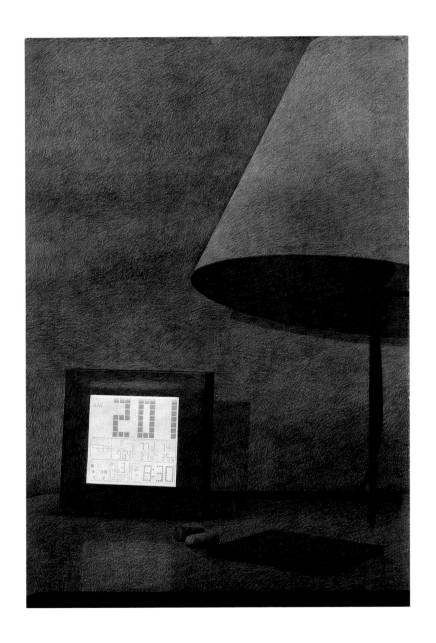

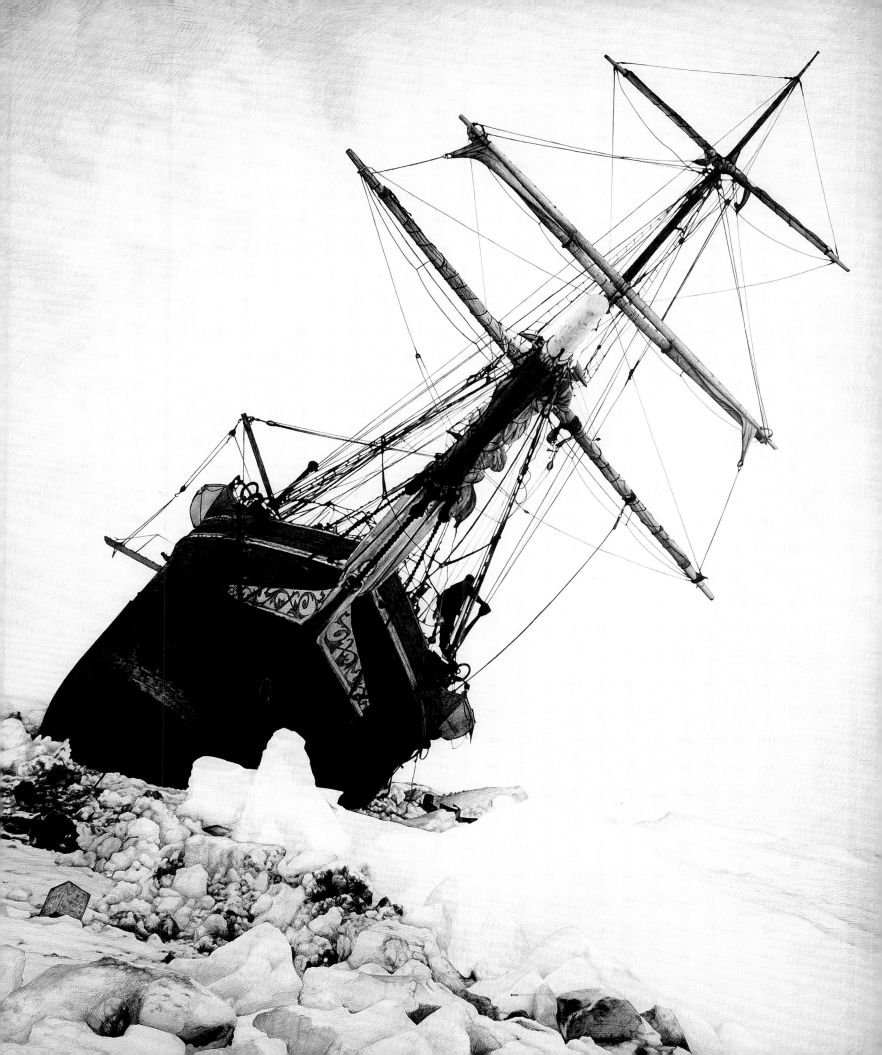

Installation view, *Prospect II*, 2011

Around Adams #1, 2011

Installation view, 2011

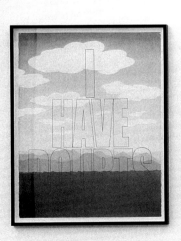

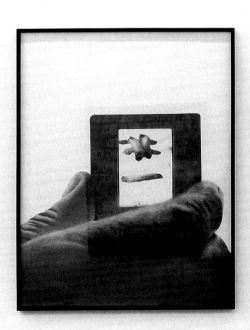

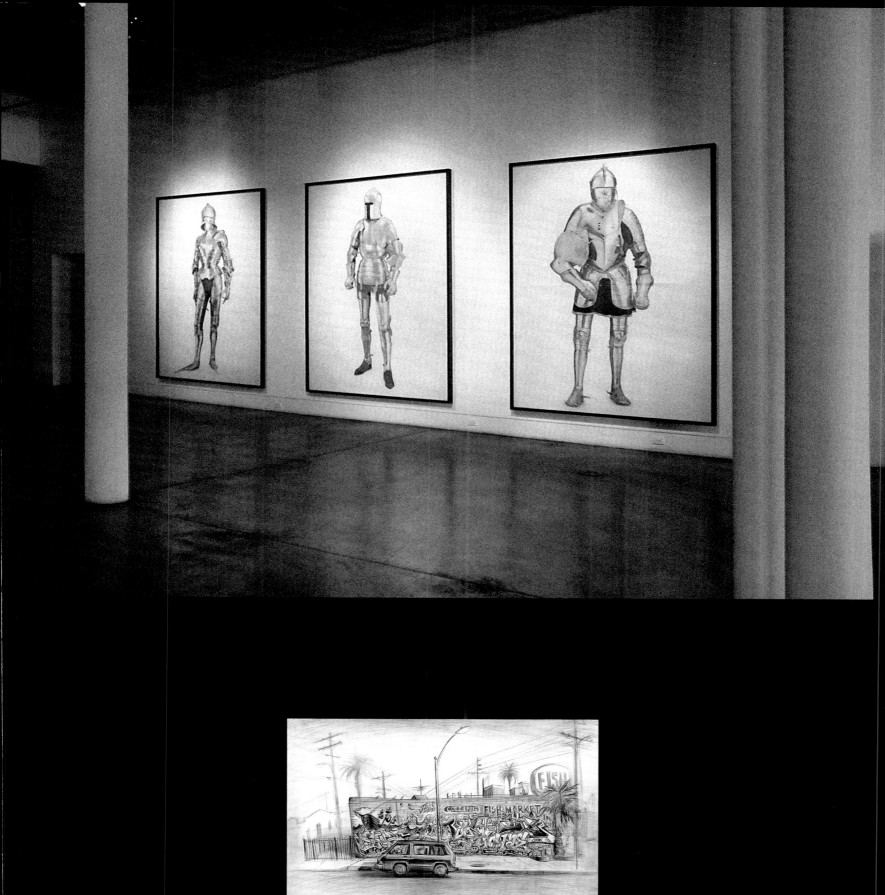

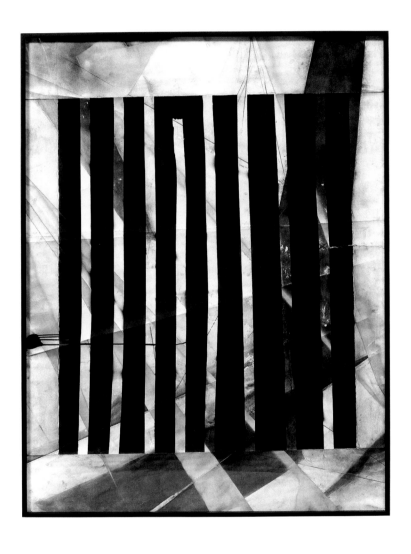

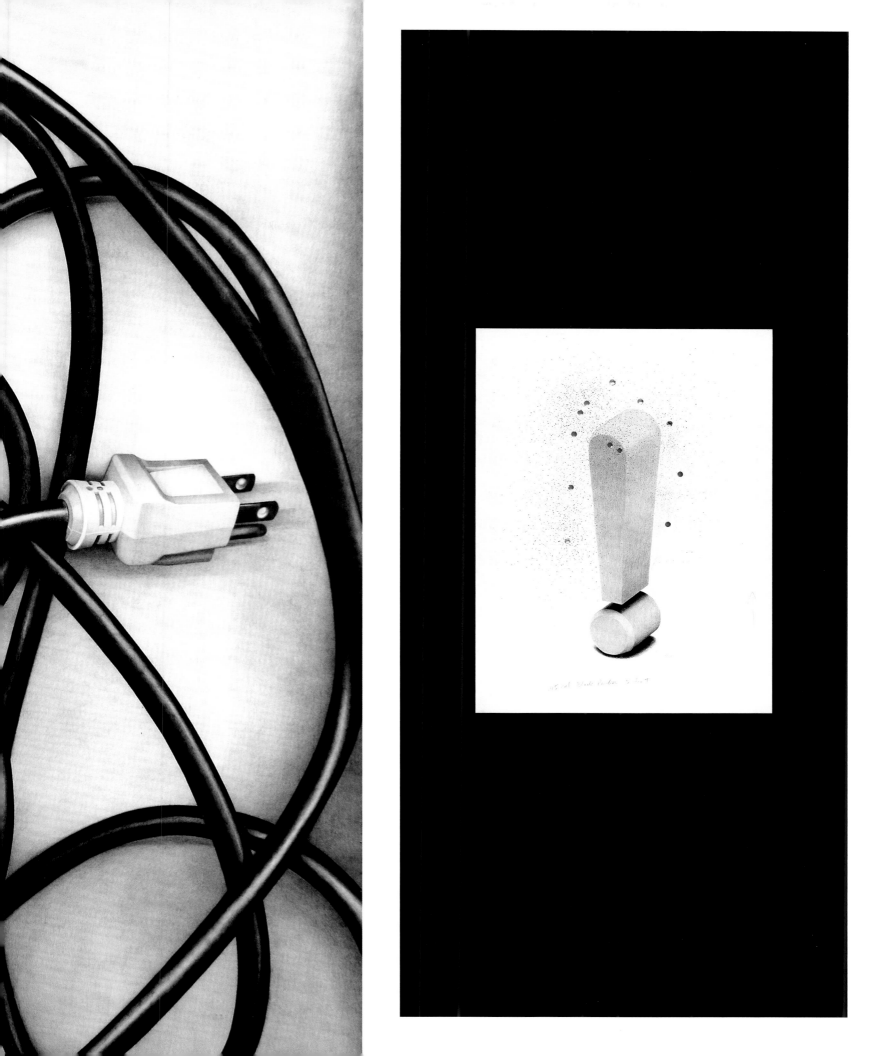

Plans, Change, Fear, Try, Doubt, Seek, Search, Hope, 2012

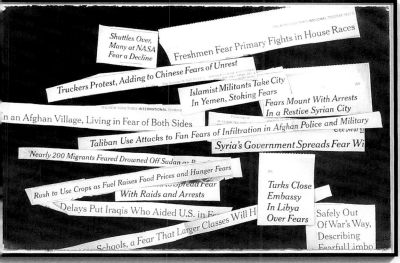

Shuttles Over, Many at NASA Fear a Decline

Freshmen Fear Primary Fights in House Races

Truckers Protest, Adding to Chinese Fears of Unrest

Islamist Militants Take City In Yemen, Stoking Fears

Fears Mount With Arrests In a Restive Syrian City

n an Afghan Village, Living in Fear of Both Sides

Taliban Use Attacks to Fan Fears of Infiltration in Afghan Police and Military

Syria's Government Spreads Fear Wi

Nearly 200 Migrants Feared Drowned Off Sudan

Rush to Use Crops as Fuel Raises Food Prices and Hunger Fears

Spread Fear With Raids and Arrests

Turks Close Embassy In Libya Over Fears

Delays Put Iraqis Who Aided U.S. in Fe

Safely Out Of War's Way, Describing Fearfull Limbo

Schools, a Fear That Larger Classes Will H

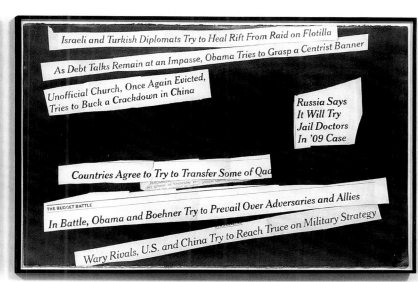

Israeli and Turkish Diplomats Try to Heal Rift From Raid on Flotilla

As Debt Talks Remain at an Impasse, Obama Tries to Grasp a Centrist Banner

Unofficial Church, Once Again Evicted, Tries to Buck a Crackdown in China

Russia Says It Will Try Jail Doctors In '09 Case

Countries Agree to Try to Transfer Some of Qad

THE BUDGET BATTLE

In Battle, Obama and Boehner Try to Prevail Over Adversaries and Allies

Wary Rivals, U.S. and China Try to Reach Truce on Military Strategy

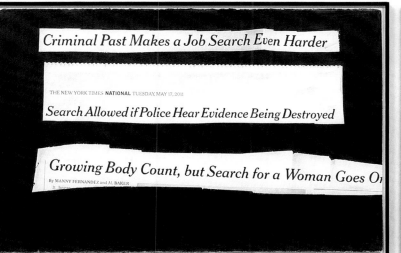

Criminal Past Makes a Job Search Even Harder

THE NEW YORK TIMES **NATIONAL** TUESDAY, MAY 17, 2011

Search Allowed if Police Hear Evidence Being Destroyed

Growing Body Count, but Search for a Woman Goes On

By MANNY FERNANDEZ and AL BAKER

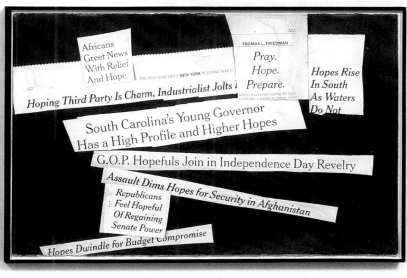

Africans Greet News With Relief And Hope

THOMAS L. FRIEDMAN

Pray. Hope. Prepare.

Hopes Rise In South As Waters Do Not

THE NEW YORK TIMES **NEW YORK** TUESDAY, MAY 17,

Hoping Third Party Is Charm, Industrialist Jolts

South Carolina's Young Governor Has a High Profile and Higher Hopes

G.O.P. Hopefuls Join in Independence Day Revelry

Assault Dims Hopes for Security in Afghanistan

Republicans Feel Hopeful Of Regaining Senate Power

Hopes Dwindle for Budget Compromise

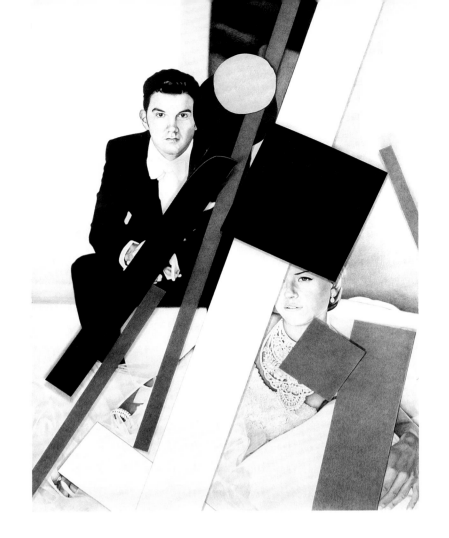

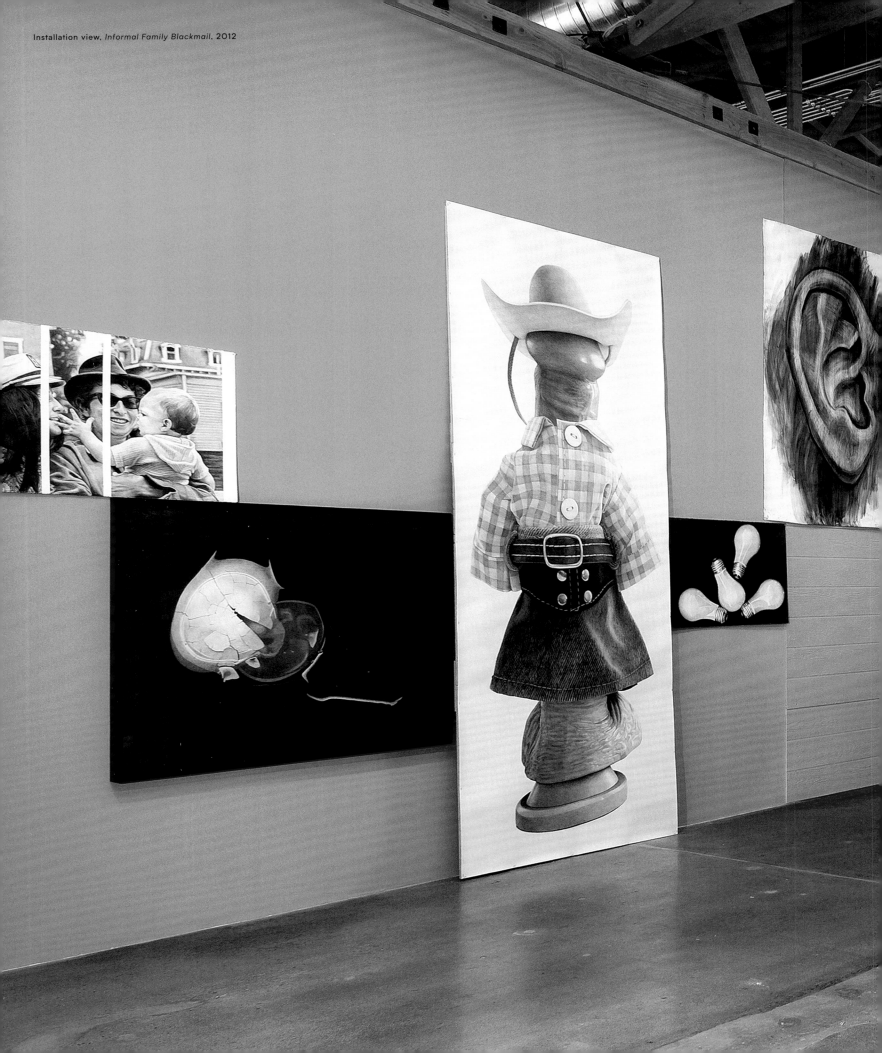

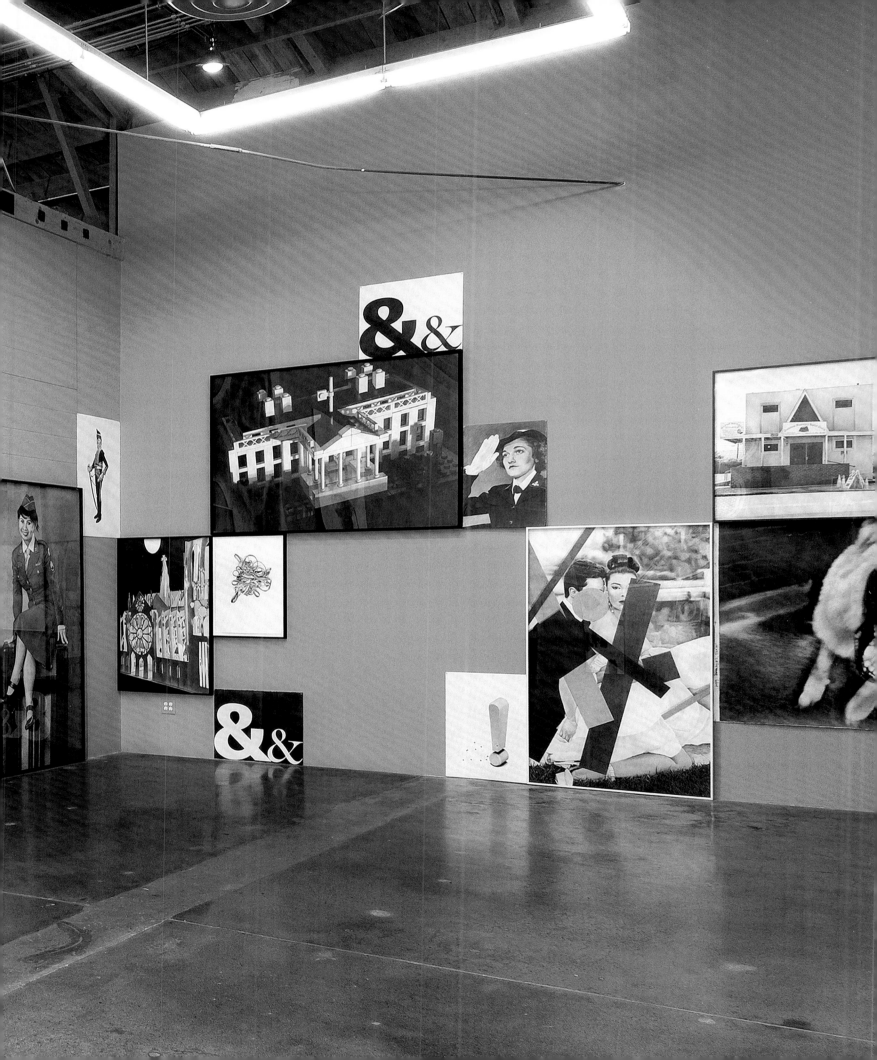

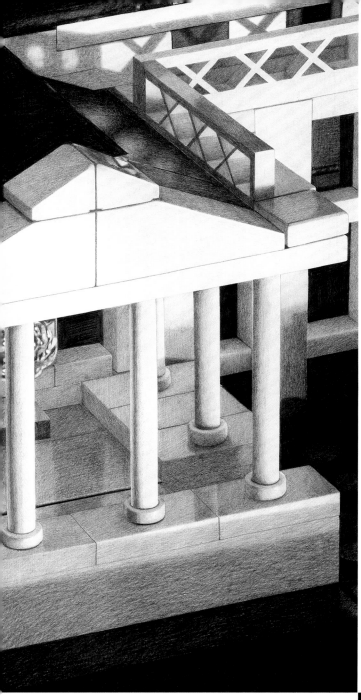

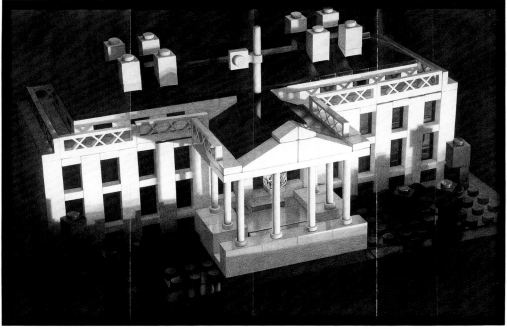

LEFT TO RIGHT:

Lego White House, 2012 [detail]

Lego White House, 2012

WAC, 2012

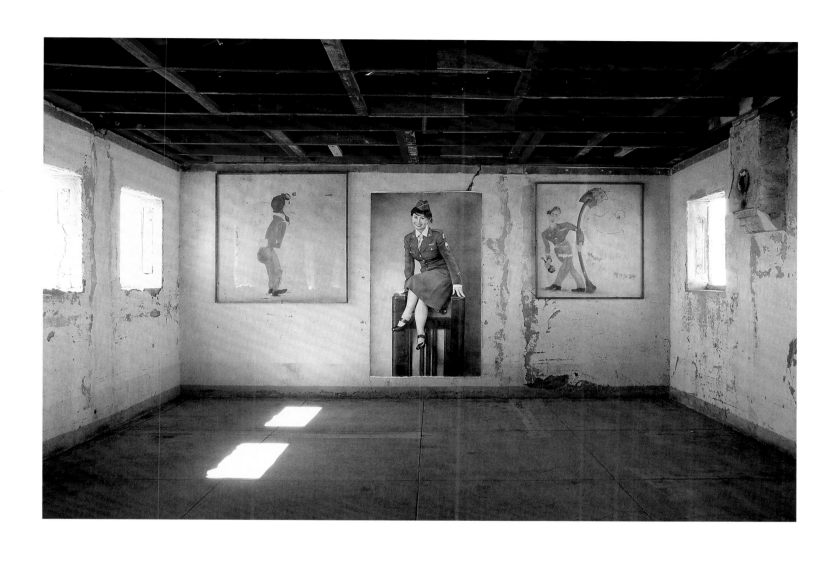

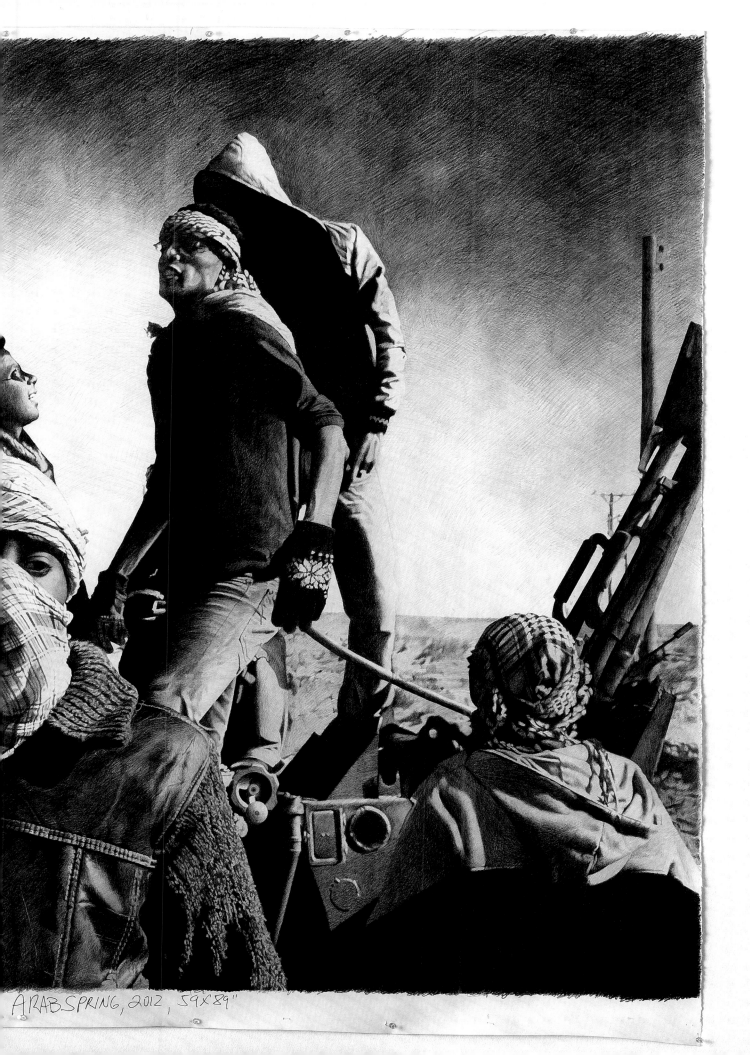

ARAB.SPRING, 2012, 59"x89"

PREVIOUS:

Arab Spring, 2012

LEFT TO RIGHT:

Mousetrap, 2011

Wishbone, 2011

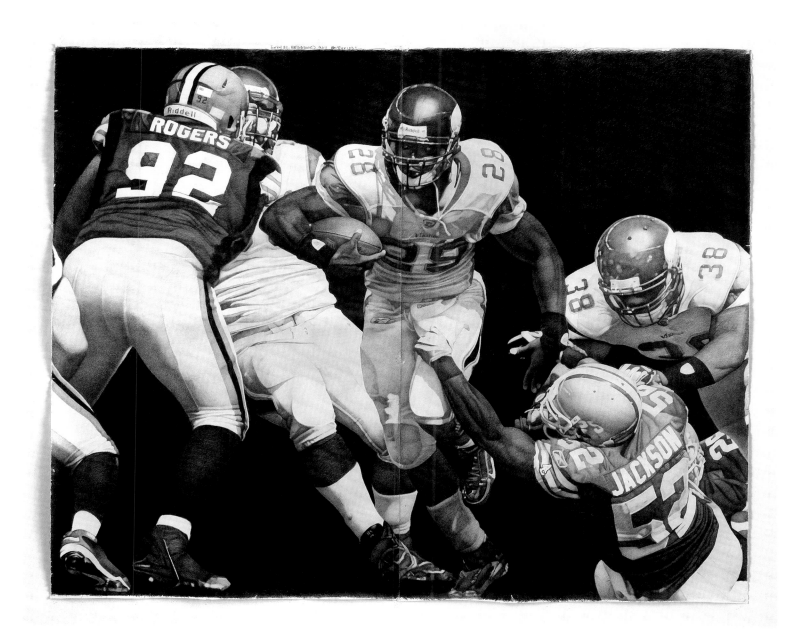

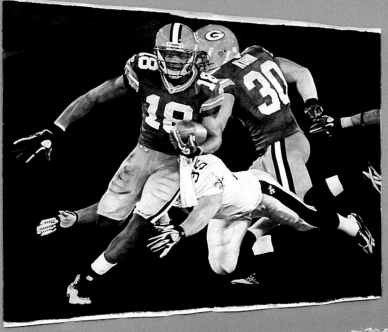
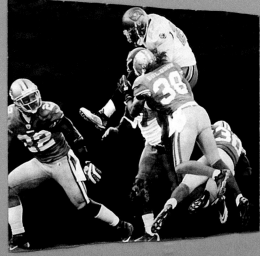

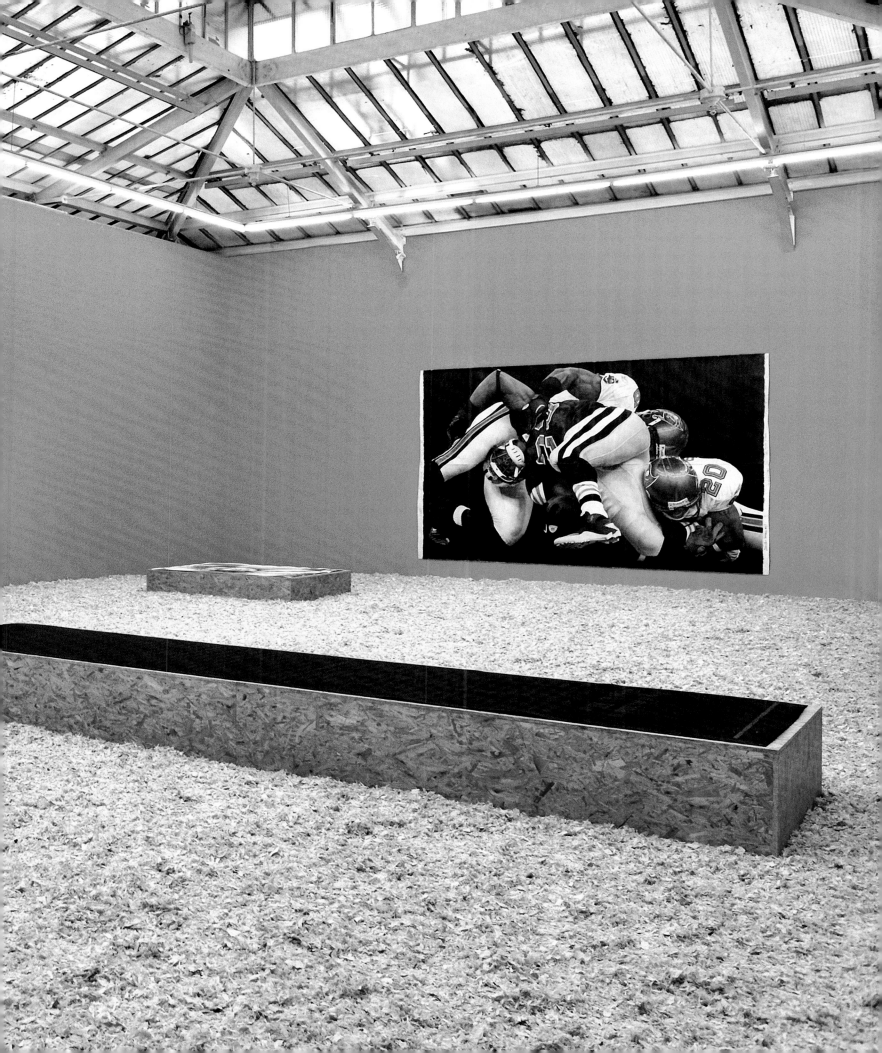

LEFT TO RIGHT:

Inked #7, 2013 [detail]

Books with Holes #6, 2013

Front Page, 2013

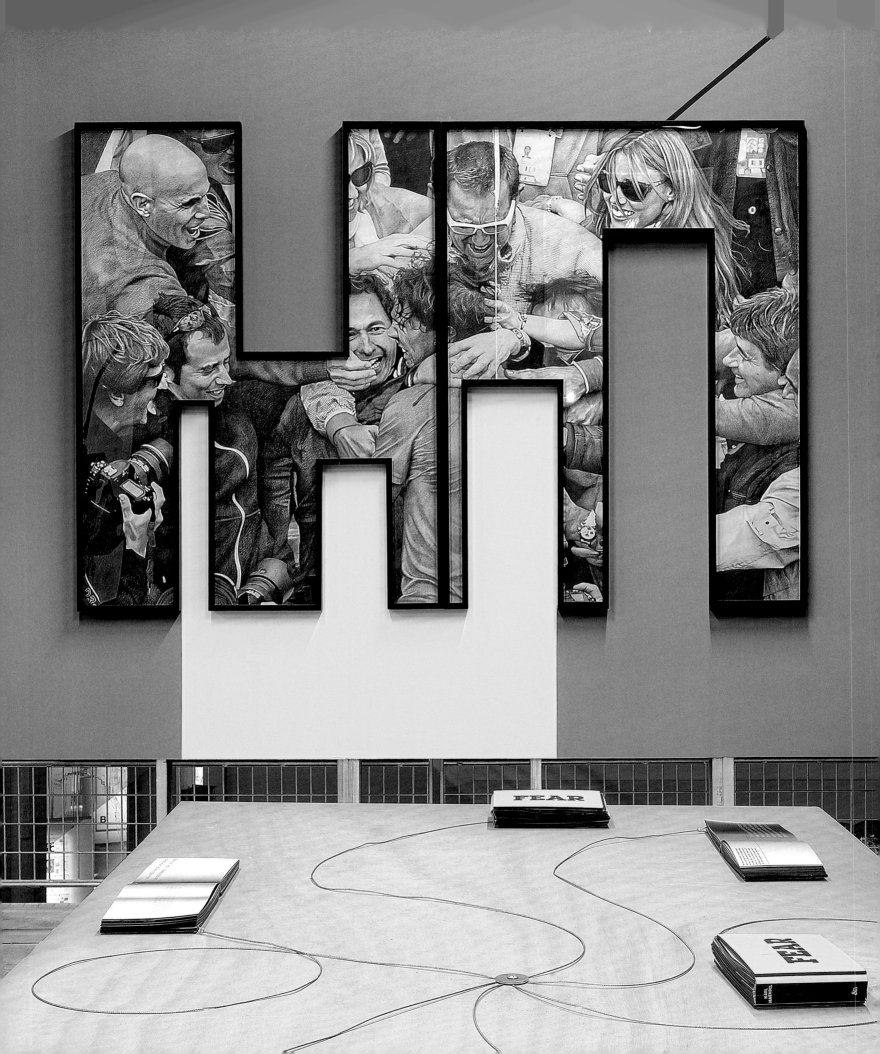

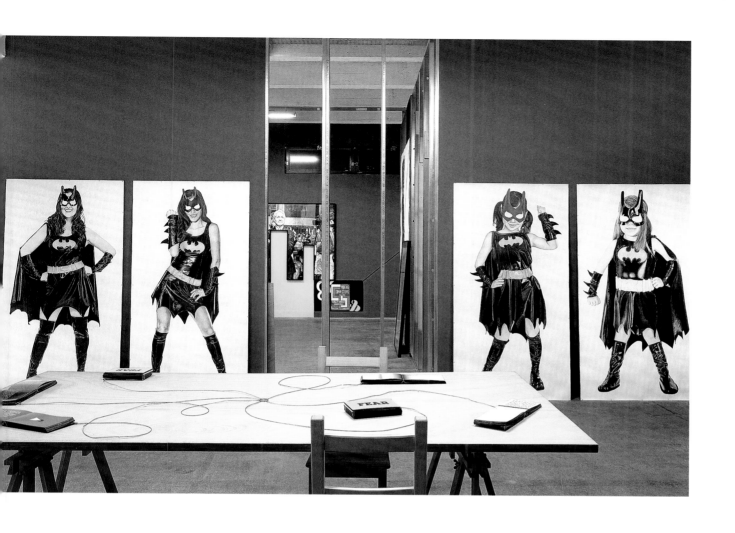

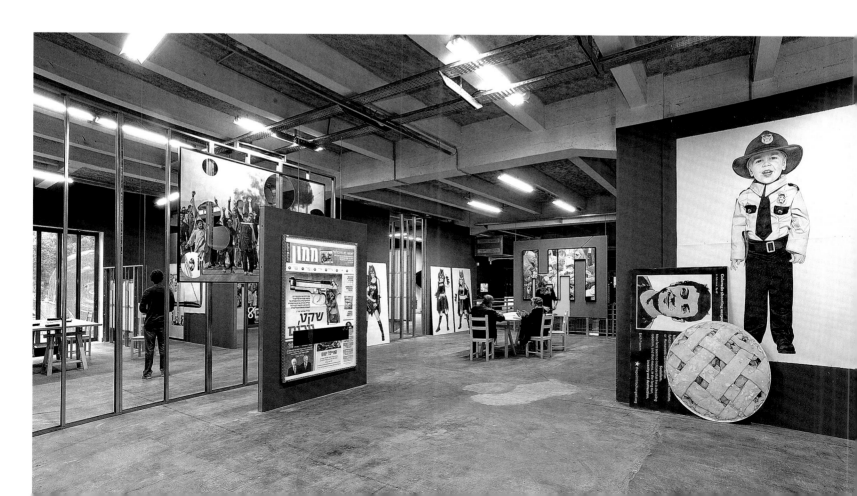

PREVIOUS:

Installation views, *12th Biennale de Lyon*, 2013

LEFT TO RIGHT:

Installation view, *12th Biennale de Lyon*, 2013

Double Ampersand (120-144), 2013

Double Ampersand (90-88.5), 2013

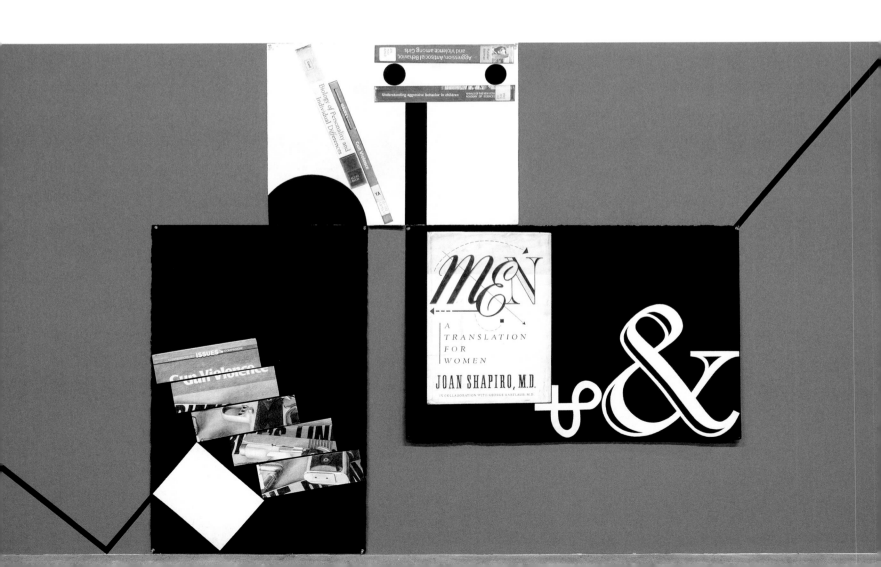

Susanne
Vielmetter
Los Angeles
Projects
/ Los Angeles

204

monique
meloche
/ Chicago

202

201

200

104

LEFT TO RIGHT:

Theme Time–Presidents Day, 2013

Theme Time–Colors, 2013

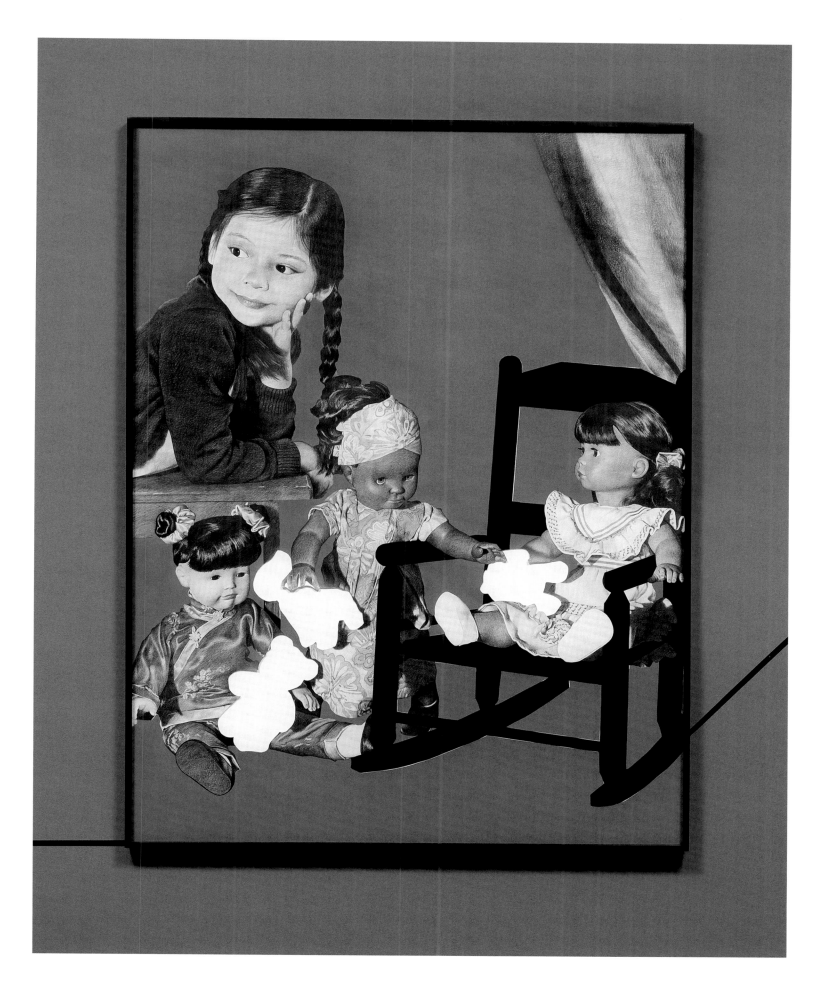

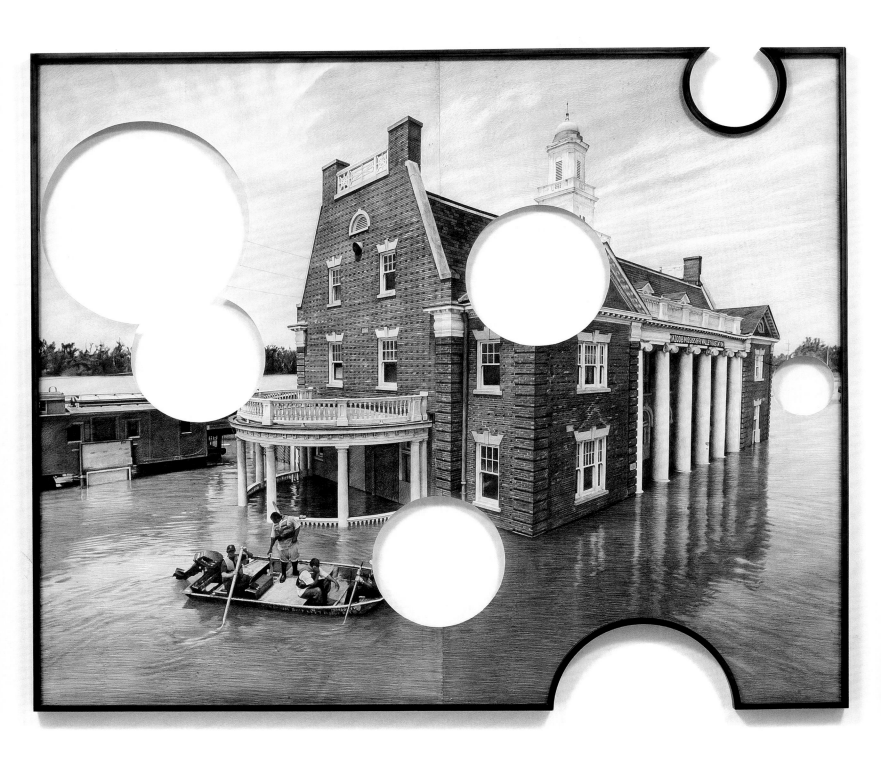

LEFT TO RIGHT:

Theme Time–Water (Vicksburg Flood), 2013

Theme Time–Fruit, 2013

Head on Hands #3, 2013

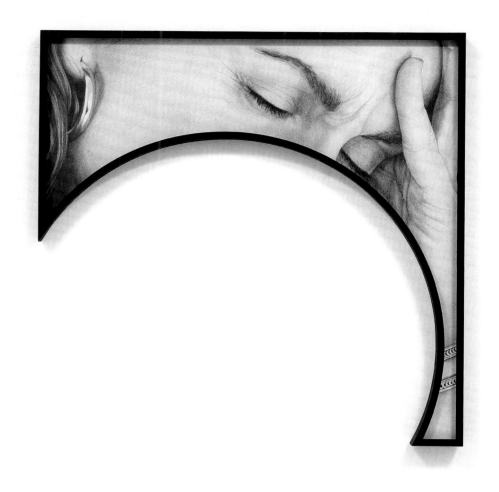

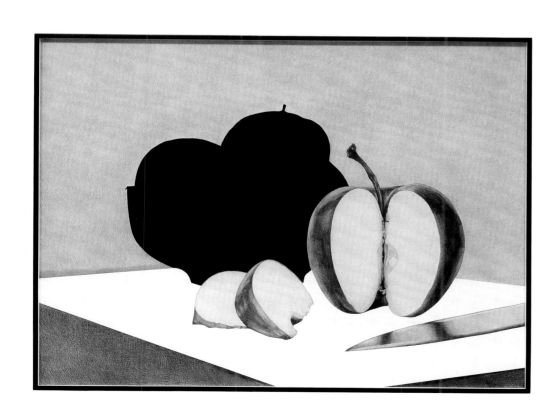

Installation view, *Whitney Biennial*, 2014

Theme Time–Questions [version 1], 2014

Theme Time–Money [version 2], 2014

Theme Time–Food (tuna sandwich) [version 1], 2014

Theme Time–Nothing, 2014

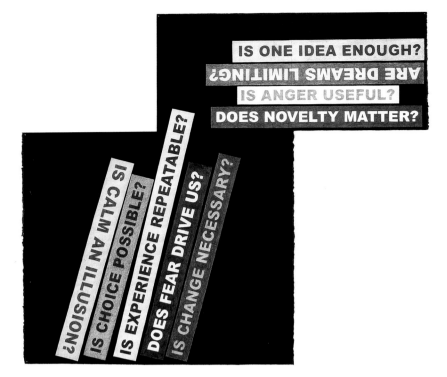

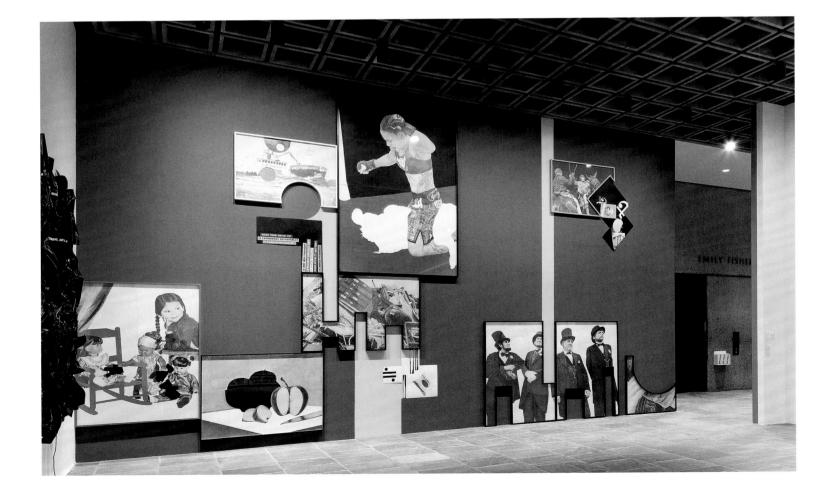

BASTIONS OF PREMODERN DECADENCE
EDIFYING CONTEMPORARY CAPITALISTS
WITH APOLITICAL SPECTACLES
OF ARCHAIC ESCAPISM

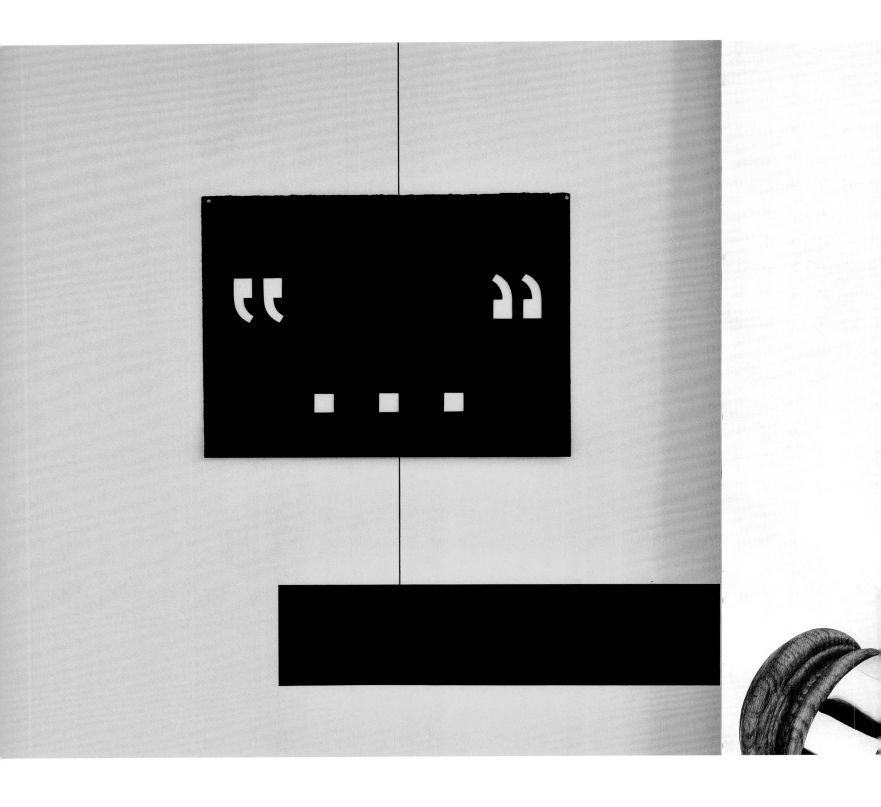

Installation views, *People Who Don't Know They're Dead*, 2014

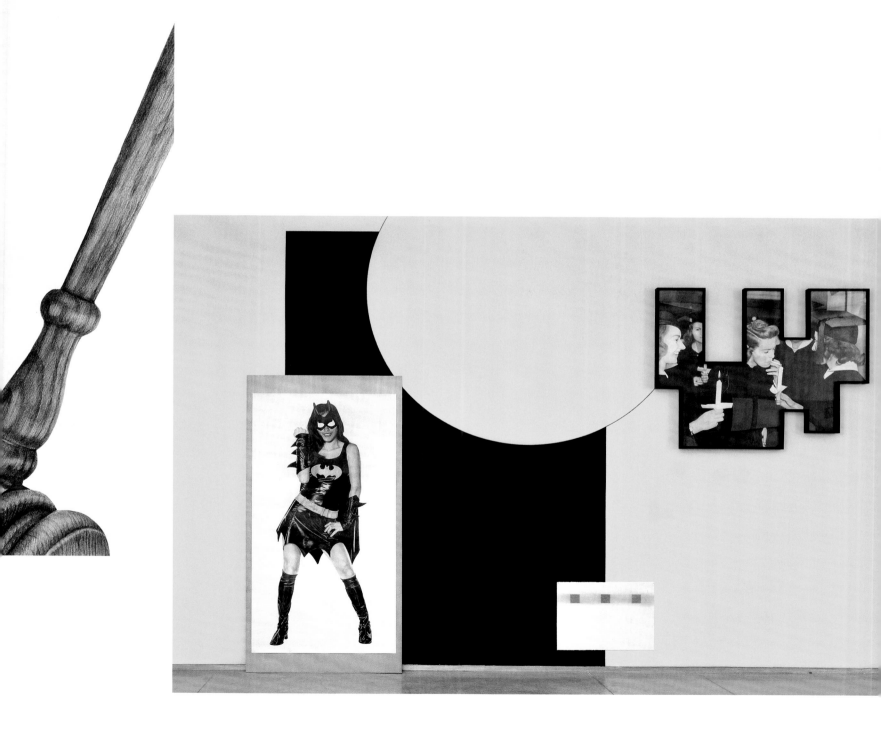

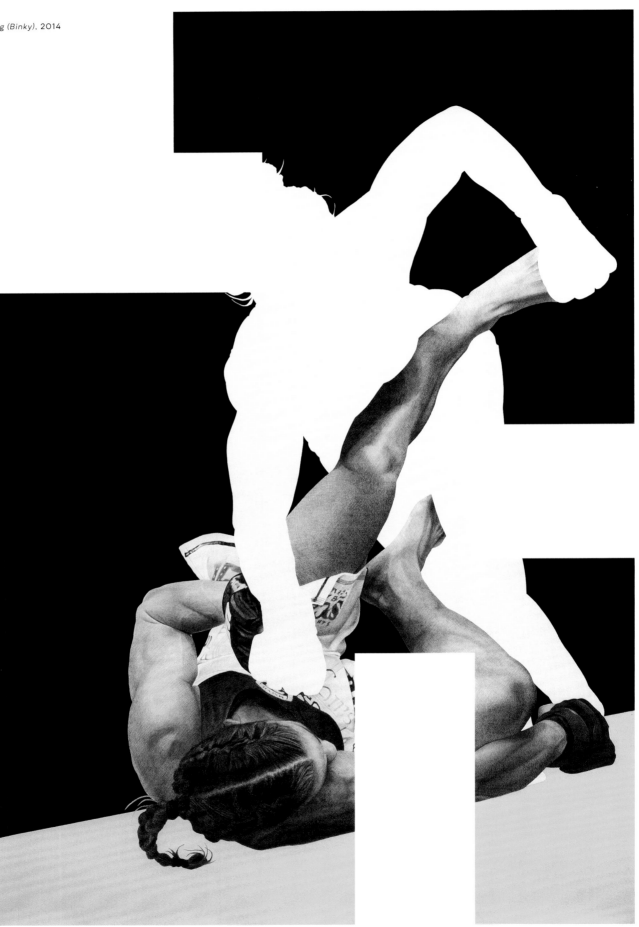

Leo Hilde, Entwürfe Serphing Koasy (?)

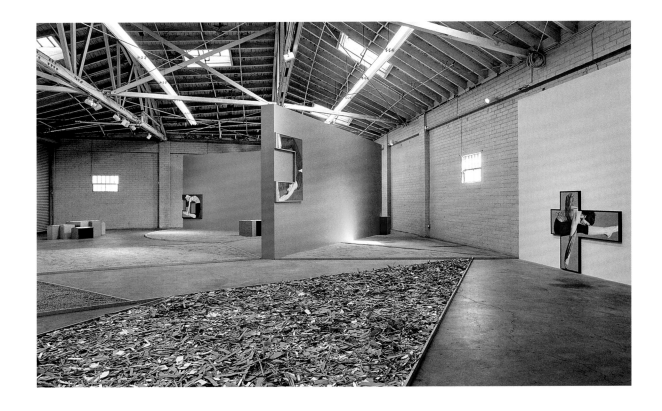

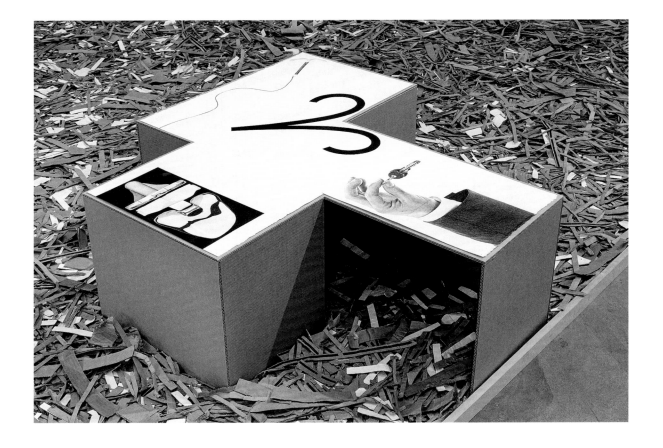

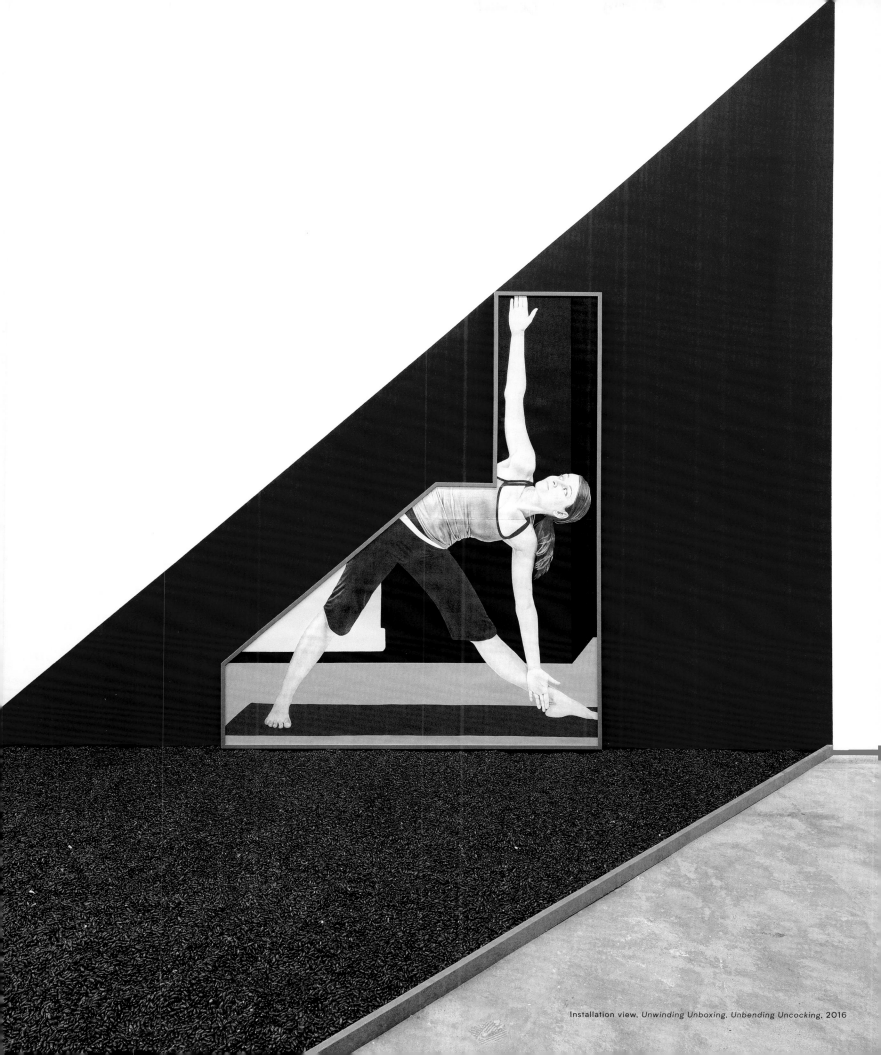

Installation view, *Unwinding Unboxing, Unbending Uncocking*, 2016

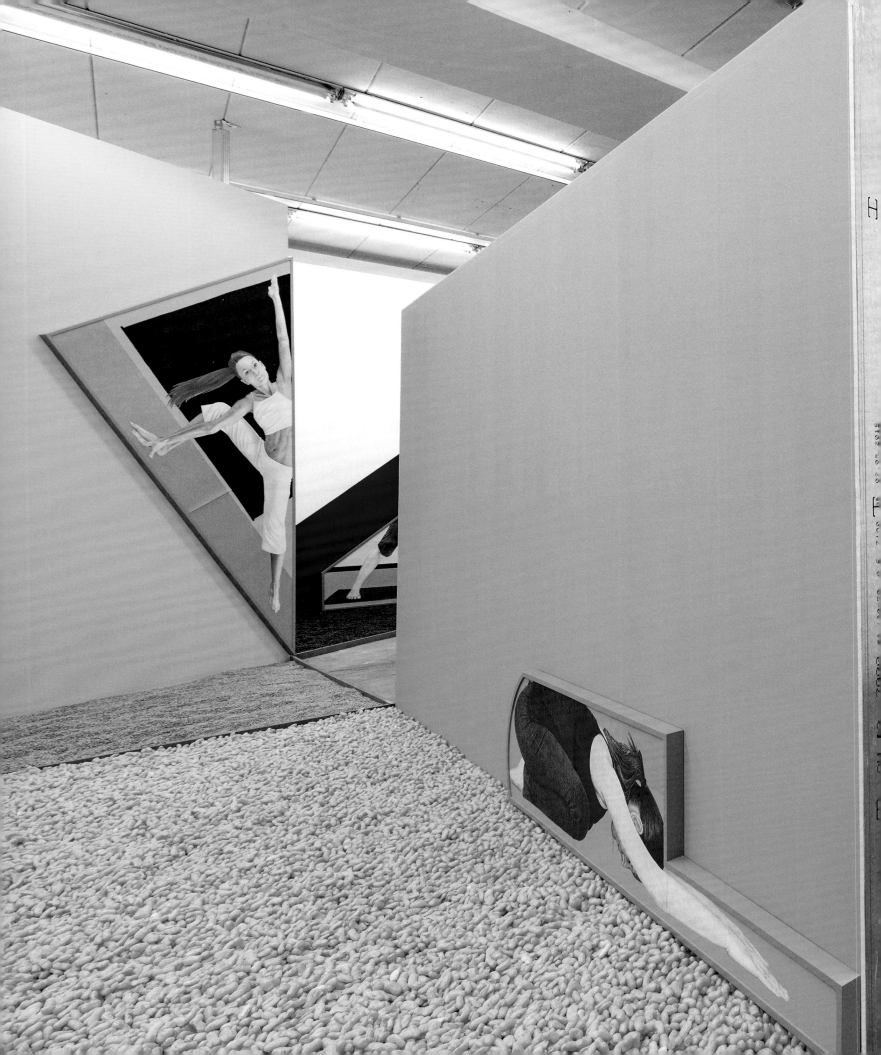

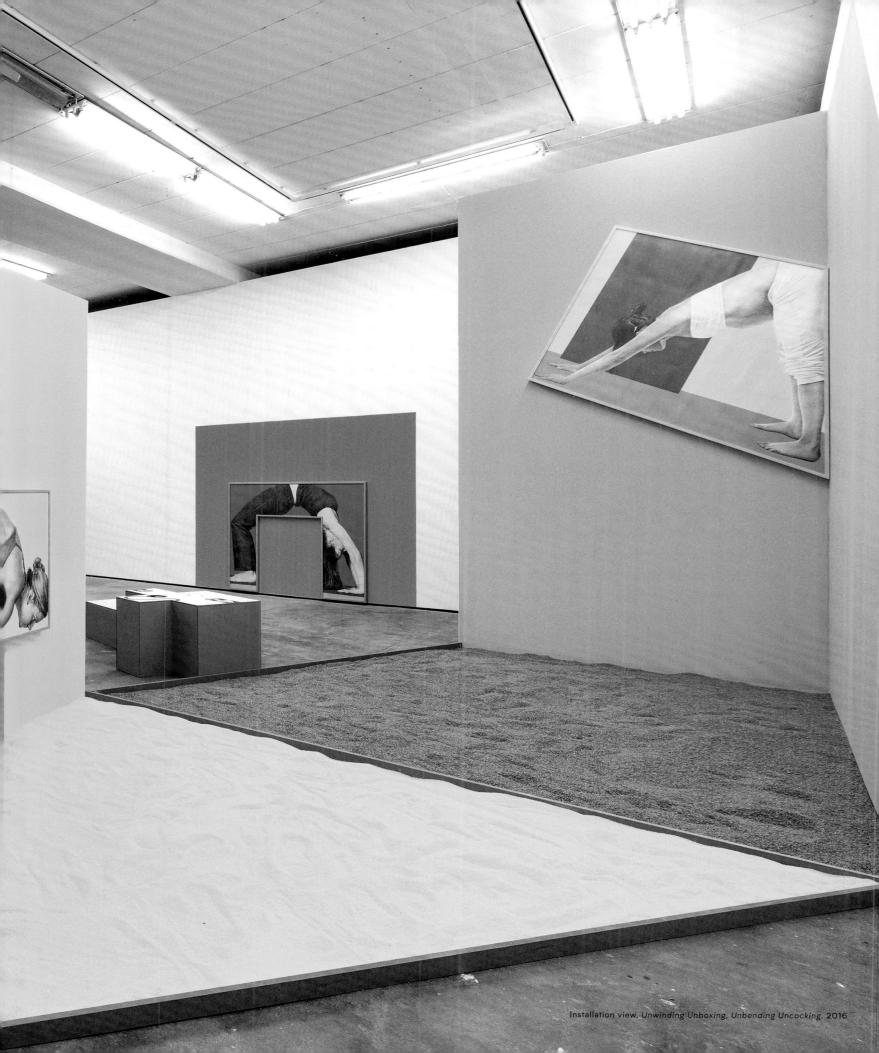

Installation view, *Unwinding Unboxing, Unbending Uncocking*, 2016

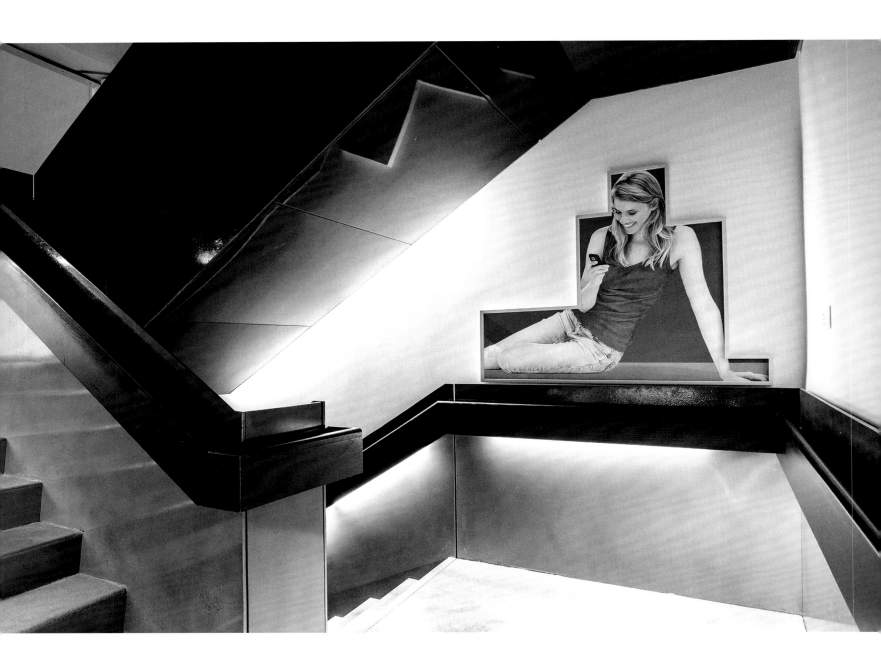

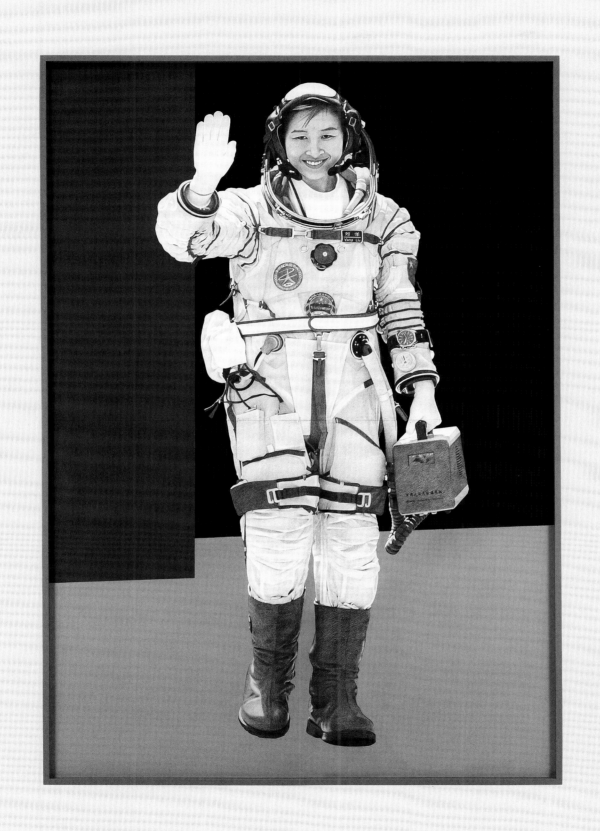

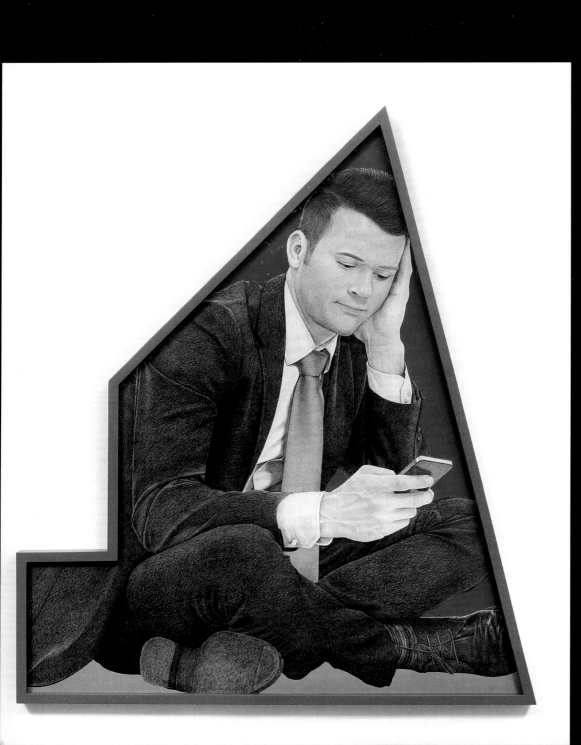

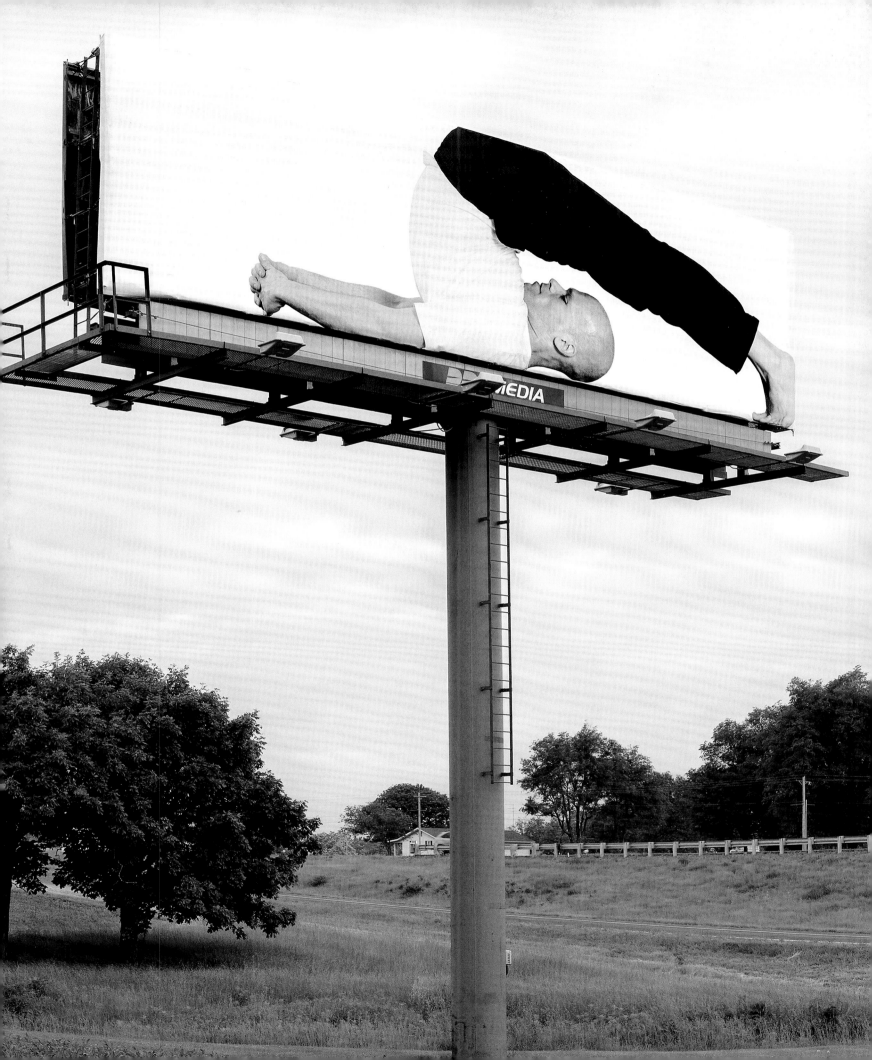

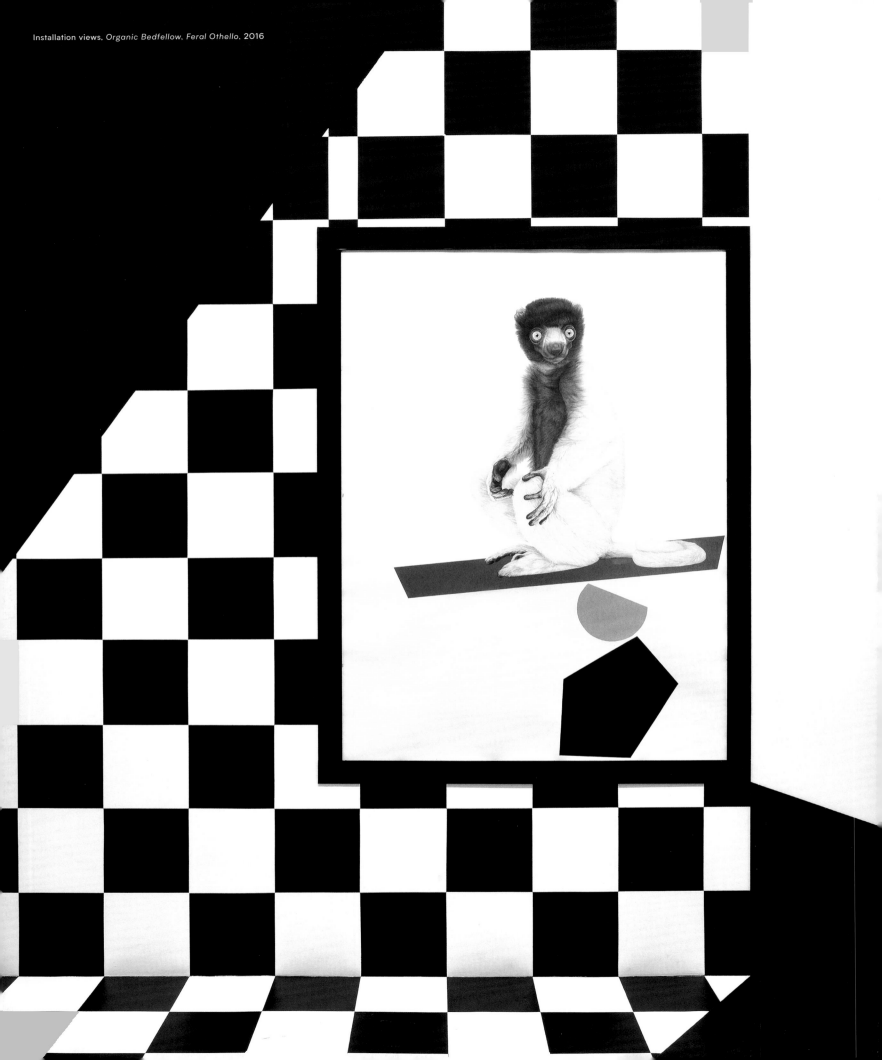

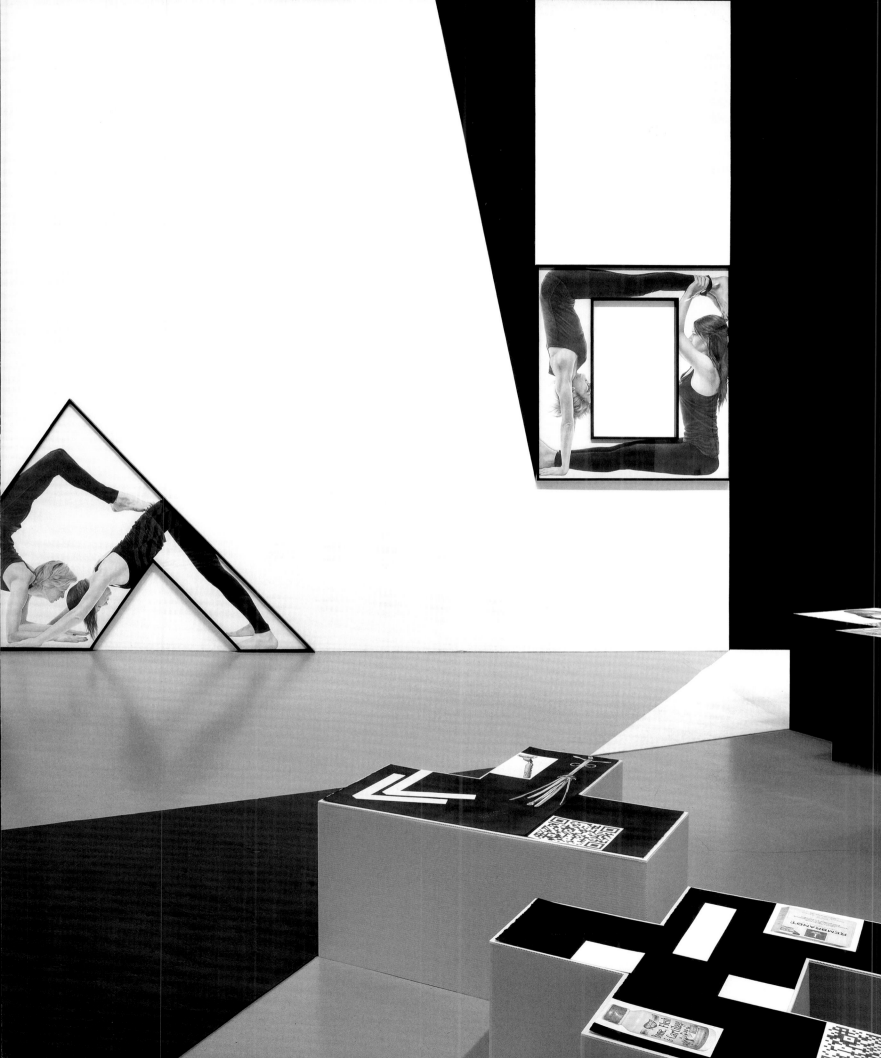

Durand (DY7), 2015

LEFT TO RIGHT:

Minus Sushi 2, 2015

Beaver, 2015

*Drawing of USCG Eagle with Sails Shot Out
(by my father with a black powder revolver),*
2014 [detail]

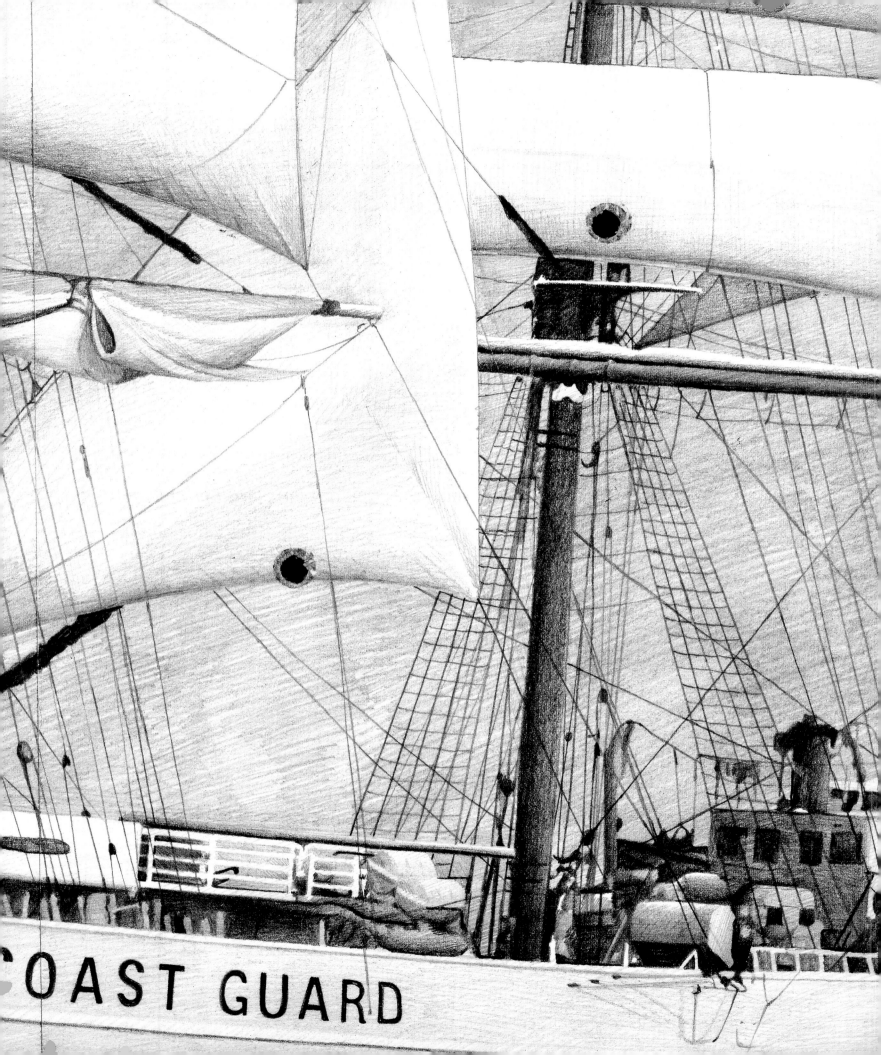

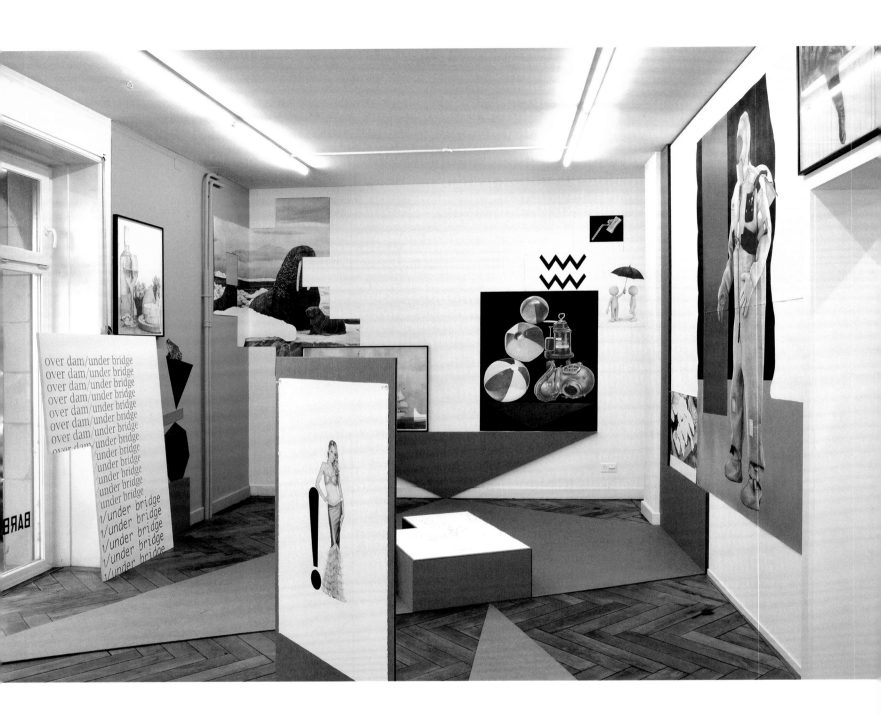

Installation views, *Weeks in Wet Sheets*, 2015

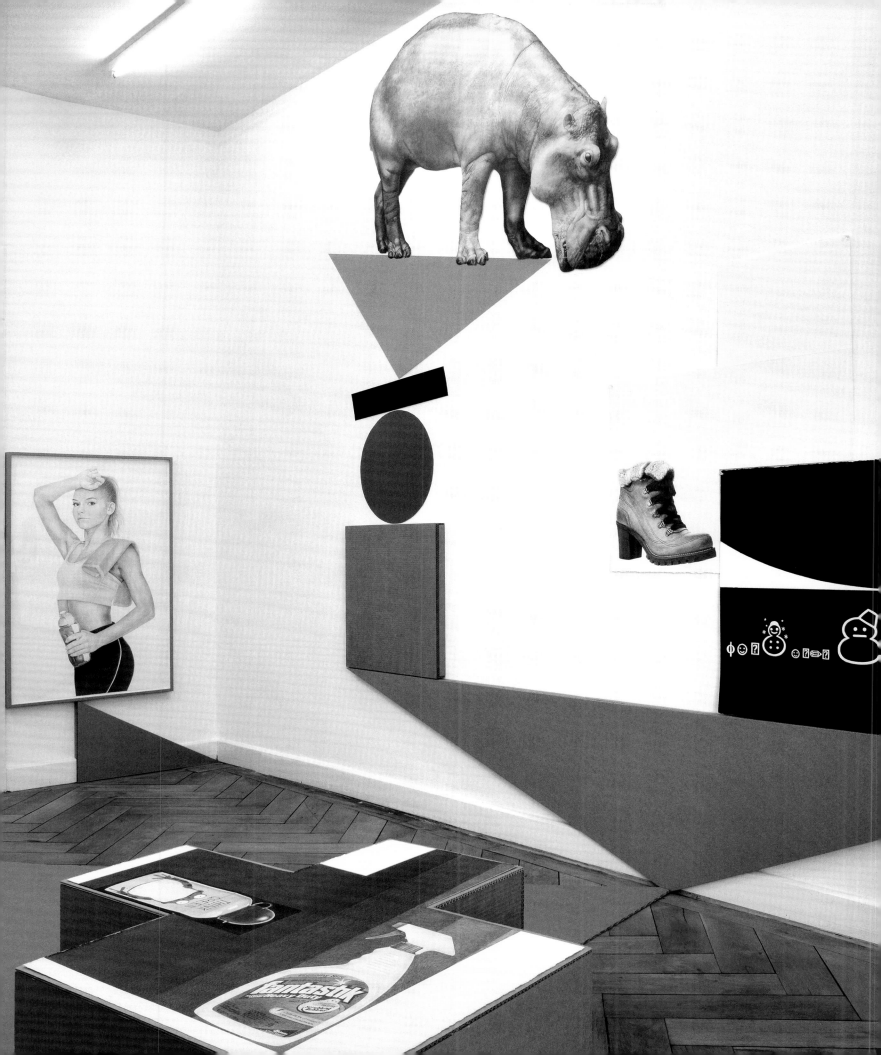

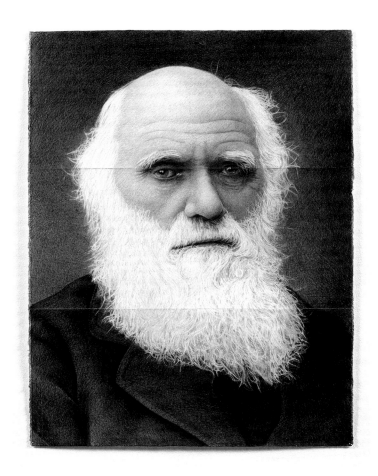

1/2 Einstein's Brain
1/2 Moon Rock

LEFT TO RIGHT:

Darwin (folded), 2016

½ Einstein's Brain, ½ Moon Rock, 2016

3 Heads, 2016

LEFT TO RIGHT:

Arab Spring (Postscript) #2, 2016

Hands and Things 3, 2016

Hands and Things 2, 2016

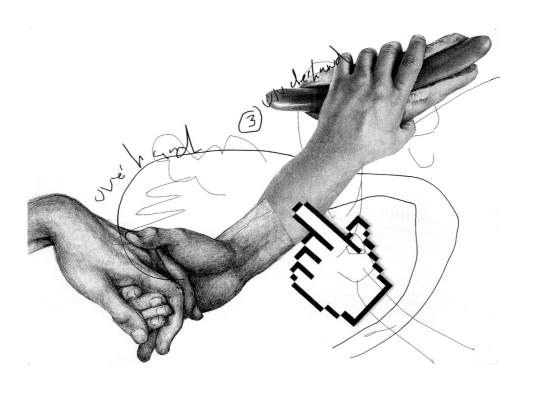

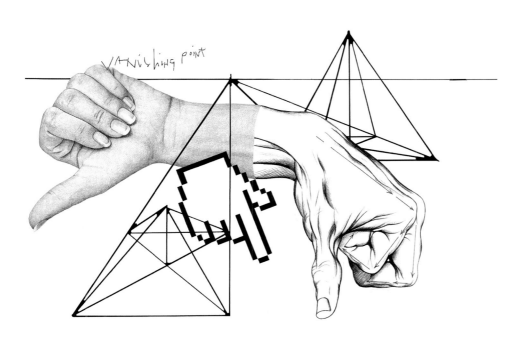

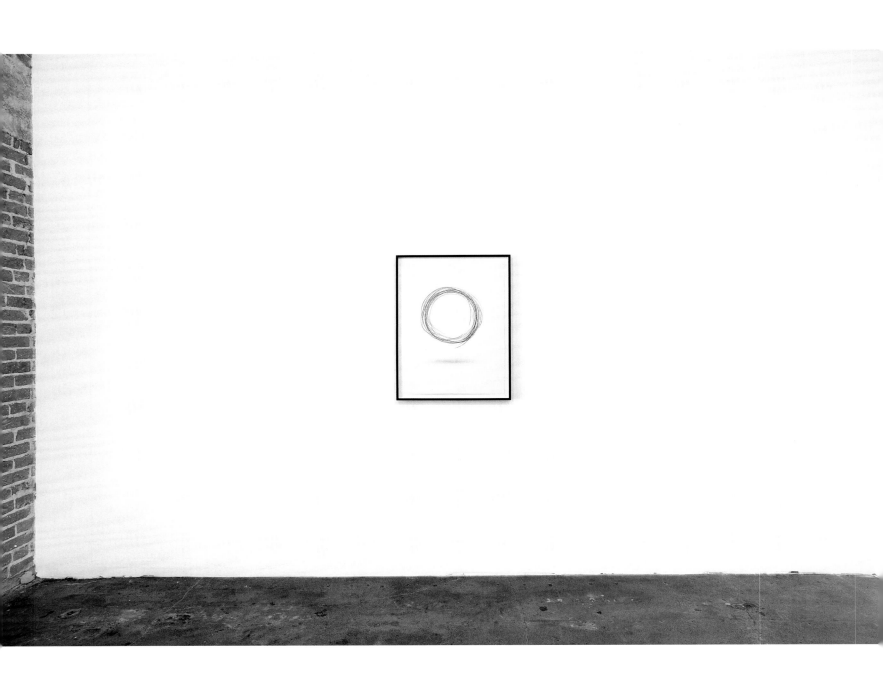

LEFT TO RIGHT:

Installation view, *Karl Haendel / Tony Lewis*, 2016

No Title, 2016

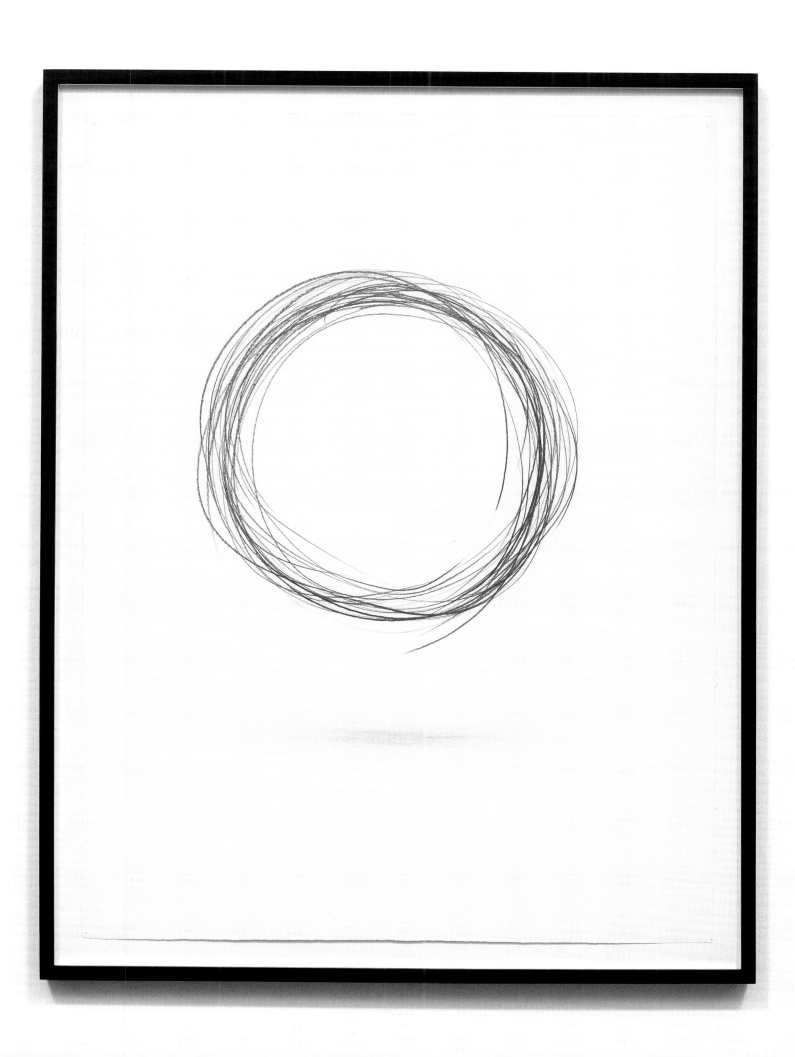

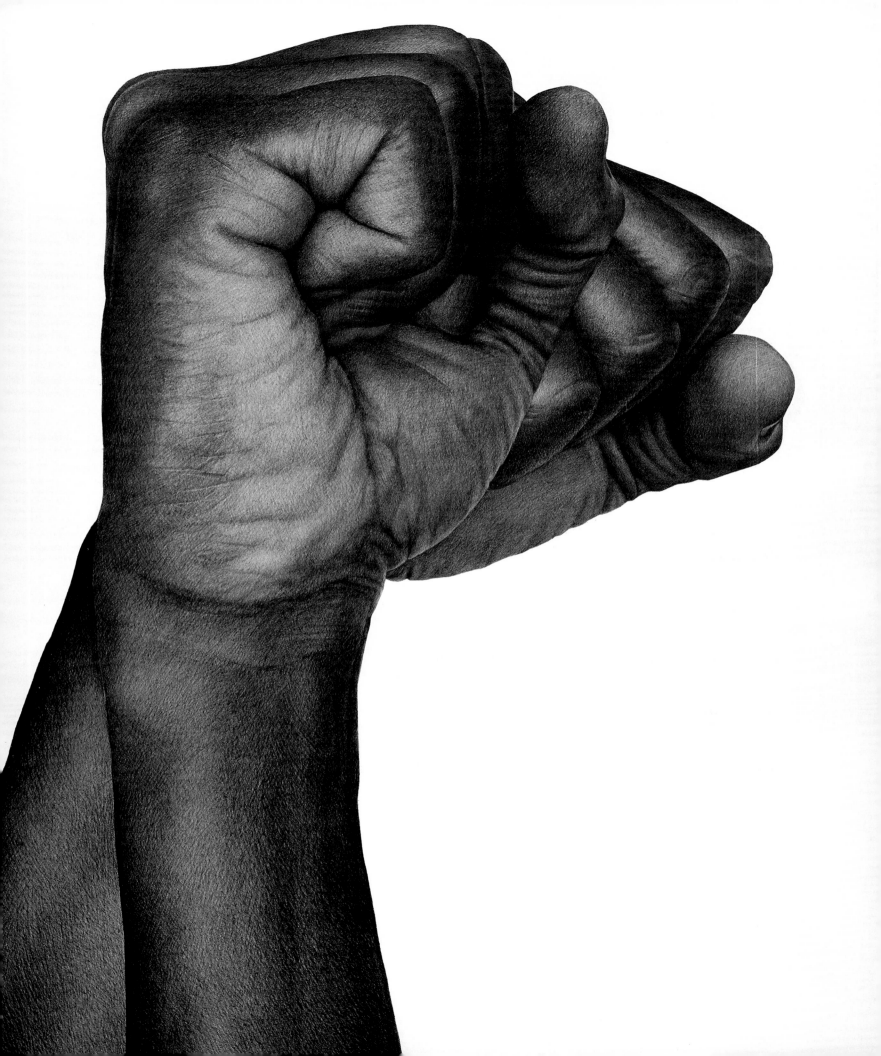

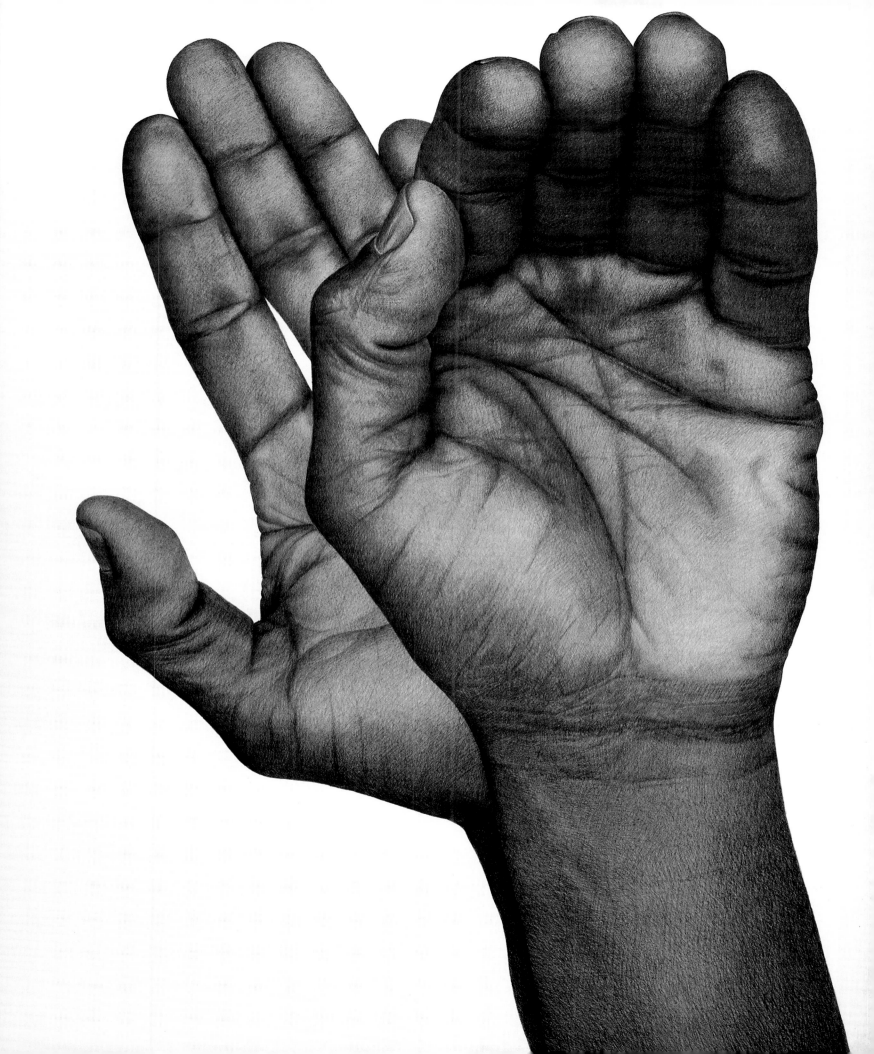

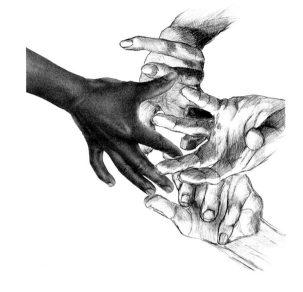

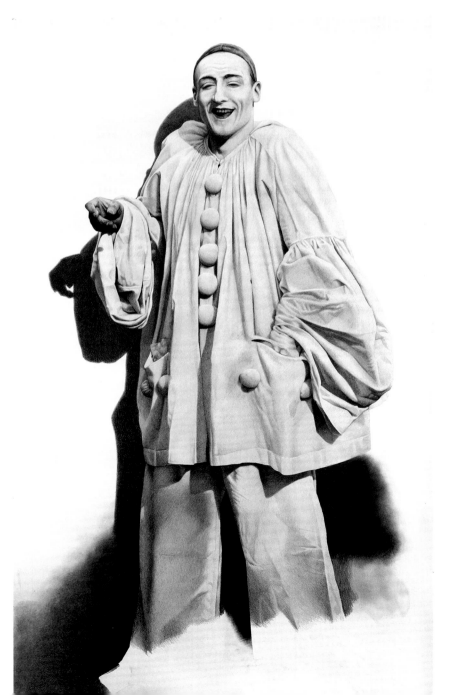

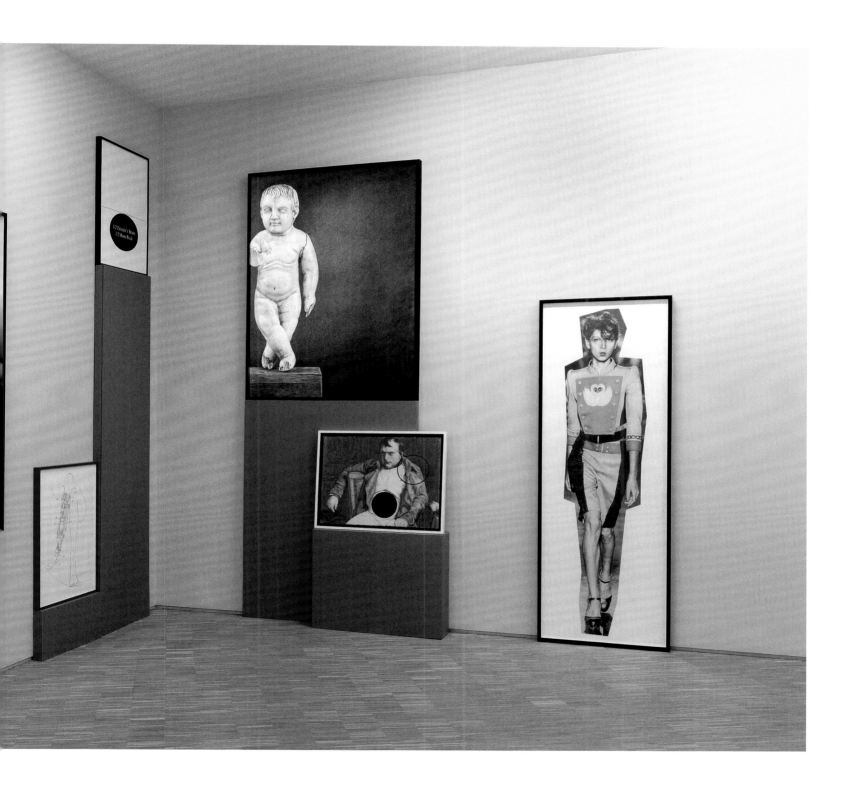

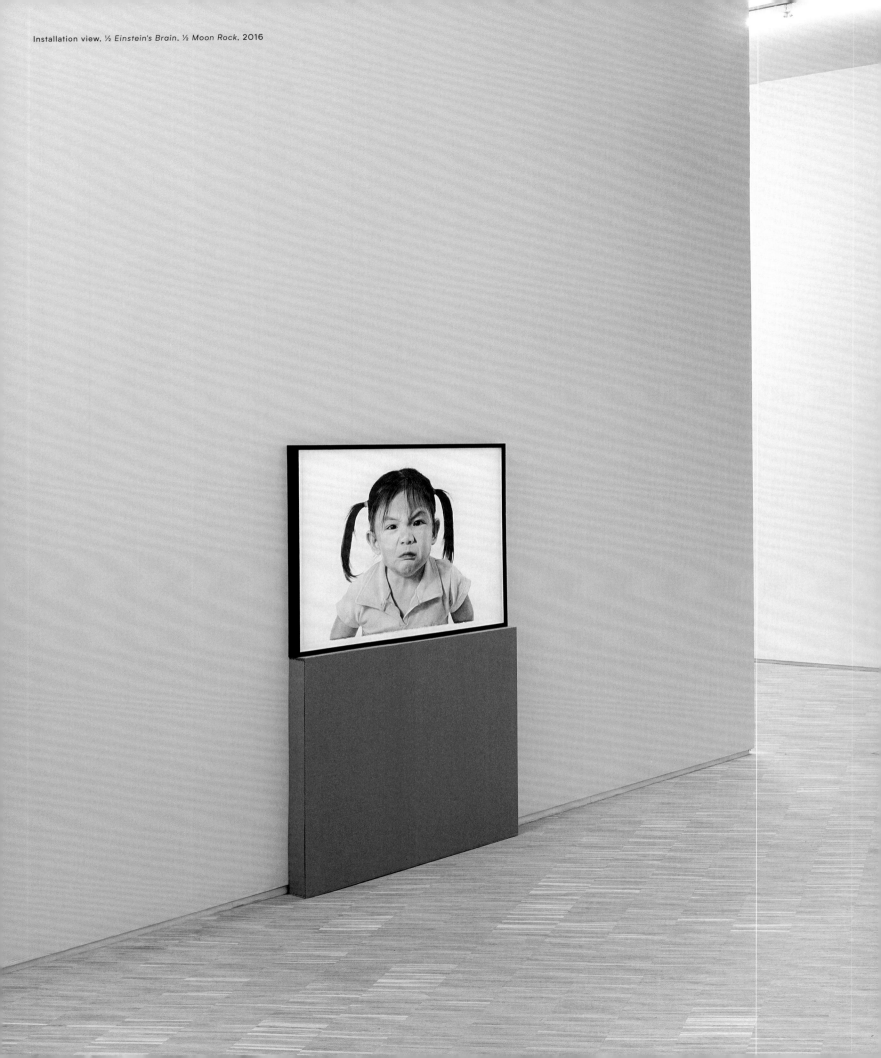

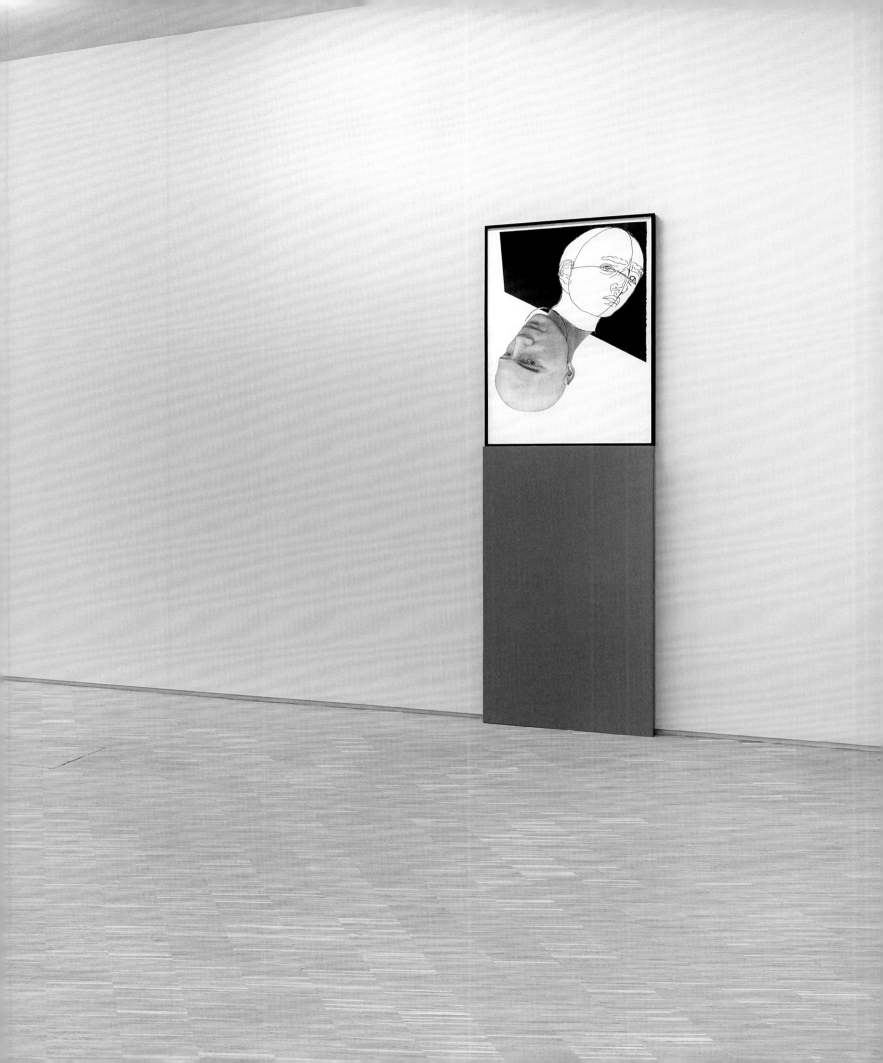

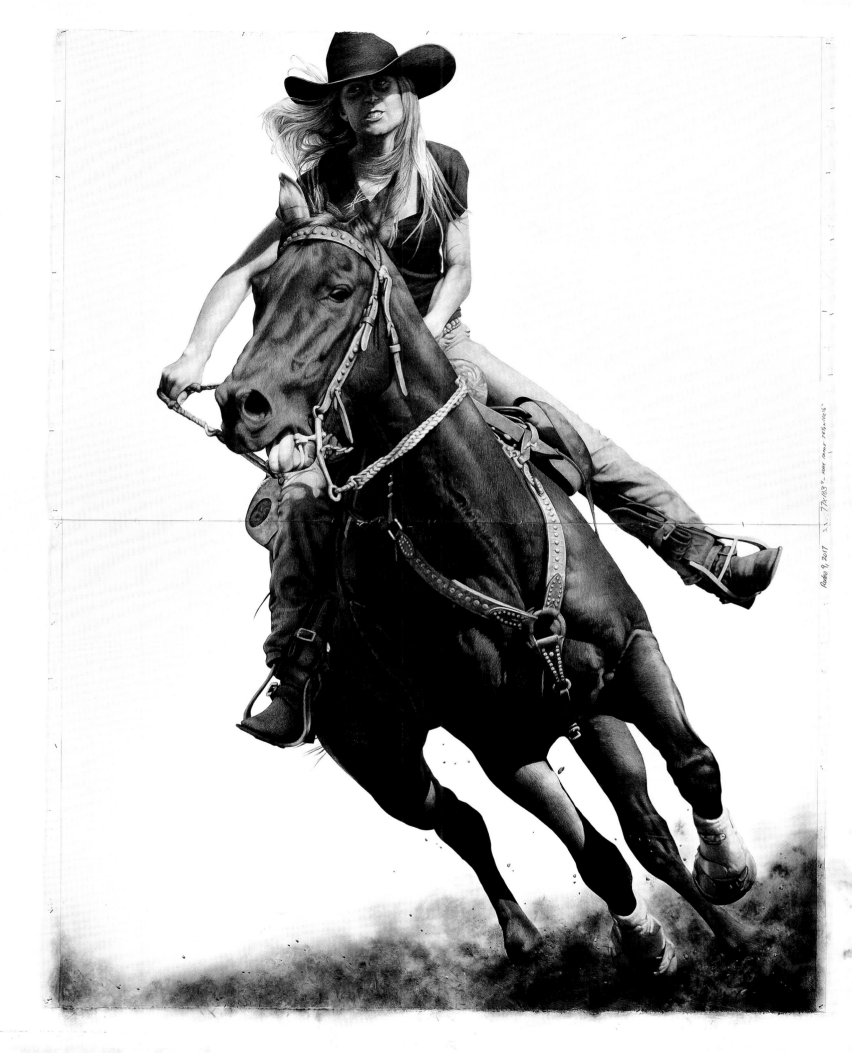

Rodeo 9, 2017 · · · · 77×63" · Graphite 76½×102½

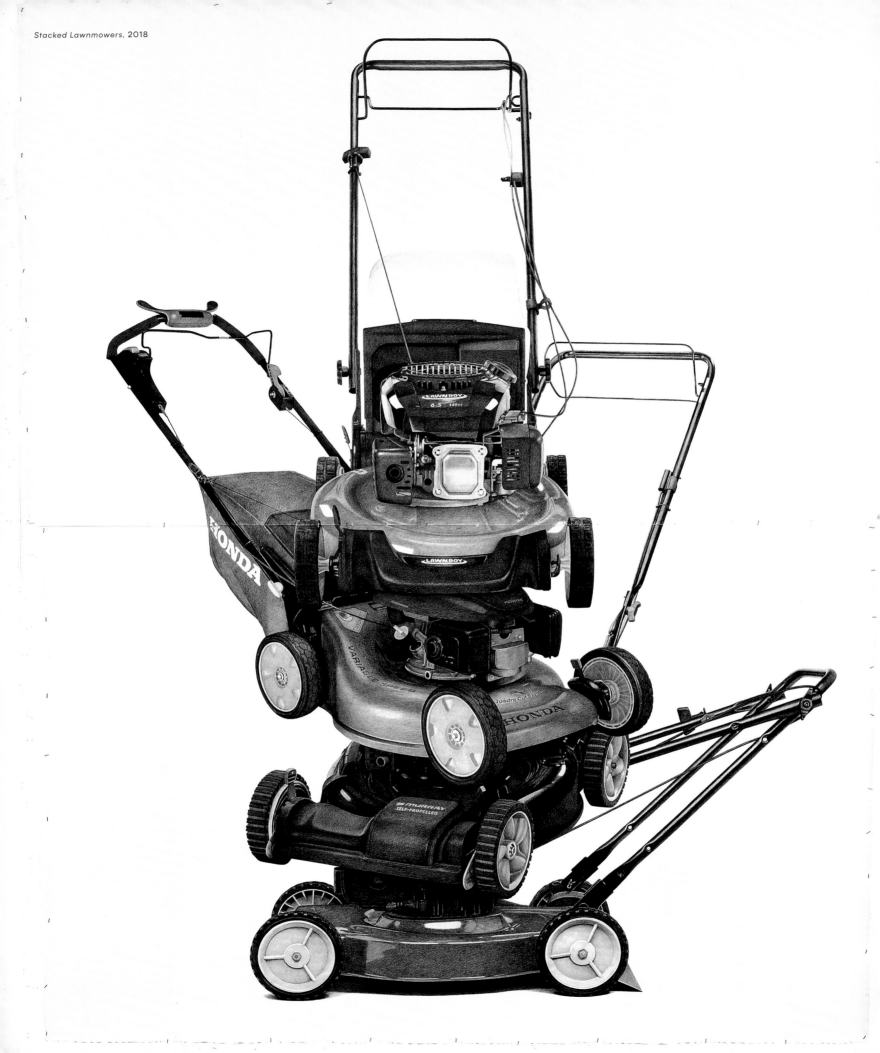

Stacked Lawnmowers. 2018

HATE

FEAR

SHAME

ANXIETY

RESENTMENT

DISGRACE

HUMILIATION

DISGUST

EMBITTERMENT

EMBARRASSMENT

JEALOUSY

DOUBT

INSECURITY

CONFUSION

INDIFFERENCE

ACCEPTANCE

REMORSE

HONESTY

CLARITY

OPENNESS

EASE

EXCITEMENT

PATIENCE

GRATITUDE

TRUST

CONFIDENCE

SECURITY

HAPPINESS

HOPE

JOY

LOVE

BY AND BY

**RITA
GONZALEZ**

In 2003, Karl Haendel produced a small run of self-designed T-shirts with the phrase "Compassionate Conceptualism" rendered in Times New Roman font. Haendel, a child of the Reagan era who snidely wore an "Oliver North for President" tee as an adolescent, coopted the term from President George W. Bush's conservative agenda. Bush's key aide and speechwriter Michael Gerson actually coined the phrase "compassionate conservatism" prior to his White House tenure, but recycled it to brand Bush's domestic policies. The appropriative strategies of resurfacing texts and images have become a signature technique for Haendel, and critical reception of his work focuses on the representational strategies of his latter day postmodernism—but his intertwining of emotion and conceptual methods has been less observed. Since

Haendel builds upon previous work, often grouping drawings from various phases from his twenty years of artistic production, he not only has developed an image data bank but a surplus of intellectual and emotion-driven pictures, books, and videos that contributes to what Natilee Harren has called "a more sensitive appropriation."[1]

I first met Karl Haendel in the early 2000s when we were both graduate students at UCLA. Karl was in the MFA program alongside a cohort that included Dawn Kasper, Sharon Hayes, Florian Maier-Aichen, Analia Saban, and Kerry Tribe. At the time, the gallery scene in Los Angeles was mostly consolidated in Chinatown and Culver City. Discovery narratives about the Los Angeles art scene and its attendant MFA factories proliferated in the arts media, and numerous art students garnered solo commercial gallery representation even before receiving their diplomas. A general dissatisfaction was also on the rise as publications like Howard Singerman's *Art Subjects: Making Artists in the American University*, and public programs on the state of arts education organized by Frances Stark and Jan Tumlir, began to reflect breakages in the bubble. For Haendel, the colliding and conspiring influences of art school, relational aesthetics, and art historical lineages segued into his attempt to reconcile generational and subjective concerns with the legacies of conceptual art. If "Compassionate Conceptualism" is the entry point for this essay, including its tongue-in-cheek questioning of doing progressive artistic work in an era of conservatism's "softening," then it is useful to delve into Haendel's provocative vocabulary in more depth. "Compassionate Conceptualism"

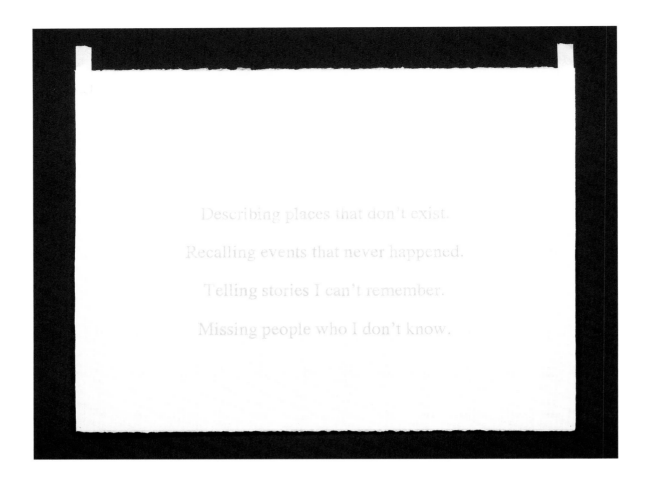

Describing places that don't exist.

Recalling events that never happened.

Telling stories I can't remember.

Missing people who I don't know.

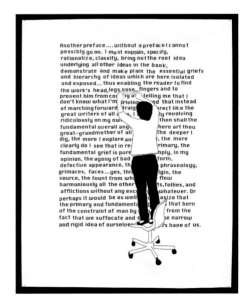

may have been a tongue-in-cheek jibe, but the phrase also resonates with what has emerged in Haendel's practice: the production of "plebian, satirical, and contemporaneous"[2] individual and grouped images.

Haendel has discussed how "the rendering of the image becomes a memorial to its loss," and that his "drawings have the quality of a tribute."[3] The quality of care for the image, in selection, production, redistribution, and exhibition, all relate to Haendel's expanded form of drawing within an installation format. His process is to accumulate and categorize images, take photographs on slide film, project and draw. The painstaking execution of the mostly graphite drawings involves both a form of memorization (if we consider the multivalent meanings of a commitment to memory) and

memorialization.[4] The text-based drawing *Describing Places that Don't Exist* (2000) functions as a primer to his subsequent drawings, installations, and videos. These word drawings are executed in the same manner as those derived from photographic or illustrated sources. Whether taken from a typed document or a hand-written example, they are projected and then drawn. This drawing is an early example of Haendel's interest in list making and personal disclosure. Executed with a lightness of hand, the text-based piece reads: "Describing places that don't exist. Recalling events that never happened. Telling stories I can't remember. Missing people who I do not know." Whether the drawing is from his own writing, as in this piece, or from archival or familial sources, Haendel suggests that there are limits to what is knowable

Footage from all the wars the United States has been
involved in between the years of 1917 and 1991 presented
in order of latest to earliest and edited to American music
which was popular between the same years played in order
of earliest to latest.

Listing all the famous people I can remember and
classifying them according to the moral standing of the
profession to which they belong beginning with the most
virtuous and ending with the most corrupt.

Attempting to read off of a piece of paper that is turned
upside down a list of names of holocaust victims who were
survived by a twin sibling and alphabetized in order of the
first name of their surviving twin.

Reciting names off the top of my head of people who I
think actually exist and live in America then looking
through the phone book to see if the names are listed and
then calling the persons listed to see if they live in America
and actually exist.

Describing a process which takes considerable time to
complete and results in material form yet nonetheless has no
actual effect and conveys no meaning thus adding nothing
but the effaced history of its coming into being to an already
overcrowded world.

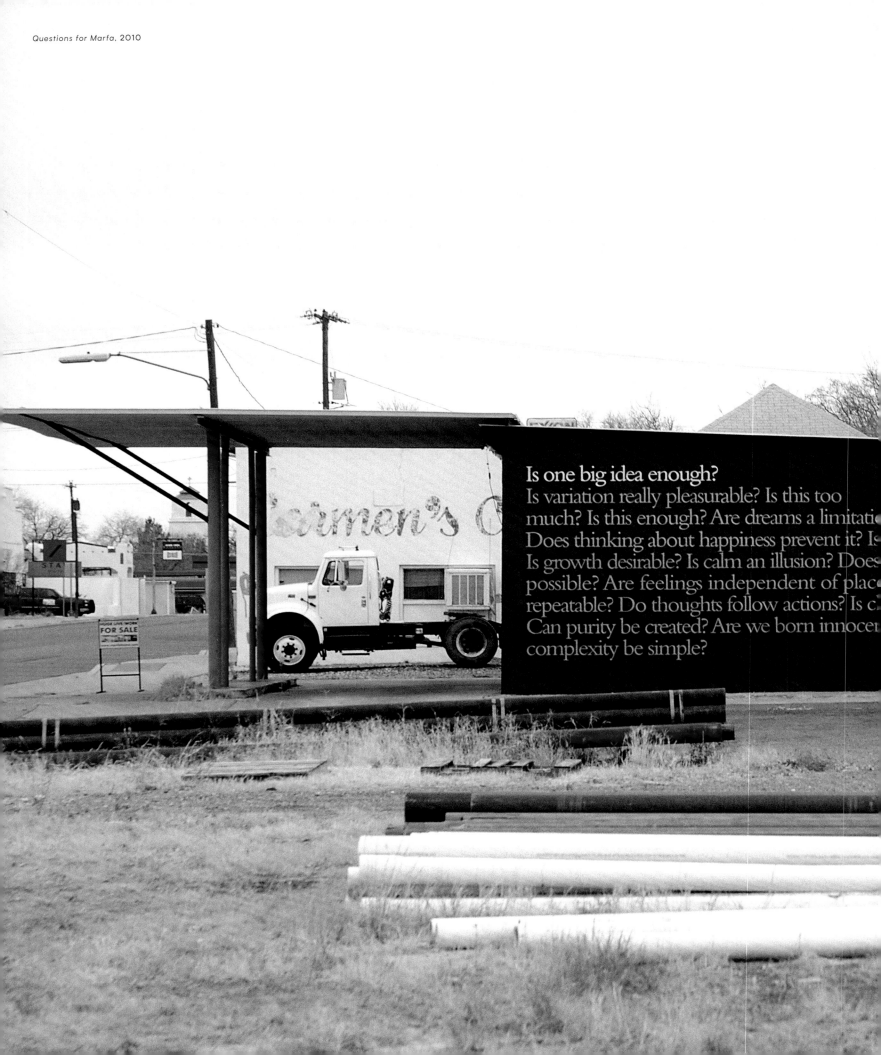

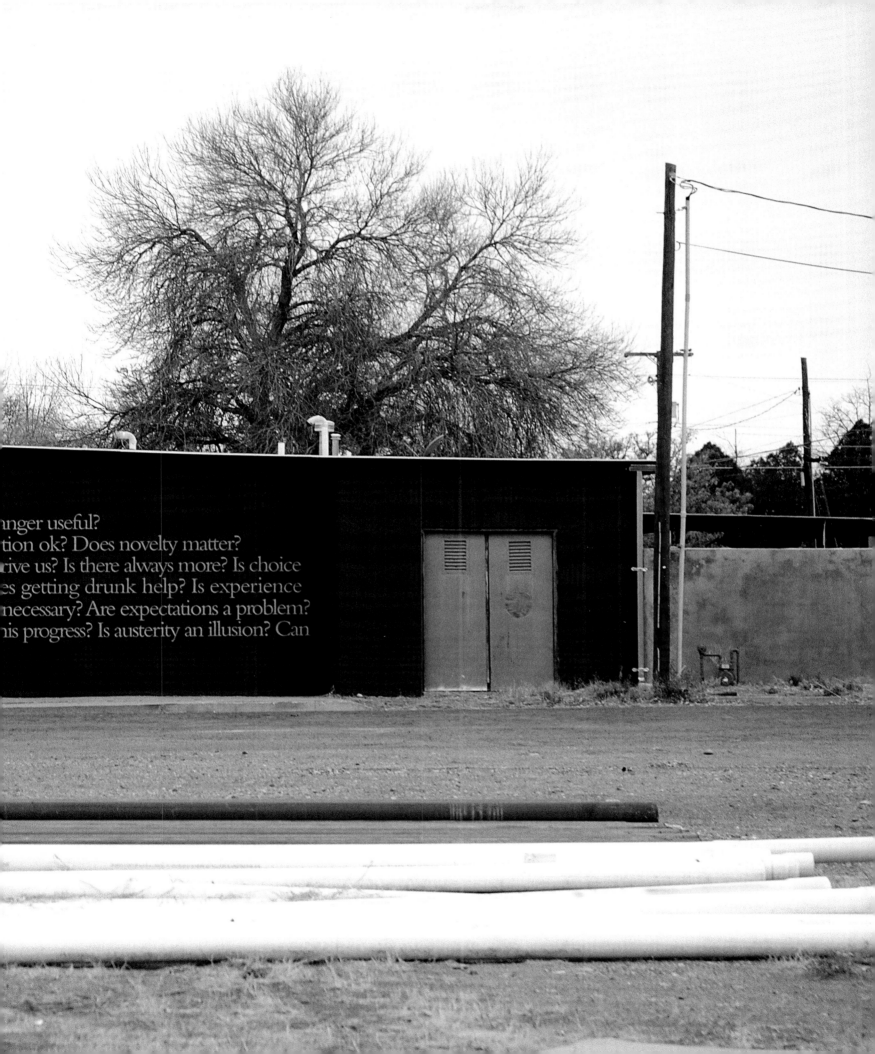

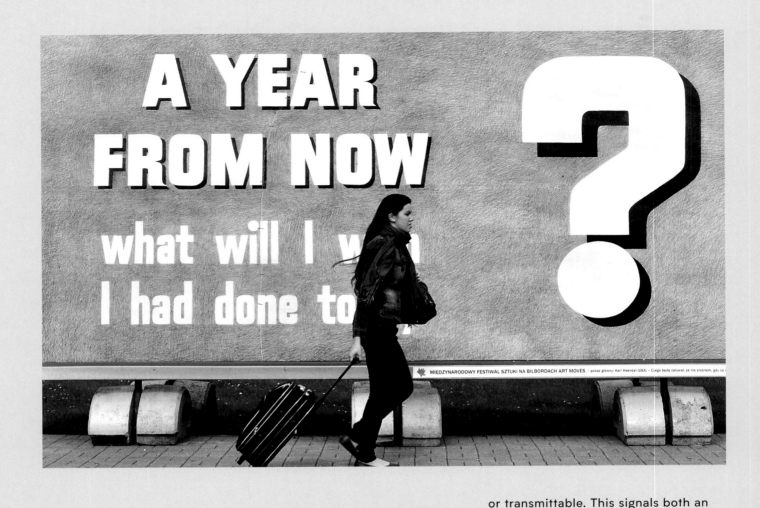

LEFT TO RIGHT:

Sharon Hayes
Ricerche: three, 2013
HD video; Pictured: Jasmine Brown, Aderike Ajao,
Laakan McHardy, and Jessica Ortiz. Courtesy of the
artist and Tanya Leighton Gallery

A Year From Now, 2008

Shame, 2012 [excerpts]

or transmittable. This signals both an opening / portal aspect of the found image as well as its impenetrability.

Christian Rattemeyer, Michelle Grabner, and Haendel himself have discussed the totality of the drawings constituting a vocabulary, but it's important to also identify the dialogical aspects of the drawings and installations. The interrogative is used to frequently elicit a response or conversation, while at the same time the artist poses questions to himself but put on display for public consumption. In his drawing and subsequent billboard, *A Year from Now* (2008), Haendel uses the aspirational texts often found pinned up in office cubicles to exteriorize and bring into the public sphere aspects of self-reflection and interior exploration. In *Questions for Marfa* (2010), Haendel stacks up the

following: "Is one big idea enough? Is variation really pleasurable? Is this too much? Is this enough? Are dreams a limitation? Is anger useful? Does thinking about happiness prevent it? Is repetition ok? Does novelty matter? Is growth desirable? Is calm an illusion? Does fear drive us? Is there always more? Is choice possible?" Haendel has deployed an isolated question mark itself to emphasize the multiplicity of the drawn form as "concept/image/word."

This dialogical aspect, and the critique of practices of historical representation, aligns his work with fellow UCLA graduates Sharon Hayes and Kerry Tribe. Hayes's interest is partially in the transcripts of historical archives—both official records and marginalized narratives—and in their ability to be activated through an intellectual and corporeal replay. Tribe's work over the years has been an interrogation of memory itself, with recent film and video installations focusing on how to represent different forms of cognition and neurological decay. Whiteness and masculinity, and frequently Jewishness and masculinity, are often referenced in Haendel's practice. In the late 1990s and early 2000s, artists of color as well as artists invested in interrogating privilege (in whatever stripe), began to operate in more open-ended, suggestive, or poetic formats. The grouping of myriad pictorial references alongside text—from personal asides to journalistic headlines—affords Haendel a flexibility to delve deeply or cautiously into reflections on his identity. His book *Shame* (2012) and video *Questions for My Father* (2011), on the other hand, are more frontal and aggressive in their skewering

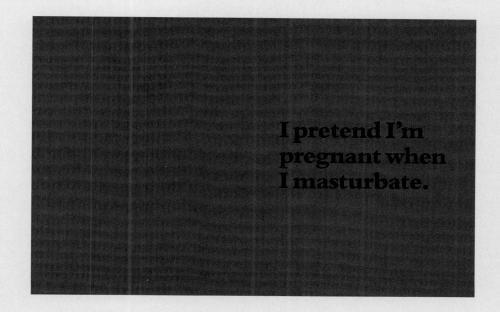

I pretend I'm pregnant when I masturbate.

I'm tired of having to hide everything that's inside me, just so that others won't be uncomfortable. The pain I feel is intensified in knowing that no one wants to hear about it. No one wants to know how horrible I feel every single day. No one can handle listening to it.

I want to kill myself.

I am jealous of other people's success all the time. Pretty much just people I know. I secretly want my friends to fail. I am competitive with them in my mind, even though I try to act supportive.

I stole when I was a kid.

How did you get out of going to Vietnam? Were there any alcoholics in our family? Do you remember your Bar Mitzvah? Did you ever think of killing yourself? Did it ever get old fucking mom? How did you feel knowing everybody who lived near us had more money? How important was it for you to marry a Jew? How many women have you slept with? Why did you borrow my porn instead of just buying your own? Did you have a favorite sibling? Who had a bigger penis, you or your brother? Did you ever cheat on mom? Where there any black kids in your school? How did you feel about Martin Luther King? How about Joan Baez? Did you ever march on anything? Did you ever come across cocaine? Did anybody ever try to convert you to Christianity? Have you ever eaten foie gras? Did you ever wonder if you were gay? What did you talk about on your first date with mom? When was the first time you came across a computer? What kind of music did you listen to in the 60's? What sports were you good at as a kid? Did you ever go to a hooker? Did you ever have anal sex with mom? Are you afraid to die? Did you ever shit your pants? Why do you like the ocean so much? Were you worried about money all the time? Why did you decide to have children? Were you ever depressed as a young man? What if I came out retarded? What did you think about Nixon? Why do you think everybody remembers where they were when Kennedy got shot? Does it feel to you that time is speeding up? Did you ever fuck a black girl? Why haven't you gone to Israel? What charities do you give to? Did you every wish you went to law school? What did you want me to be? Did you have any friends who died in Vietnam? Did you wish you were taller? When did you stop feeling like a boy? Why did you name me Karl? Do you read the letters I send you? Did you every chop down a full-grown tree? Why are you a Democrat? Do you every wish your life was different? What are your regrets? What makes you cry? Do you think you are good looking? Do you often want to fuck other women besides your wife? Did you ever jerk off while thinking about one of my girlfriends? When were you the happiest? Did you ever hit your father? How did you learn to cook? Why were you so mean all the time? How close did you come to hitting me? Did you ever vote for a Republican?

LEFT TO RIGHT:

Questions for My Father #4, 2008

Karl Haendel & Petter Ringbom,
Questions for My Father, 2011

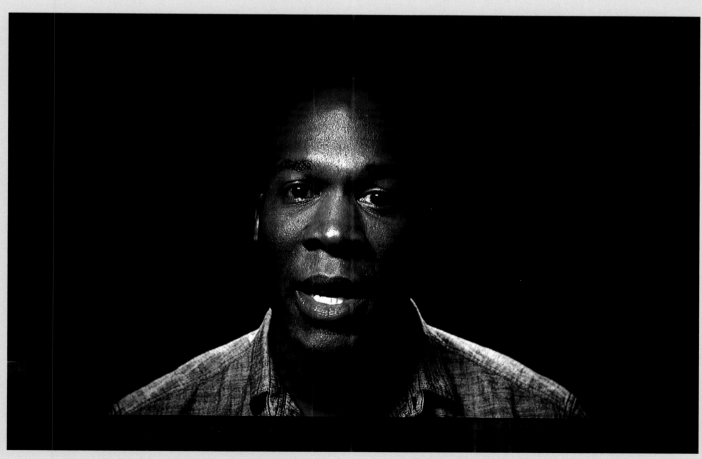

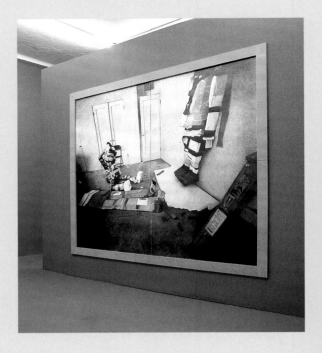

of social conventions. Haendel's research methods for each project differed, with *Shame* functioning as a "compendium of Western shame,"[5] sourced through Haendel's scouring chat rooms and online forums for these semi-public admissions. *Questions for My Father* is both an elaboration on an eponymous drawing by Haendel, and an effort by the artist to go as far as possible into an earnest face forward address of the complex and typically unspoken aspects of masculinity and patriarchy.

This staging of intergenerational dialogue, along with Haendel's frequent "tributes" to his personal networks and affiliations (seen in his appropriation of the work of peers like Walead Beshty, Mungo Thomson, and Hirsch Perlman, among others) is a case of Haendel historicizing his own brand of conceptualism. In fact, the artist Karl Haendel can be considered a performative entity whose voice and idiosyncratic staging of images is often a subtext. The Karl character is self-effacing but also frequently appears to argue for the merits of his approach to identity politics by recognizing boundaries and power differentials and his subjective position as a straight white male, albeit with a particular emphasis on his Jewish cultural and intellectual heritage. The artworks that emerge out of academic training, and acknowledgment and staging of his conceptual / pedagogical lineage, get portrayed, satirized, and at times lambasted in his installations. Case in point is the list drawing, *Hitler–Karl* (2002) that flies in the face of decorum with its indexing of extremely messed up Adolf against nice but a little bit flawed Karl (the smoker to Hitler's health oriented non-smoker).

PAGE LEFT, TOP TO BOTTOM:

Hirsch #2, 2009

Allen Ruppersberg
Great Acts of the Imagination Volume I World War II, 1978 [detail]. Pencil on paper and black-and-white photographs; work in sixteen parts: nine drawings, each 23 x 29 in. (58.4 x 73.7 cm); seven photographs, each 8 x 10 in. (20.3 x 25.4 cm). Private collection, Brussels

Allen Ruppersberg
Excerpt from The Novel the Writes Itself, 1981–2012 Unlimited edition of posters, each 22 x 14 in. (55.9 x 35.6 cm). Printed by The Colby Poster Printing Company, Los Angeles

PAGE RIGHT, TOP TO BOTTOM:

Walead #2, 2008

Karl the Pencil Monkey #2, 2008 [detail]

Hitler / Karl #2, 2007

Haendel has also represented fragmentation of memory and the impossibility of inhabiting all sides of cultural history through his frequent overlay of highly personal materials (scribbles, notes, lists, confessions, and even the contents of his studio desk) with images of twentieth- and twenty-first-century war, forced migrations, mass political movements, and historical portraits. Haendel has noted his affinities with Allen Ruppersberg, a left coast "compassionate conceptualist" whose forty years of art making is a mélange of the artist's interests in literature, print culture, music, and reflections of his own biography vis-à-vis Americana and popular culture. Ruppersberg has an abiding interest in persona, going back to *Al's Café* (1969), but also emblematized through the artist's highly personal

Hitler	Karl
mustached	clean shaven
can't type	can type
instills terror	instills laughter
hard working	lazy
bad dancer	good dancer
vegatarian	meat eater
Jew hater	Jew
war monger	pacifist
bad hair	good hair
acts on violent thoughts	represses violent thoughts
baggy pants	tight pants
mean	nice
failed artist	failing artist
soldier	scared of guns
non-smoker	smoker
dog lover	cat lover
murderer	jay walker
dictator	hipster
teetotaler	drunk
listens to Wagner	listens to Dylan

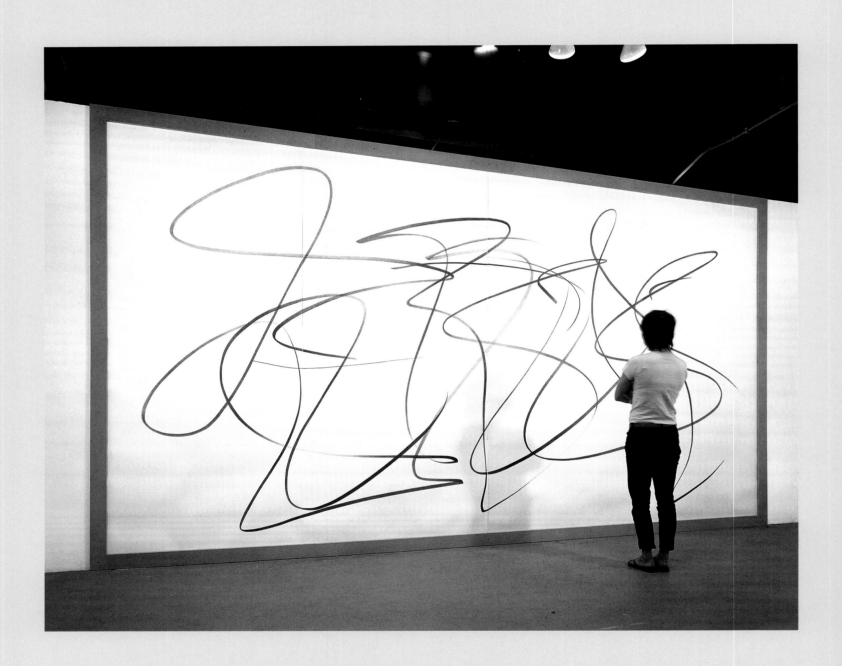

LEFT TO RIGHT:

Very Big Scribble, 2003

Public Scribble #1, 2009

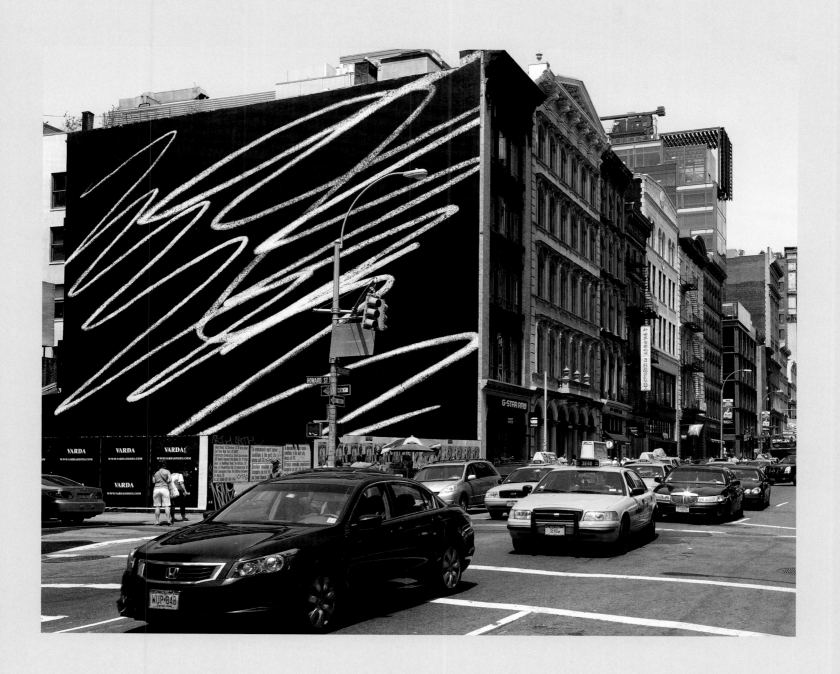

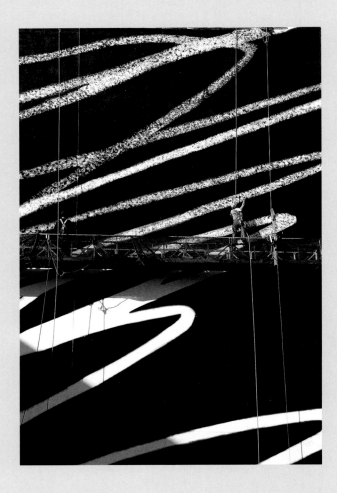

LEFT TO RIGHT:

In progress view of *Public Scribble #1*, 2009

Production #2, 2008

In progress view of *Public Scribble #1*, 2009

and idiosyncratic combination of aspects of fan culture with textual strategies drawn from Conceptual Art. Haendel's appropriation emerges out of this tributary, as he has described his own reading of Haim Steinbach as an "art of affection and engagement."[6] As Steinbach and Ruppersberg enact, and Haendel has elaborated on "appropriation is an art of Comic-Con and Trekkies, of classic car buffs and health nuts, of snowboarders and sun worshippers, of Civil War reenactors and football linebackers."

In 2005, curator Ralph Rugoff curated the group exhibition *Monuments for the U.S.A.*, calling upon artists to address the challenges of thinking through monuments after 9/11. In her review of the exhibition, Eve Melzer wrote about a problem that surfaced for the World Trade Center Site Memorial Competition.

In their words, the difficulty of conceiving monuments in this day and age would now involve the collection of "the disparate memories of individuals and communities together in one space, with all their various textures and meanings," and a translation into material form. Historically, the relationship of drawing to public monuments has been through a representation of the conceptualization and planning phases of an architectural or sculptural form. In *Monuments for the U.S.A.*, as in earlier work of artists such as Claes Oldenburg and Robert Smithson, the artist rendering functions as a critique on the elevated and aspirational claims of historical monuments. Although Haendel was not included in Rugoff's exhibition, one can consider Haendel's use of enlargement and monumentalizing in a similar vein. Relatedly, the grouping of variously scaled drawings tend to take on elevated

topics such as political and cultural history, while simultaneously exposing and indexing the "disparate memories" in public referred to by the World Trade Center Memorial Commission.

When Haendel was invited to execute his largest drawing to date—a building-sized mural—he gravitated to the entirely unconstrained and simultaneously thoughtful and thoughtless form of the scribble. Thinking about abstraction as a type of image that in the early 2000s was regaining currency, in particular in photography and painting, Haendel took on the tropes of gestural abstraction vis-à-vis the scribble. The concept was first executed as a series of enlargements of small doodle-sized scribbles on large sheets of paper, then as a wall-size drawing (104 x 200 in. / 264.2 x 508 cm) with *Very Big Scribble* in 2003. The scribble works

LEFT TO RIGHT:

All the Clocks in My House #7 (10:24), 2010

Blackhand, 2008

Union #6, 2008

also made their way into the public sphere like the interrogation works previously mentioned, first through a commission by the Art Production Fund in New York, installed in 2009 on a side of a five-story building in SoHo, New York, and then on the façade of LAXART in Los Angeles in 2010. To construct these monumentalized works, Haendel employed some of the few remaining traditionally trained sign painters, colloquially referred to as wall-dogs, whose expertise is in rendering super graphics on the sides of building by hand. The work follows Sol LeWitt's claims in *Paragraphs on Conceptual Art*: "The idea itself, even if not made visual, is as much a work of art as any other aesthetic product. All intervening steps—scribbles, sketches, drawings, failed works, models, studies, thoughts, conversations—are of interest." William Anastasi's *Subway* drawings, made blindly while the artist traveled on New York subways, also comes to mind with its similar elevation of chance, humor, and failure.

For Haendel, the choice of drawing as a medium has to do with accountability. In various accounts of his own art practice, from published pieces to public lectures, Haendel frequently emphasizes the daily aspect of studio work. The labor of drawing, and the protocols used to photograph, project, trace, and then draw the pictures, provide the quality of an honest day's work for the artist and studio assistants. Aligned with the measurable labor is a space of slowness and contemplation. This daily accumulation, production, and circulation of imagery produce several lines of inquiry, and Haendel's *By and By* exhibition at Susanne Vielmetter Gallery in 2017 reflects the multidimensionality of his oeuvre. *By*

and By coincided with the inauguration of Donald Trump, and its title brought to mind the lilting refrain of "We Shall Overcome"—that someday, somewhere in the future, there might be relief. The drawings labored over various sites of memory—both public memorials as in murals and in popular images such as Norman Rockwell's iconic *Liberty Girl*. In the central gallery, flanked on both sides with pictures and text pieces projecting national identity as a form of or forum for image consumption, Haendel presented his video *J* (2016), a slow and intensely close up shot of a man's naked body. Just outside of the darkened projection space on top of a table one could read the lengthy transcript of an interview conducted by Haendel with the man in question. The narrative goes into detail about his rape of a woman, and while in no way glorifying the action, provides

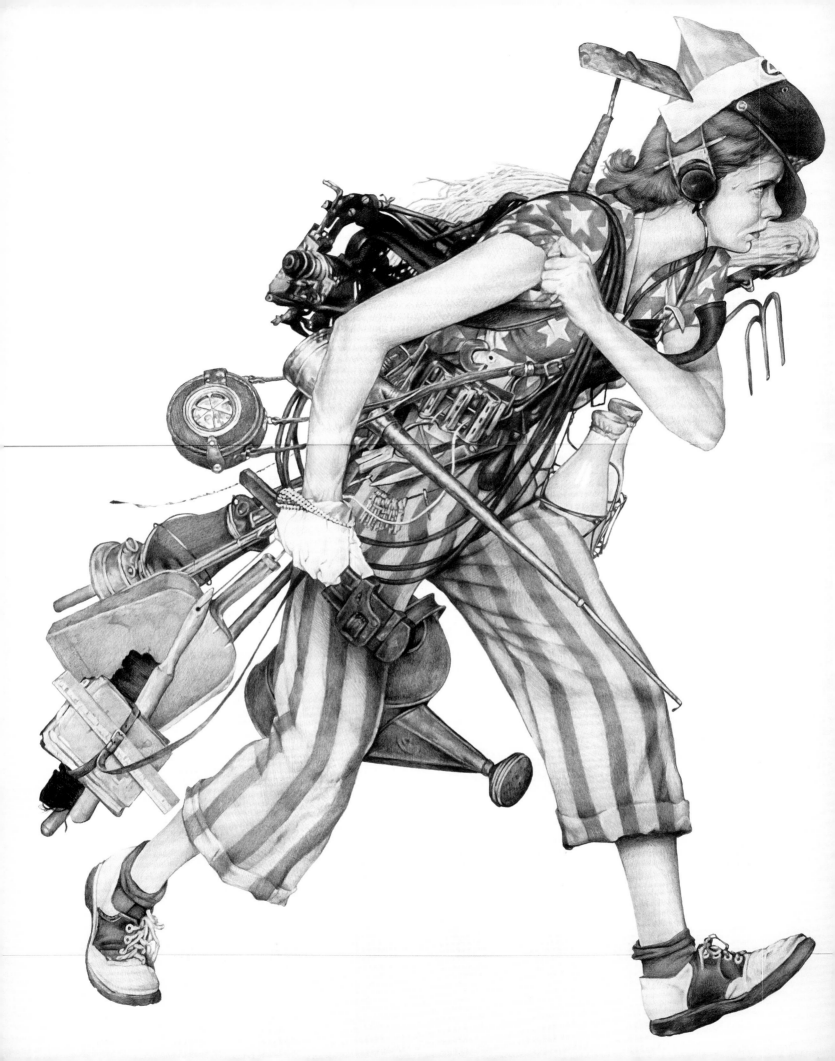

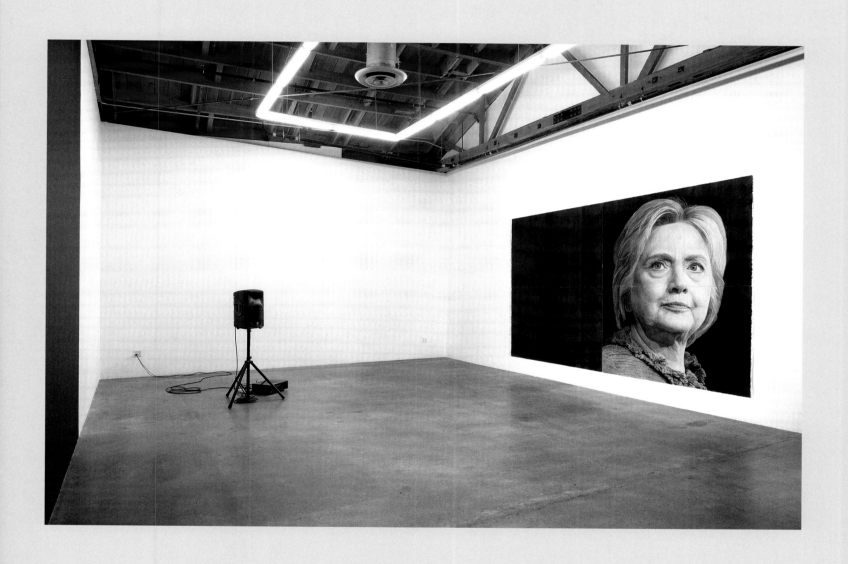

LEFT TO RIGHT:

Liberty Girl, 2016

Hillary Clinton, 2016

J.N.: I think men have it because they are egotistical jerks. It comes from generations of ... Men think they have to be in charge or they have to be macho. I think it just came from generation to generation. Now I think it's changing because women are a big part of everything now and they're in charge. I think it's changed a little.

K.H.: It's changed?

J.N.: I'm a non-violent person. I was always really a non-violent person. There's a lot of other people that were more violent than I was that I know. I don't know, probably not too much out of the ordinary.

K.H.: What were you angry about? What is ... do you have any ...

J.N.: When I started drinking and drugging?

K.H.: Yeah, when the violence was coming out when you were 25 when you were starting fights?

J.N.: I was 22. It was all about our family. I just had graduated from [▮▮▮ 00:24:54] in Alaska and I had scholarships and stuff like that, and then my dad died. It just changed the whole dynamic of our family, moving, who's going where, all that. It was just too much for me.

K.H.: You're doing good by the way, so thank you. I want to ask you some questions about your childhood and some of your family relationships. You mentioned that you were sexually abused as a child, right? As a kid?

J.N.: Yeah I was 12 years old in ▮▮▮ California in a swimming pool.

K.H.: Did that just happen once or more than once?

J.N.: It was just the once.

K.H.: Did you feel any ... do you remember if you felt any shame or guilt as a result of this?

J.N.: I know during ... I remember I was scared to death. For one thing this person was bigger and stronger. Yeah, I was scared. I remember that part. After I don't know at that age if I ... I'm sure I felt a lot of guilt, but at that age I don't think ... I don't know. You feel a whole bunch of stuff at that age. Probably. I just can't remember all the feelings. I remember being scared. I remember not wanting to go around them. I probably still stayed scared. That would be my guess.

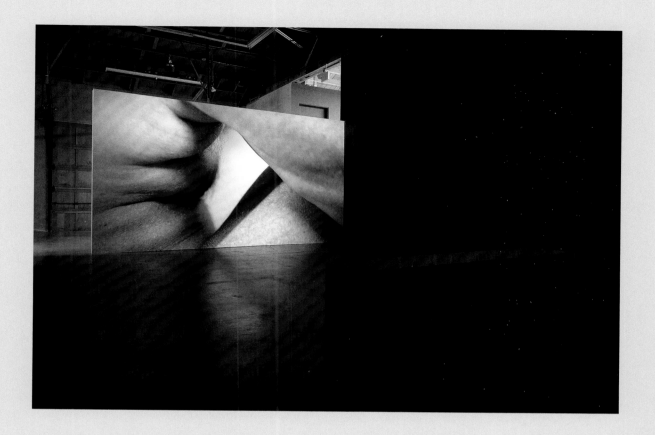

a space for an accounting from the perspective of the victimizer. As accounts of Trump's misogyny failed to tip the balance of the electoral process, Haendel's earnest attempt to ask fundamental questions about male violence and privilege became a tonal counterpoint to the more traditional historical portraiture in the show.

The memorization and memorialization involved in holding an image through drawing was achingly manifested in Haendel's portrait *Hillary Clinton* (2016), his largest work on paper to date. In this election cycle, like many others of a highly polarized nature, time was experienced through the minute-to-minute documentation of the campaign. Haendel selected a photojournalistic image of a pensive Hillary that could have resonance whether she won or lost, and worked on the drawing with his studio assistant for over four months. The resulting drawing, accompanied by an audio recording of the artist's three-year-old daughter reciting the first names of all the American presidents as if they were boys in her class, ends up depicting a dead time, either too soon or too late, in its grasping at a sense of national failure. What does it mean to declare and disclose in the era of "post-truth"? And when this "by and by" is to occur, will it end up like the *Unfinished Obama (mirrored)* (2016)? Over a span of twenty years, Haendel has treated his art practice as mutable space for an arrangement of a vast array of pictures and texts. He has found humor as well as pathos in these arrangements, while all the while reflexively nodding to and narrating his function as a "compassionate conceptualist."

1 Natilee Harren, "Knight's Heritage: Karl Haendel and the Legacy of Appropriation, Episode One, 2000," in *Art Journal Open*, February 29, 2016, http://artjournal.collegeart.org/?p=6929.
2 Ronald Jones, RBS, press release, Milliken Gallery, 2009.
3 Karl Haendel, "Thoughts on My Drawings," May 2012, unpublished text.
4 In an exchange with Haendel, he noted the importance of Jacques Derrida's *Memoirs of the Blind* on his practice, in particular, the notion that every drawing involves an act of blindness.
5 E-mail from Karl Haendel to author, February 15, 2018.
6 Haendel was a studio assistant for Steinbach from 1997—2000, and has discussed his surprise at discovering Steinbach's affective relationships to his found objects.
7 Karl Haendel, "Complicated Sneakers," in Juan Roselione-Valadez, ed., *Beg Borrow Steal: Rubell Family Collection* (Miami: Rubell Family Collection, 2009), p. 87.
8 Eve Melzer, "Monuments for the USA," June 13, 2005, *Frieze*, accessed online at https://frieze.com/article/monuments-usa.

POST-TRUTH
POST-TRUTH
POST-TRUTH
POST-TRUTH
POST-TRUTH
POST-TRUTH
POST-TRUTH
POST-TRUTH
POST-TRUTH
POST-TRUTH

We hold these truths to be self-evident, that all men are created equal, that they are endowed by their Creator with certain unalienable Rights, that among these are Life, Liberty and the pursuit of Happiness.

We hold these truths to be self-evident, that all people evolved differently, that they are born with certain mutable characteristics, and that among these are life and the pursuit of pleasure.

Installation view, *BY AND BY*, 2017

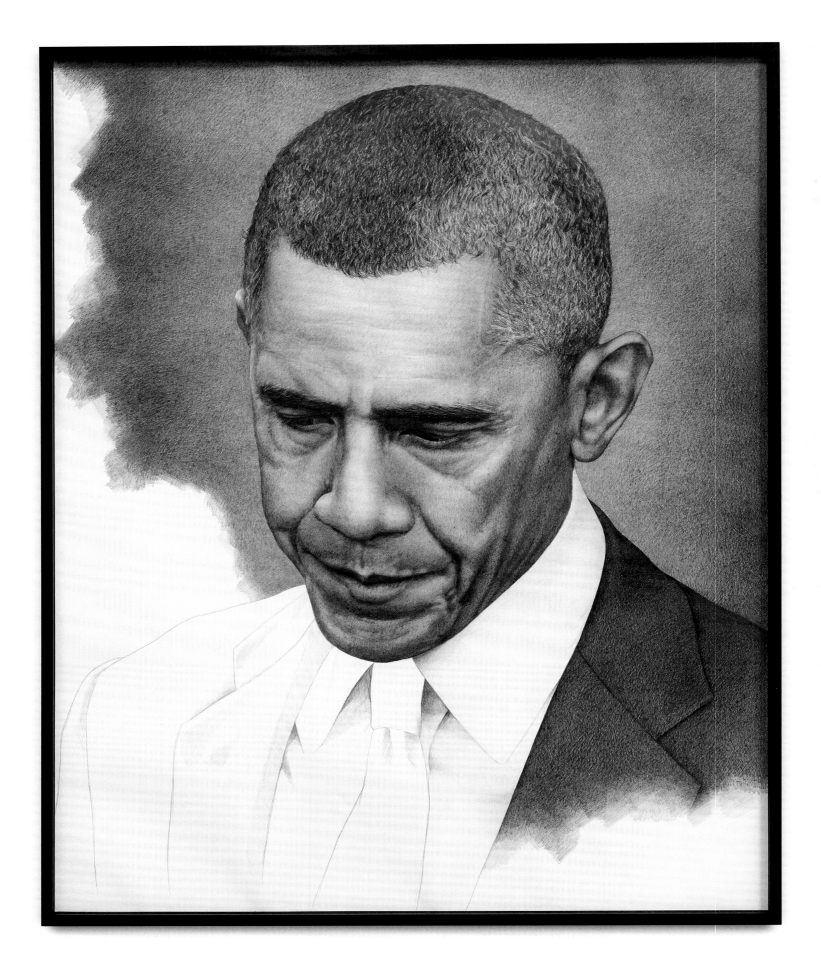

Unfinished Obama (mirrored), 2016

KARL HAENDEL

Born 1976, New York
Lives and works in Los Angeles

EDUCATION

2003
MFA, University of California, Los Angeles, CA

2000
Skowhegan School of Painting and Sculpture, Skowhegan, ME

1999
Whitney Museum Independent Study Program, New York, NY

1998
BA, Brown University, Providence, RI

SELECTED ONE AND TWO PERSON EXHIBITIONS

2018
Wentrup, Berlin, Germany

2017
BY AND BY, Susanne Vielmetter Los Angeles Projects, Los Angeles, CA
Pink Cup and The Facts, Mitchell-Innes Nash, New York, NY (with Jay DeFeo)

2016
Unwinding Unboxing, Unbending Uncocking, Wentrup, Berlin, Germany
LAXART, Los Angeles, CA (with Tony Lewis)
½ Einstein's Brain, ½ Moon Rock, Galleria Raucci/Santamaria, Naples, Italy

2015
Organic Bedfellow, Feral Othello, Mitchell-Innes Nash, New York, NY
Unwinding Unboxing, Unbending Uncocking, Night Gallery, Los Angeles, CA
Weeks in Wet Sheets, Barbara Seiler Gallery, Zurich, Switzerland

2014
People Who Don't Know They're Dead, Sommer Contemporary Art, Tel Aviv, Israel
Water Works, Halsey McKay Gallery, East Hampton, NY (with Adam Helms)

2013
The Competition Myth, Yvon Lambert, Paris, France
High Performance Stiffened Structures, Museo de Arte de El Salvador, San Salvador, El Salvador
High Performance Stiffened Structures, Locust Projects, Miami, FL

2012
Oral Sadism and The Vegetarian Personality, Human Resources, Los Angeles, CA
Questions for My Father, Utah Museum of Contemporary Art, Salt Lake City, UT (with Petter Ringbom)
Questions for My Father, The Box, Wexner Center for the Arts, Columbus, OH (with Petter Ringbom)
Informal Family Blackmail, Susanne Vielmetter Los Angeles Projects, Los Angeles, CA

2011
Yvon Lambert, Paris, France
Celestial Spectacular, Night Gallery, Los Angeles, CA (with Jennifer Bornstein)

2010
Lever House, New York, NY
Sir Ernest Shackleton and All The Clocks in My House, Susanne Vielmetter Los Angeles Projects,
 Los Angeles, CA

2009
Displeasure, Milliken Gallery, Stockholm, Sweden
Plug n' Play, Redling Fine Art, Los Angeles, CA (with Walead Beshty)
How to Have a Socially Responsible Orgasm and Other Life Lessons, Harris Lieberman, New York, NY

2008
Kommitment Karl, Sommer Contemporary Art, Tel Aviv, Israel

2007
The Suburban, Chicago, IL
I Need Work, Harris Lieberman, New York, NY
Last Fair Deal Gone Down, Anna Helwing Gallery, Los Angeles, CA

2006
MOCA Focus: Karl Haendel, Museum of Contemporary Art, Los Angeles, CA
Make Me Down a Pallet on Your Floor, Sorcha Dallas, Glasgow, UK

2005
Grits Ain't Groceries (All Around the World), Anna Helwing Gallery, Los Angeles, CA

2003
You Can't Lose What You Ain't Never Had, Anna Helwing Gallery, Los Angeles, CA

SELECTED GROUP EXHIBITIONS

2018
A Slice through the World: Contemporary Artists' Drawings, Drawing Room, London, UK, and Modern Art, Oxford, UK

2017
I Who Make Mistakes on the Eternal Typewriter, Drawing Centre Diepenheim, Diepenheim, Netherlands
American Dream: Paintings and Drawings of American Realism Since 1965, Kunsthalle Emden, Emden, Germany
Unsere Amerikaner, Kunsthalle Bielefeld, Bielefeld, Germany
Game On!, Philbrook Museum of Art, Tulsa, OK

2016
Halftime in America, Arturo Bandini, Los Angeles, CA
Questions for My Father, Sommer Contemporary Art, Tel Aviv, Israel

2015
Biennial of The Americas, Museum of Contemporary Art, Denver, CO
The World is Made of Stories, Astrup Fearnley Museum of Modern Art, Oslo, Norway

2014
2014 Whitney Biennial, Whitney Museum of American Art, New York, NY
Manifest Intention. Drawing in All its Forms, Castello di Rivoli, Turin, Italy
Second year: 30 New Works from Giancarlo and Danna Olgiati Collection, -1, Lugano, Switzerland

2013
12th Biennale de Lyon, Lyon, France
Michelle Grabner: I Work From Home, MOCA Cleveland, OH

2012
The Residue of Memory, Aspen Art Museum, Aspen, CO
Graphite, Indianapolis Museum of Art, Indianapolis, IN
True Stories, Locks Gallery, Philadelphia, PA
Kathryn Andrews, Darren Bader, Karl Haendel, United Artists, Ltd., Marfa, TX
American Exuberance, The Rubell Family Collection, Miami, FL

2011
The Voyage or Three Years at Sea Part II, Charles H. Scott Gallery, Emily Carr University of Art & Design, Vancouver, BC, Canada
Prospect II, New Orleans, LA
Drawn From Photography, The Drawing Center, New York, NY (traveled to the DePaul Art Museum, Chicago, IL)
Nothing Beside Remains, Los Angeles Nomadic Exhibitions, Marfa, TX
Greater LA, New York, NY
The Unbearable Lightness of Being, Yvon Lambert, Paris, France
In the Name of the Artists, São Paulo Bienal Pavilion, São Paulo, Brazil
Arrêt sur Image: Collection du MAMAC, Galerie des Ponchettes, Musée d'Art Moderne et d'Art Contemporain, Nice, France

2010
Haunted, Guggenheim Museum, New York, NY
The Last Newspaper, The New Museum, New York, NY
Art Moves 2010, 3rd International Festival of Art of Billboards, Torun, Poland
Karl Haendel & Walead Beshty, Sheree Hovsepian, and Barbara Kasten, Monique Meloche, Chicago, IL
Image Transfer: Pictures in a Remix Culture, Henry Art Gallery, Seattle, WA, (traveled to the Peeler Art Center, DePauw University, Greencastle, IN; Center for Art, Design and Visual Culture, Baltimore, MD; Newcomb Art Gallery, Tulane University, New Orleans, LA; Salina Art Center, Salina, KA)
New Art for a New Century: Contemporary Acquisitions, 2000–2010, OCMA, Newport Beach, CA

2009
Collection: MOCA's First Thirty Years, MOCA, Los Angeles, CA
Beg, Borrow and Steal, The Rubell Family Collection, Miami, FL (traveled to Palm Springs Art Museum, Palm Springs, CA; Taubman Museum of Art, Roanoke, VA)
Maximal Minimal, Primopiano, Lugano, Switzerland
Play with your own Marbles: Walead Beshty, Karl Haendel & Patrick Hill, Noma Gallery, San Francisco, CA
Nothingness and Being, Fundación/Colección Jumex, Mexico
Picturing the Studio, The School of the Art Institute of Chicago, Chicago, IL
This is Killing Me, Massachusetts Museum of Contemporary Art, North Adams, MA

LEFT TO RIGHT:

Haendel, Los Angeles, 2011

Haendel at the UCLA Warner studios, 2002

2008

Meet Me Around the Corner — Works from the Astrup Fearnley Collection, Astrup Fearnley Museum of Modern Art, Oslo, Norway
2008 California Biennial, Orange County Museum of Art, Newport Beach, CA

2007

The New Authentics: Artists of the Post-Jewish Generation, Spertus Museum, Chicago, IL, and Rose Art Museum, Brandeis University, Waltham, MA
Lines, Grids, Stains, Words: Minimal Art Drawings from the Collection of The Museum of Modern Art, The Museum of Modern Art, New York, NY (traveled to Museu Serralves, Porto, Portugal, and Museum Wiesbaden, Wiesbaden, Germany)
Hammer Contemporary Collection Part I, Hammer Museum, Los Angeles, CA
HB — Works on Paper, Studio Guenzani, Milan, Italy
The Price of Everything. . ., The Art Gallery, CUNY Graduate Center, The City University of New York, New York, NY

2006

Red Eye: Los Angeles Artists from the Rubell Family Collection, The Rubell Family Collection, Miami, FL
Transforming Chronologies: An Atlas of Drawings, Part Two, The Museum of Modern Art, New York, NY
Particulate Matter, Mills College of Art, Oakland, CA
Pierre Bismuth, Ryan Gander, Karl Haendel, T.Kelly Mason, New York, NY, Cohan and Leslie
Down by Law, Whitney Museum of American Art, New York, NY

2005

Uncertain States of America, Astrup Fearnley Museum of Modern Art, Oslo, Norway (traveled to CCS Bard, New York, NY; Serpentine Gallery, London; Reykjavik Art Museum; Moscow Biennale; Herning Art Museum; CCA Warsaw; Le Musée de Sérignan; Galerie Rudolfinum, Prague; and Songzhuan Art Centre, Beijing)
Rogue Wave, LA Louver, Venice, CA
Hunch and Flail, Artists Space, New York, NY

2004

California Biennial, Orange County Museum of Contemporary Art, Newport Beach, CA,

2003

Richard Croft, Karl Haendel, Mitchell Syrop, Rosamund Felsen, Santa Monica, CA

2002

Emily Jacir, Karl Haendel, Kevin Hooyman, La Panaderia, Mexico City, Mexico

1999

100 Drawings, P.S.1 Contemporary Arts Center, Long Island City, NY

PUBLIC PROJECTS

2019

Holding History, LA Metro, Wilshire/Fairfax Station, Los Angeles, CA

2015

Plow Pose, I-70 Sign Show, St. Louis, MO

2011

Questions for Marfa, building façade, part of Nothing Beside Remains, LAND, Marfa, TX

2010

A Year From Now, Art Moves 2010, 3rd International Festival of Art of Billboards, Torun, Poland

2009

Public Scribble #2, façade of LAXART, Los Angeles, CA
Public Scribble #1, 411 Broadway, New York, NY, with Art Production Fund

2008

A Year From Now, billboard on La Cienega Blvd, Los Angeles, California Biennial 2008

1998

Desires, Kennedy Plaza Bus Terminal, Providence, RI

SELECTED PUBLICATIONS

2017

Karl Haendel: Knight's Heritage, Natilee Harren, LAXART, Los Angeles, CA

2014

2014 Whitney Biennial, Anthony Elms, Michelle Grabner, Stuart Comer, Whitney Museum, NY
Rubell Family Collection: Highlights & Artists' Writings Volume 1, RFC/Contemporary Arts Foundation, Miami, FL
Michelle Grabner: I Work From Home, David Norr, MOCA Cleveland, OH
Lyon Biennale 2013 T.2, les presses du réel, Dijon, France
12th Biennale de Lyon, ed., Thomas Boutoux, les presses du réel, Dijon, France
Subaltern, issue #2, Umea, Sweden
Vitamin D2: New Perspectives in Drawing, ed., Christian Rattemeyer, Phaidon Press, London
Bright: Typography Between Illustration and Art, ed., Slanted, Daab, Cologne
Blind Spot, issue 46, ed., Walead Beshty
Graphite, ed., Sarah Urist Green, Indianapolis Museum of Art, Indianapolis, IN

How do I sell more art? People tell me I should use color. And less text. Nobody buys text. Less politics would probably also help. Does that go for substance in general? Will less sell more? I'll lose it if I have to. And I should probably make my drawings all the same not too big, not too small size...kind of always the same-ish all around. Actually doing more of the same of what sold last would be good. I can't even remember what sold last. I doubt it looked like this. People don't buy drawings that look like this. As my daughter would say, this drawing is bore-ring. I should probably try to get my work into fashion magazines because I bet those artists make a lot of money. Actually, just get myself into fashion magazines. I'm skinny and somewhat attractive—I'll put your clothes on. And fancy interior design spreads too. Why don't interior designers want to hang this drawing in an unused living room? If you are still reading this I want to assure you that I really need to sell more drawings. This is not a joke. I am running out of money. Do you know how much my health insurance costs? Mounting drawings to canvas is one strategy, because then they're paintings. But I couldn't do that to Drawing. Do you know that drawings are 1/4 the price of comparably sized paintings? People say I would sell more if I were younger. Or older. Anything but middle aged. There is just no money coming in. It's making me anxious and terribly irritable, like, all the time. If you are one of those people who buys art maybe you can tell me what you buy, because this clearly isn't it. That said, I should probably stop refusing commissions. Commissions are money for art...but is it really art if it's a commission? Really? Being a white guy probably doesn't help. Who needs more art by us? Although am I even white anymore? I think Trump revoked the Jews' whiteness. Maybe I can play up the Yid angle? Hitler killed a lot of my family. Does that make this drawing more desirable? Does sex still sell? TITS! DICKS! Yes? No? Don't think that because you are reading this in a gallery that it sells. Lots of stuff doesn't sell here. By the way, if you are still reading this, props. You probably could have been looking at something colorful instead.

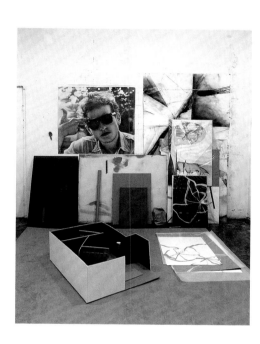

2012

Why Did the Chicken Cross the Road? Original Jokes about The Suburban and the Poor Farm by Artists Who have Exhibited There, Poor Farm Press, Manawa, WI
Hyperdrawing, Beyond the Line of Contemporary Art, eds., Phil Sawdon and Russell Marshall, I.B. Tauris, London
The Residue of Memory, Aspen Art Museum, Aspen, CO
Prospect 2, New Orleans, by Dan Cameron and Miranda Lash, US Biennial, Inc.

2011

American Exuberance, The Rubell Family Collection, Miami, FL
LA><ART>5, LA><ART, Los Angeles, CA
Drawn From Photography, Drawing Papers 96, The Drawing Center, New York, NY
Art Moves 2010, Fundacja Rusz, Torun, Poland

2010

Haunted: Contemporary Photography, Video, Performance, Guggenheim Museum, eds., Jennifer Blessing, Peggy Phelan, Nat Trotman
Image Transfer, Henry Art Gallery, Seattle, WA
Words Without Pictures, Aperture/LACMA, ed., Alex Klein
The Studio Reader: On the Space of Artists, University of Chicago Press, eds., Michelle Grabner and Mary Jane Jacob

2009

Beg, Borrow and Steal, The Rubell Family Collection, Miami, FL
The Judith Rothschild Foundation Contemporary Drawings Collection: Catalogue Raisonne, ed., Christian Rattemeyer, The Museum of Modern Art, NY

2008

2008 California Biennial, Lauri Firstenberg, Orange County Museum of Art, Newport Beach, CA
Lines, Grids, Stains, Words: Minimal Art Drawings from the Collection of The Museum of Modern Art, Christian Rattemeyer, The Museum of Modern Art, NY

2007

The New Authentics: Artists of the Post-Jewish Generation, Staci Boris, Spertus Museum, Chicago, IL
Red Eye: Los Angeles Artists from the Rubell Family Collection, Rubell Family Collection, 2007

2006

Anna Helwing Gallery Conversations: Karl Haendel and Mario Ybarra Jr., Anna Helwing Gallery, Los Angeles, CA
Karl Haendel, Museum of Contemporary Art, Los Angeles, CA

2005

do it, ed., Hans Ulrich Obrist, e-flux and Revolver, Frankfurt am Main, Germany
Uncertain States of America, Astrup Fearnley Museum of Modern Art, Oslo, Norway
Rogue Wave, LA Louver, Venice, CA

2004

La Panaderia: 1994—2002, ed., Yoshua Okon, Turner, Mexico City, Mexico
California Biennial 04, Orange County Museum of Art, Newport Beach, CA
American Stars N' Bars, Chapman University, Orange, CA.

2000

McSweeney's, issue 6, ed., Dave Eggers, McSweeney's Publishing, San Francisco, CA

1999

Billboard: Art on the Road, Laura Heon et al., MASS MoCA and MIT Press

SELECTED BIBLIOGRAPHY

2017

Astorga, Elena. "Planes culturales para este Inauguration Day en Los Ángeles," *La Opinión*, January 18, 2017
Goldman, Edward. "France and the US: Art and politics two centuries apart," *KCRW Art Talk*, January 10, 2017
Horst, Aaron. "Karl Haendel at Susanne Vielmetter," *Carla*, Winter 2017
Los Angeles Review of Books, Quarterly Journal, No. 14
Lüddemann, Stefan. "The American Dream: Risse im American Way of Life," *Osnabrücker Zeitung*, November 17, 2017
Vanduffel, Dirk. "I'm interested in the overall physical experience of the viewer—not just a visual experience," *Artdependence Magazine*, December 19, 2017
Walters, Sydney. "Karl Haendel: Drawing the American Ego," *Art and Cake*, Februrary 3, 2017

2016

Farago, Jason. "Politics and Commerce Collide at Art Basel Miami Beach," *The New York Times*, December 2, 2016
Harren, Natilee. "Knight's Heritage: Karl Haendel and the Legacy of Appropriation," *Art Journal Open*, April, 2016
Harrison, Nate. "Response to Natilee Harren's 'Knight's Heritage: Karl Haendel and the Legacy of Appropriation,'" *Art Journal Open*, April 2016
Kazakina, Katya. "Trump Alters Vibe at Miami Art Fair," *Bloomberg*, December 1, 2016
Martin, Lucy. "Now showing: Karl Haendel, Unwinding Unboxing, Unbending Uncocking" *Elephant Magazine*, Spring 2016

Mizota, Sharon. "At LAXART, boundary-blurring drawing as a form of sculpture," *Los Angeles Times*, May 2, 2016
"Reviews in Brief: Karl Haendel," *Modern Painters*, January 2016, p. 84
Thomson, Anne. "I-70 Sign Show," *Public Art Dialog*, vol. 6, no. 2
Vogel, Wendy. "Karl Haendel, Mitchell-Innes & Nash," *Art in America*, January 2016, p. 92
Woods, Gaea. "LA Artists and their Cars," *Kaleidoscope*, issue 26, Winter 2016

2015

Haendel, Karl. "BioPic," *Modern Painters*, March 2015
Rosenmeyer, Aoife. "Karl Haendel at Barbara Seiler Galerie Zürich," *Frieze*, November 12, 2015
Rosenthal, Katie. "Virgo Vape, Strap-On Tampon: Karl Haendel At Night Gallery," *The Hundreds*, March 15, 2013
Sanati, Mercedeh. "Karl Haendel, Mitchell-Innes & Nash," *The Globe and Mail*, October 31, 2015
Schuessler, Ryan. "'Blah, blah, blah'? Billboard art show confronts Missouri drivers head-on," *Al Jazeera America*, May 21, 2015
Slocum, Amy Maire. "Karl Haendel: 'Tis in Ourselves That We Are This or Thus," *Flaunt*, Fall 2015, pp. 64—65
Swenson, Eric Minh. "Understanding Karl Haendel," *TheHuffingtonPost.com*, March 30, 2015
Zellen, Jody. "'Unwinding Unboxing, Unbending Uncocking' at Night Gallery," *art ltd.*, May/June 2015, p. 24

2014

Dambrot, Nys Shana. "Whitney Biennial: The View From LA," *art ltd.*, March/April 2014, pp. 44—45
Yahav, Galia. "Karl Haendel: Drawer of Tabloid Soul," *Haarretz*, May 25, 2014, p. 24

2013

Dagen, Philippe. "Des histories émergent dans un océan d'images," *Le Monde*, September 11, 2013
Heurteloup, Laura. "Quand l'art fait des histories," *Arts Magazine*, September 26, 2013, p. 129
"Le récit au coeur de la 12e Biennale d'art de Lyon," *La Presse*, September 12, 2013
McGarry, Kevin. "12th Lyon Biennial," *Frieze*, October 2012
Packer, Matt. "The 12th Biennale de Lyon," *Kaleidoscope*, November 2013
Saati, Briana. "Locust Projects' New Exhibits Force Viewers Outside Their Comfort Zones," *Miami New Times*, January 25

2012

Caldwell, Ellen C. "Karl Haendel at Susanne Vielmetter Los Angeles Projects," *New American Painting*, July 2012
Davis, Ben. "Karl Haendel, Harris Lieberman Gallery," *Modern Painters*, February 2012
Drohojowska-Philp, Hunter. "Karl Haendel-Family Blackmail," *Artnet*, June 15, 2012
"Graphite's Spotlight: Drawing outside the lines of a medium," *Modern Painters*, December 2012
Frankel, David. "Reviews: Karl Haendel at Harris Lieberman," *Artforum*, January 2012, p. 218
Ise, Claudine. "2 Exhibits explore the boundaries of lines on paper, photography," *Chicago Tribune*, July 11, 2012
Lipschutz, Yael. "Karl Haendel, Susanne Vielmetter Projects—Los Angeles," *Flash Art*, Summer 2012, p. 98
Speed, Mitch. "The Voyage, or Three Years at Sea: Part II," *Frieze*, March 2012 p. 164

2011

Davis, Ben. "Tough Questions for Dad: In Praise of Karl Haendel's Quietly Poignant New Video," *Artinfo*, October 29, 2011
Douglas, Sarah. "All About My Father: Artist Karl Haendel and His Friends Have Lots of Questions," *NY Observer*, September 20, 2011
Dorfman, John. "The Lens and the Pencil," *Art & Antiques*, February 2011
Griffen, Jonathan. "The New Verisimilitude," *Art Review*, October 2011, p. 143
Rosenberg, Karen. "Authorship or Translation? Notes Toward Redefining Creativity," *The New York Times*, February 22, 2011, C24
Smith, Roberta. "A Bit of Hollywood, Minus the Tinsel," *The New York Times*, June 1, 2011, C1/C6
Smith, Roberta. "Art in Review, Karl Haendel, Questions for My Father," *The New York Times*, October 28, 2011, C32

2010

"500 Words: Karl Haendel," *Artforum.com*, March 23, 2010
Harren, Natilee. "Karl Haendel at Susanne Vielmetter Projects," *Artforum*, May 2010
Latimer, Quinn. "The High Modernist Drawing Board," *Art In America*, March 2010
"Posters," *First Person*, issue 4, Summer 2010
Pulimood, Steve. "Now Showing: Karl Haendel at Lever House," *The New York Times Style Magazine*, May 3, 2010
Smith, Roberta. "In Fields of Art, Snapping Photos," *The New York Times*, April 2, 2010
Waxman, Lori. "Walk this way, and draw this way," *Chicago Tribune*, November 12, 2010
Weinberg, Lauren. "Art Review: Karl Haendel," *TimeOut Chicago*, 297, November 4—10, 2010

2009

Beshty, Walead. "Walead Beshty puts four questions to Karl Haendel," *Modern Painters*, April 2009, p. 80
Johnson, Ken. "How to Have a Socially Responsible Orgasm and Other Life Lessons," *The New York Times*, June 12, 2009
"Goings On About Town: Karl Haendel," *The New Yorker*, June 8, 15, 2009
"Portfolio," *First Person*, issue 3, Fall 2009, pp. 64—69
Szupinka, Joanna. "Play with Your Own Marbles," *Artslant*, September 14, 2009
Vogel, Carol. "Karl Haendel's Jottings, Writ Large, on a SoHo Wall," *The New York Times*, May 7, 2009
Wilson, Michael. "Karl Haendel, 'How to Have a Socially Responsible Orgasm and Other Life Lessons,'" *TimeOut NY*, issue 714, June 4—10, 2009
Zellan, Jody. "Karl Haendel," *Art Papers*, September/October 2009

LEFT TO RIGHT:

Mieke Marple spreading lentils, Night Gallery, Los Angeles, 2015

Martin DiCicco fixing drawings, Haendel studio, Los Angeles, 2010

2008

Bryan-Wilson, Julia. "Signs and Symbols, On Billboard Projects in Los Angeles," *Artforum*, October 2008
Foumberg, Jason. "Review of The New Authentics: Artists of the Post-Jewish Generation, The Spertus Museum, Chicago, USA," *Frieze*, January 8, 2008
Haramis, Nick. "The New Regime: Karl Haendel," *BlackBook*, December 2008
Watson, Simon. "New Artist Karl Haendel: Redrawing," *Whitewall*, Winter 2008, pp. 68—69
Whitehead, Vagner M. "An Interview with Karl Haendel (I)," *Art Signal: Contemporary Art Magazine*, issue 3, January/March 2008, pp. 16—31

2007

Bell, Eugenia. "Karl Haendel Harris Lieberman," *Artforum*, November 2007
Cotter, Holland. "Quirks and Attitude to Burn," *The New York Times*, June 8, 2007
Garcia, Kathryn. "Karl Haendel at MOCA Focus," *Textfield*, Fall/Winter 2006-07, pp. 112—13
"Goings on About Town, Art," *The New Yorker*, September 25, 2007
Saltz, Jerry. "Has Money Ruined Art," *New York Magazine*, October 15, 2007
Smith, Roberta. "Karl Haendel," Art in Review, *The New York Times*, October 5, 2007

2006

Bluhm, Erik. "Karl Haendel," *ArtUS*, issue 13, May/June 2006, p. 5
"Focus Los Angeles," *Flash Art*, January/February 2006, p. 70
Pagel, David. "A late 80s date gets penciled in," *Los Angeles Times*, February 22, 2006, p. E2
Schimmel, Paul. "Future Greats 2005," *ArtReview*, December/January 2006, p. 92.
Searle, Adrian. "Rebels without a cause," *The Guardian Unlimited - UK*, September 12, 2006
Smith, Roberta, "Endgame Art? It's Borrow, Sample and Multiply in an Exhibition at Bard College," *The New York Times*, July 7, 2006
Thompson, Susannah. "Karl Haendel," *Contemporary Magazine*, no. 83, 2006, p. 60—63
Wullschlager, Jackie. "Bright, Brash, Unmissable: the US legacy," *Financial Times UK*, September 15, 2006
Zellan, Jody, "Karl Haendel," *Art Press*, April 2006, issue 322, pp. 74-75

2005

Jones, Leslie. "Karl Haendel at Anna Helwing Gallery," *Art on Paper*, July/August, vol. 9, no. 6, p. 65
Kite, Kristina. Critics' Pick, *Artforum.com*, March 18, 2005
Ollman, Leah. *Los Angeles Times*, April 1, 2005
Pence, Elizabeth. "Karl Haendel at Anna Helwing Gallery," *Artweek*, June 2005, vol. 35, issue 5, p. 18

2004

Knight, Christopher. "Biennial arrives, and so does museum," *Los Angeles Times*, October 13, 200, E1 & 7

AWARDS, GRANTS, AND RESIDENCIES

2015

CCF Fellowship for Visual Artists
Pollock Krasner Foundation Grant

2011

Chinati Foundation Artist-in-Residence

2004

Penny McCall Foundation Award
Durfee Foundation Grant

PUBLIC COLLECTIONS

Art Gallery of Ontario, Toronto, Canada
Astrup Fearnley Museum of Modern Art, Oslo, Norway
The Center for Curatorial Studies, Bard College, NY
Collection Lambert, Avignon, France
Deutsche Bank Collection, Frankfurt, Germany
Fogg Art Museum, Harvard University, Boston, MA
Guggenheim Museum, New York, NY
Hammer Museum, Los Angeles, CA
Kadist Art Foundation, Paris, France / San Francisco, CA
Kunsthalle Bielefeld, Germany
La Colección Jumex, Mexico City, Mexico
Los Angeles County Museum of Art, Los Angeles, CA
Marciano Art Foundation, Los Angeles, CA
Museum of Contemporary Art, Los Angeles, CA
The Museum of Modern Art, New York, NY
Orange County Museum of Art, Newport Beach, CA
Perez Art Museum, Miami, FL
Philbrook Museum of Art, Tulsa, OK
RISD Museum, Providence, RI
Rubell Family Collection, Miami, FL
Whitney Museum of American Art, New York, NY

LIST OF WORKS:

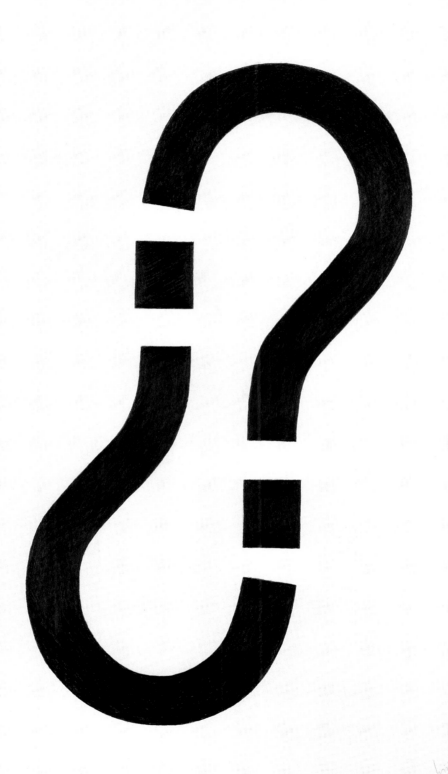

Copyediting:
Aaron Bogart

Graphic design and typesetting:
Jesse Willenbring, The Sunset People, Los Angeles

Typeface:
Biotif

Production:
Heidrun Zimmerman, Hatje Cantz

Project management:
Claire Cichy, Hatje Cantz

Reproductions:
Echelon Color, Santa Monica

Printing:
DZA Druckerei zu Altenburg GmbH, Altenburg

Paper:
LumiSilk, 170 g/m²

Copyright:
All photographs by Karl Haendel, except: Colossal Media: cover, pp. 183–84 (left), 185; Ruben Diaz: pp. 1, 71, 156–57; Trevor Good: pp. 2, 137–39, 194; Florian Maier-Aichen: p. 9; Jason Mandella: p. 10 (bottom); The Museum of Modern Art / Licensed by SCALA / Art Resource, NY: p. 13; The Warburg Institute, University of London: p. 15; Dawn Kasper: pp. 16–17 (top); Kerry Tribe: p. 17 (bottom); Josh White: pp. 26, 43 (right), 45, 46 (middle), 47 (right), 48, 50–51, 55–57, 63, 65–66, 68–70 (left); Chris Kendall: pp. 28–29; Kris McKay / SRGF, NY: pp. 30–31; Robert Wedemeyer: pp. 36–37, 74–75, 80 (middle), 96–99, 101, 103 (top), 104 (left), 106–108 (left), 109 (left)–112, 114–17, 126–29, 142, 172 (top), 179, 186, 188–93; Chi Lam: pp. 40, 85; Bliss Photography: p. 43 (left); LA Louver Gallery, Venice, CA: p. 52; Brian Forrest: pp. 60–61 (top); Larry Lamay: pp. 67 (left), 70 (right); Fredrik Nilson: p. 72 (bottom); Yigal Pardo: pp. 73, 132–33; Jesse David Harris: pp. 92–93; Didier Barroso: p. 102 (bottom); Michael Smith: p. 103 (top); Blaise Adilon: pp. 122–23, 124 (bottom); Sheldan C. Collins: p. 130 (bottom); Lee Thompson: p. 136; Kelly Shroads: p. 140; Christopher Burke Studios: pp. 141, 146–47; Anne Thompson: p. 143; Stephan Altenburger Photography: pp. 150–51; Andrea Rossetti Milan: pp. 163–65; Amir Zaki: p. 171; Marcus Leith: p. 172 (bottom); Imaging Department, President and Fellows of Harvard College: p. 178; Gary Krueger: p. 180 (middle); Jason Schmidt: p. 196

© 2018 Hatje Cantz Verlag, Berlin, and authors

© 2018 for the reproduced works by Karl Haendel: the artist

Published by
Hatje Cantz Verlag GmbH
Mommsenstraße 27
10629 Berlin
Tel. +49 30 3464678-00
Fax +49 30 3464678-29
www.hatjecantz.de

A Ganske Publishing Group Company

Hatje Cantz books are available internationally at selected bookstores. For more information about our distribution partners, please visit our website at www.hatjecantz.com.

ISBN 978-3-7757-4371-6

Printed in Germany

Cover illustration:
Public Scribble #1, 2009 [detail]. Enamel on wall, 80 x 120 ft. (24.4 x 36.6 m). Courtesy Art Production Fund, New York

Frontispiece:
Ripped Scribble #4, 2007 [detail]. Pencil and staples on ripped paper with MDF frame, 59 x 100 in. (149.9 x 254 cm) (framed). Private collection

p. 2:
Sigmund Silent 2, 2017. Pencil on paper, 62 x 45 in. (157.5 x 114.3 cm). Courtesy of the artist and Wentrup Gallery, Berlin

p. 4:
The Facts (in a Rice Cake), 2017 [detail]. Pencil on paper, 30 x 22 in. (76.2 x 55.9 cm). Courtesy of the artist and Mitchell-Innes & Nash, NY

The artist would like to thank Lucy Mitchell-Innes and Josie Nash at Mitchell-Innes & Nash, New York, Tina and Jan Wentrup at Wentrup Gallery, Berlin, Susanne Vielmetter and Ariel Pittman at Susanne Vielmetter Los Angeles Projects, Irit Sommer and Tamar Zagursky at Sommer Contemporary Art, Tel Aviv, Umberto Raucci and Carlo Santamaria at Raucci / Santamaria, Naples / Milan, Walead Beshty, Lonnie Blanchard, Aaron Bogart, Claire Cichy, Andrew Curry, Martin DiCicco, Bridget Finn, Rita Gonzalez, Michelle Grabner, Anitra Haendel, Theodore Haendel, Natilee Harren, Siobhan Hebron, Adam Helms, Haley Hopkins, Tony Jolet, Mary Kelly, Tony Lewis, Holger Liebs, Tony Manzella, Mieke Marple, Eric and Martha Mast, Davida Nemeroff, Christian Rattemeyer, Petter Ringbom, Justin Smith, Jim Walters, Susanna Weingarten and Hugh McCormick, Jesse Willenbring, Heidrun Zimmermann and, most especially, Emily Mast and Hazel.